Caspar David Friedrich

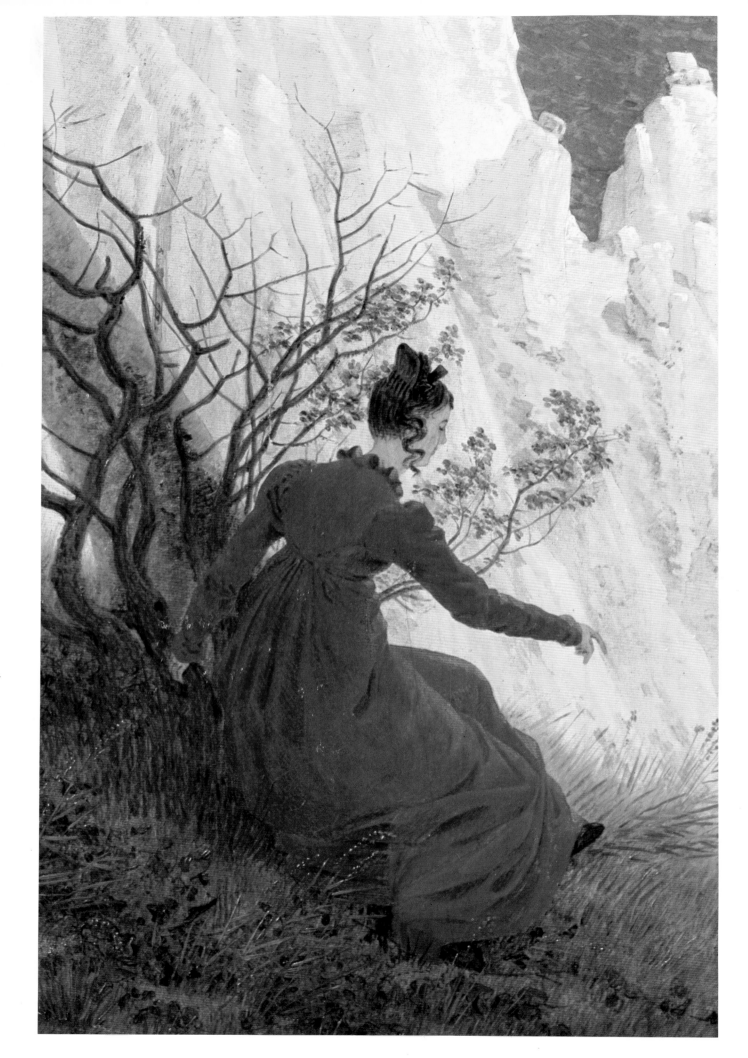

Caspar David Friedrich

Helmut Börsch-Supan

George Braziller New York

Translated from the German by Sarah Twohig

Published in the United States in 1974 by George Braziller, Inc.
English translation © 1974 Thames and Hudson, Ltd., London
Originally published in West Germany © 1973 Prestel Verlag,
Munich

Published simultaneously in Canada by Doubleday Canada, Ltd.
George Braziller, Inc., One Park Avenue, New York 10016
Library of Congress Catalog Number: 73-93687
Standard Book Number: 0-8076-0747-9
First Printing
Printed and bound in West Germany

Contents

The Plates – *cont.*

Caspar David Friedrich: Landscape as Language

On 30 January 1825 in Rome the young Dresden landscape painter Ludwig Richter (1803–84) wrote in his diary: 'It seems to me that Friedrich's manner of interpretation leads in a false direction that could become highly epidemic in our time; the majority of his pictures exude that morbid melancholy, that feverishness that grips every sensitive observer so forcefully, but which always produces a disconsolate feeling – this is not the seriousness, not the character, nor the spirit and importance of Nature, this has been imposed from without. Friedrich chains us to an abstract idea, making use of the forms of Nature in a purely allegorical manner, as signs and hieroglyphs – they are made to mean this and that. In Nature, however, every thing expresses itself; her spirit, her language lies in every shape and colour. A beautiful scene of Nature, it is true, also arouses only one feeling (not a thought), but this is so all-embracing, so grand, powerful and intense, that every allegory seems in comparison desiccated and shrivelled up.'

Richter's doubts were shared by many other painters of his generation. The attitude they embody was taken absolutely for granted later in the nineteenth century and still largely determines the consciousness of our own day. Landscape is regarded as a category of beauty removed from the canons applied to the human body and to artistic forms. It is seen as something only distantly related to man which creates tensions and yet arouses a sense of unity. Landscape gives man criteria of time and space which extend beyond his ability for aesthetic comprehension. Yet precisely because of this it stimulates his emotions and his versatile nature and gives him the confidence to assert himself. The reaction of many artists to this way of experiencing nature was to abandon partially or completely any form of composition, to limit their choice to only the most beautiful of her endless abundance of images, and to endeavour to render what they saw as faithfully as possible.

Friedrich also perceived nature in this way, but for him the experience was an allegory of a religious one in which the certainty of death and the hope of eternal life to come were interwoven. In a poem he summed up the *Leitmotiv* of his own thought and creativity thus: 'Why, it has often occurred to me to ask myself, do I so frequently choose death, transience and the grave as subjects for my paintings? One must submit oneself many times to death in order some day to attain life everlasting.'

In Friedrich's art this overwhelming experience of nature is associated with the no less overwhelming experience of his own unfathomable existence. Friedrich's painting is the expression of those experience that link the self and the external world. This is what he meant when he wrote: 'The artist should paint not only what he sees before him, but also what he sees within him. If, however, he sees nothing within him, then he should also refrain from painting that which he sees before him. Otherwise his pictures will be like those folding screens behind which one expects to find

only the sick or the dead.' Landscape became for him a language, an allegory, but without becoming arid in the sense that Richter had outlined.

Richter was not the only one of Friedrich's contemporaries to observe that his paintings were like a language. He was frequently described as the founder of a poetic tendency in the modern style of landscape painting. In 1808 the philosopher Gotthilf Heinrich von Schubert (1780–1860), a friend of Friedrich and former fellow-student, published his widely read *Ansichten von der Nachtseite der Naturwissenschaft* (Views on the Dark Side of Natural Science) in which he included an interpretation of almost every detail of one of Friedrich's sepia cycles.

Later on, Friedrich's basic aim was forgotten. His paintings were regarded merely as atmospheric landscapes which aimed at inducing a feeling of melancholy in the observer, a misunderstanding that had already occurred in Richter's comments, and had in fact been expressed earlier still. In his famous criticism of the *Tetschen Altar* (pl. 6), the connoisseur and art critic Friedrich Wilhelm Basilius von Ramdohr (1757–1822) said of Friedrich that he aimed solely at the 'pathological arousal of emotion'. Totally misunderstanding the clarity of Friedrich's thought, Ramdohr accused him of mysticism.

It was against this reproof that the Dresden writer Ludwig Tieck (1773–1853) defended Friedrich particularly impressively in his short novel *Eine Sommerreise* (A Summer Journey), using the character Walter von Reineck as his mouthpiece. 'This truly wonderful Nature has a hold over me even though much of its essence remains obscure. In his landscape themes Friedrich tries to express and suggest most sensitively the solemn sadness and the religious stimulus which seem recently to be reviving our German world in a strange way. This endeavour finds many friends and admirers and, much more understandably, many opponents. Historical paintings and, to an even greater degree, many church paintings have often been completely reduced to symbol and allegory, and landscape seems to be intended rather to evoke a feeling of meditation, well-being, or joy at the imitation of reality, which is itself linked with a gracious longing and fantasizing. Friedrich on the contrary strives rather to evoke a certain feeling, a definite attitude with precise thoughts and concepts which merge with that sadness and solemnity. Thus he also tries to introduce allegory and symbolism in light and shadow, in Nature living and dead, in snow and water, and also in the figures. Indeed, by a strict clarity he attempts to lift landscape above history or legend; whereas before it had always seemed such a vague theme, like a dream or some arbitrary occurrence. This is a new endeavour and it is astonishing how much he has achieved more than once with so few means.'

The fact that Friedrich's language was only comprehensible to a few people during his lifetime was not only the fault of the public, but was due equally to his own abhorrence of revealing his most intimate feelings to the casual observer. Many of his pictures are like monologues which are meaningful only if one knows enough biographical details about the artist. Some of his works could not be interpreted at all until present-day art historians managed to form an overall impression of his *oeuvre*.

In keeping with this reserve Friedrich rarely spoke about his works, and when he did it was invariably in a cryptic and, at times, ironic manner which the observer then had to unravel before he could apply the words to the picture in question. A typical instance of this habit can be found in the letter he wrote to the Dresden

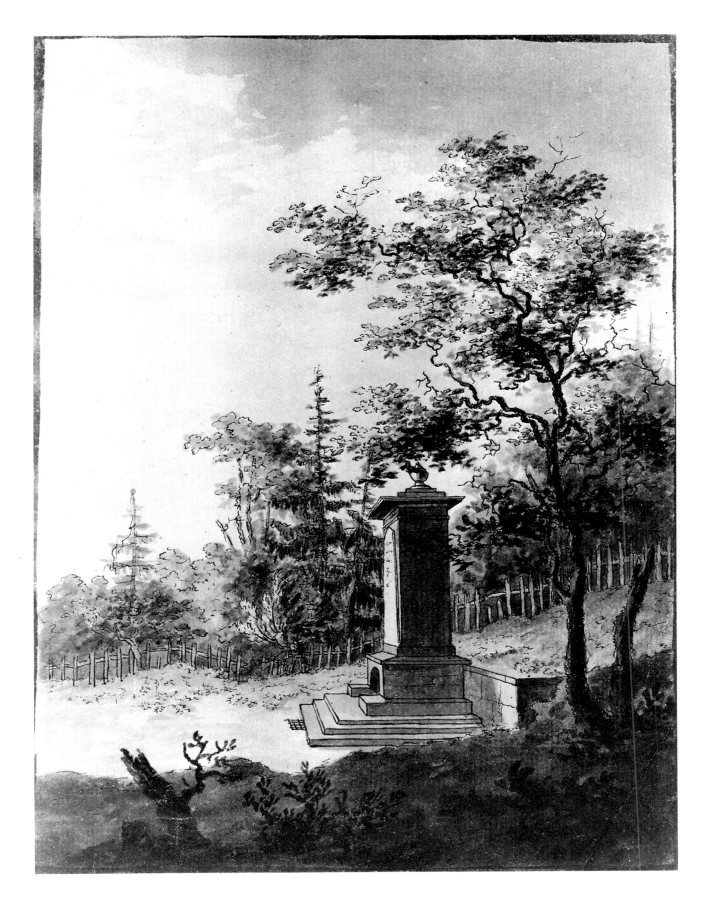

1 *Emilie's Spring*, 1797, watercolour, 21.8 x 16.7 cm. Hamburg, Kunsthalle

artist Luise Seidler on 9 May 1815. In it he explained the cross on the shore in *The Cross on the Baltic* (pl. 14) as being 'to some a consolation, to others simply a cross', by which he meant not only sailors on ships but also those looking at the painting. In his later works in particular, Friedrich always gives the observer the chance to see in his pictures something quite different from what he himself had intended, thus diverting superficial curiosity from his real intentions. This ambiguity is an inherent part of his paintings. He combines humility and an aristocratic aloofness to popular customs in a way that is difficult for us to understand today.

If we can indeed describe Friedrich's paintings as language, then it is a very secret, mysterious one, and served the artist not only as a means of conveying his ideas but also offered him a certain emotional release. To penetrate into Friedrich's art therefore necessarily involves the betrayal of his secret. It is as if one were over-hearing someone at prayer: the intrusion can only be justified afterwards by a feeling of sympathy and shock. It cannot be denied that the display and popularization of Friedrich's art is a problematical enterprise if it attempts to lay open its core.

Though in his old age Friedrich was sometimes hurt by the undeserved neglect of his art, the striving for fame and self-immortalization was very much a subordinate motive of his creativity. Whenever he included a self-portrait in a landscape he always adopted a posture of humility. Posterity does not do him justice if it celebrates him as an intellectual hero; it can only do justice to his work by revealing the depths of humanity to which it attains.

Art of this kind is indissolubly bound up with the personality and life of its creator. The sculptor Johann Gottfried Schadow (1764–1850) acknowledged this when he remarked in a letter to Goethe, though with critical undertones: 'Friedrich is right, for if he did not do it like that, it would not be anything at all; and then the action is in keeping with the man – he is like that through and through.'

Friedrich's art is clearly not just the result of the conditions of his life; quite the reverse, his life is the product of his creative will. He did not surrender himself to impressions, but took only as much from his environment as he could absorb and assimilate. The same 'economic' principle that ruled his art also dictated the events of his life. For this reason his circle of friends remained fairly narrow and those around him took less notice of him than of other intellects of lesser or equal stature.

In the late eighteenth century Greifswald, Friedrich's birthplace, was an insignificant port with about five thousand inhabitants. Few students went to the university there any more. There was no industry worthy of mention; in fact the only commerical interest in the entire town was a saltworks. Since 1631 the town had been under Swedish rule and was ceded to Prussia only in 1815. Its outward appearance was largely determined by the architecture of the Middle Ages. In more recent centuries it had produced no noteworthy artistic achievements. It was a town living on in the shadow of its past and this severely impeded any activities geared to the future.

Friedrich's father was a soap-boiler and chandler and had lived in Greifswald since 1763. Both he and his wife were natives from Neubrandenburg in the Duchy of Mecklenburg-Strelitz, which Caspar David therefore regarded as his home town just as much as Greifswald. Comments made by his niece, Lotte Sponholz, give an idea of the Friedrich family life and reveal the strict moral principles according to

which the father brought up his children. After the death of their mother in 1781 the children were looked after by a housekeeper, 'Mother Heiden'. The six sons and two daughters had lessons from a tutor who laid special emphasis on Latin as well as awakening their appreciation of poetry and music. The father's business seems to have ensured a certain modest prosperity.

A dark shadow was cast over Friedrich's life relatively early on when, in 1787, his younger brother Christoffer, in the act of saving him from drowning, was himself drowned. One of his sisters also died in tragic circumstances in 1791. To attribute his subsequent outlook on life solely to these childhood experiences, as was done even during his lifetime, is scarcely tenable. The assessment of his friend, the painter Caroline Bardua, that Friedrich was by nature inclined to melancholy seems far more likely.

The first evidence we possess of his artistic activity is contained in six pages of handwriting which he did at the age of fourteen or fifteen. They consist of moralizing texts written in calligraphic script. It is presumably no coincidence that the beginning of his artistic career should not consist in childish attempts to depict or record his impressions of the outside world. Even at this stage Friedrich's chief concern was to present his own thoughts, clothed only in the minimal amount of pictorial form necessary. Even on these modest sheets the poetic side of his character begins to make itself apparent.

Greifswald at that time was not exactly overflowing with artistic stimuli. The university teacher Johann Gottfried Quistorp (1755–1835), who gave Friedrich his first drawing lessons, was the only artist of note in the town, and he in fact spent most of his time working as an architect. Friedrich must have seen his considerable collection of paintings and engravings, though no specific reaction is discernible. The local literary scene was dominated by the figure of Gotthard Ludwig Kosegarten (1758–1818) who lived in nearby Wolgast, and later in Altenkirchen on the island of Rügen between 1785 and 1792. The predominant intellectual force was the Lutheran faith. All these factors may have contributed to the way in which, from quite early on, Friedrich began to use the intellectual side of his own character as a protection against the naive sensuous experience of nature.

In 1794 he went to the Academy in Copenhagen, the artistic metropolis of the north, where the painter Philipp Otto Runge (1777–1810) was to begin his studies five years later. The leading artists there were Jens Juel (1745–1802), a painter of elegant yet lively portraits, and Nicolai Abildgaard (1743–1809), who depicted literary themes and allegories in a style strongly influenced by Michelangelo and Fuseli. The few surviving examples of Friedrich's work dating from his four years at the Academy show relatively little influence of his teachers there. He may have been impressed by Abildgard's profundity of thought, but not to the extent that he tried to imitate him. Friedrich must have realized at about this time that he could not adopt some previously coined style, that he would have to find a language of his own. During these years he did a number of watercolours showing views of the parks and gardens near Copenhagen (fig. 1; pl. 1). At first sight they strike one as simple topographical views, but they also have an allegorical meaning because the landscaped gardens of that period were laid out in a manner that was intended to provoke certain thoughts.

When Friedrich left Copenhagen in May 1798 he was still by no means technically competent as an artist, and was searching in a variety of directions. Indeed, he apparently did not even know whether he wanted to become a figure painter or a landscapist. After travelling to Dresden via Berlin in October 1798 he tried to improve his rendering of the human figure by drawing from life. Between 1799 and 1800 he executed a number of emphatic figure drawings, including some illustrations

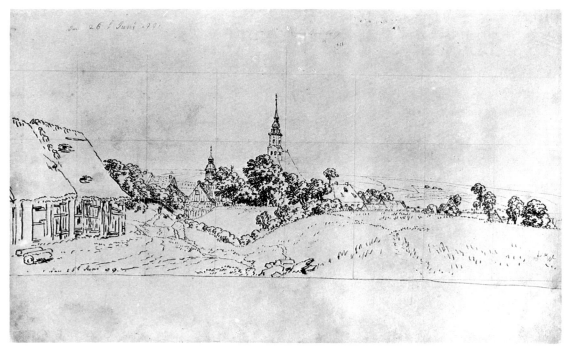

2 *Landscape with two Churches*, dated 26 June 1799, pen and ink, 23.5 x 38 cm. Hamburg, Kunsthalle

to Schiller's drama *Die Räuber*. One of his reasons for deciding to live and study in Dresden was probably the beautiful countryside around it and the fame the city had acquired as a centre for landscape painting through the work of Johann Christian Klengel, Jakob Wilhelm Mechau, Adrian Zingg and others. Two of Friedrich's extant sketchbooks from the years 1799–1800 show him intently preoccupied with training himself to draw from nature and at the same time collecting a number of models for landscape compositions. The subjects which dominate this collection are trees in full summer foliage with just a few branches withered and bare of leaves; fir-trees; rocks; various plants; and cloud studies. The books contain relatively few illustrative landscape studies (fig. 2). This strikingly limited choice of subjects can only be understood as a deliberate intention to build up a personal vocabulary of natural motifs. For him nothing was ever an object *per se*, it was also a symbol. In order to depict subjects from nature convincingly in his pictures he had to record the natural appearance of things. The drawings also prove how much surer his hand had become since his Copenhagen days. He was intent on developing artistic formulas for the outward appearance of things, in particular for foliage.

In October 1799 Friedrich began a series of etchings using the sketches he had made that summer. The first group of ten etchings were executed in rapid succession between

then and the following February. Since each sheet is dated exactly, we can trace his development in the course of the series, observing how he undertook a new step with each sheet. The expressive power of these works has to date been wholly underestimated, and his individual touch has not been acknowledged because he was still

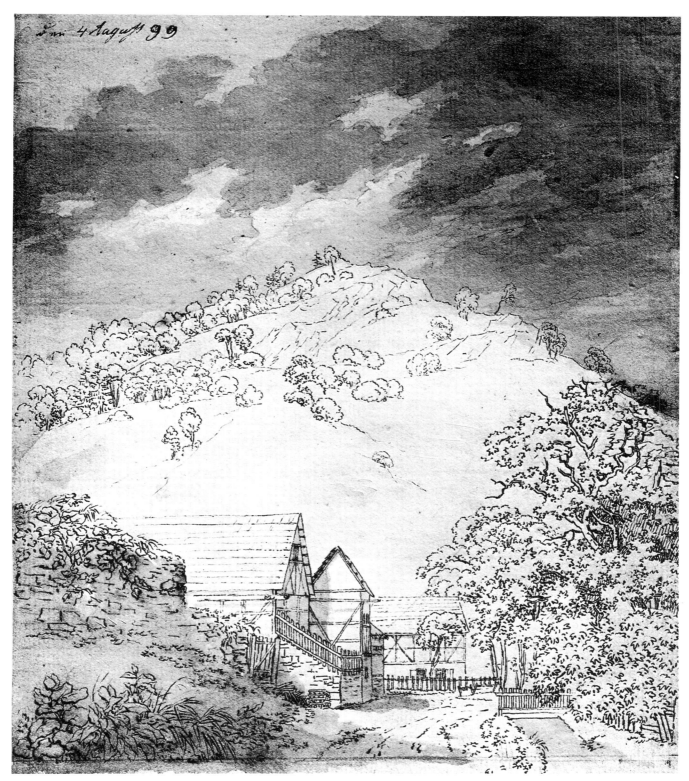

3 *Houses and Steep Slope*, dated 4 August 1799, pen and ink, wash, 23 x 19 cm. Düsseldorf, Kunstmuseum

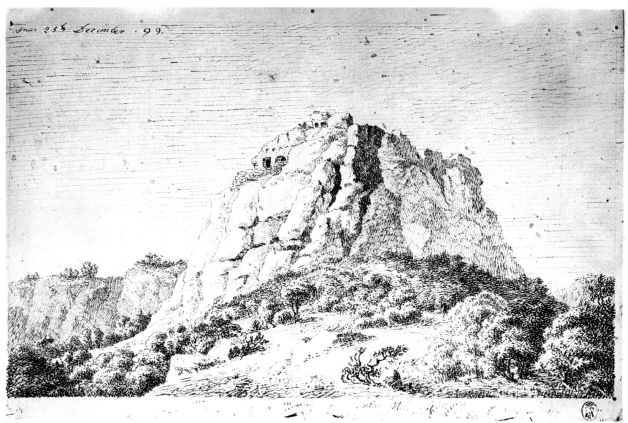

4 *Rocky Crag*, dated 25 December 1799, pen and ink, 16.1 x 23.2 cm. Formerly Dresden, Collection of Friedrich August II

5 *Path between Trees, with Figures*, 1800, etching, 8.8 x 12.7 cm. Formerly Bremen, Kunsthalle

using old-fashioned techniques and motifs. What is interesting about these etchings is the way he infused old-fashioned forms with a new meaning. For example, one of these sheets (fig. 5) shows a path leading into the distance between two groups of trees. The left-hand group has thick foliage, whereas that on the right consists of a young tree, as a symbol of life, juxtaposed with a dying oak symbolizing death. Behind this group the sky is bright and the eye is led into the distance, symbolizing salvation and freedom. The rider on the path is pointing in this direction as if indicating a future existence.

The vocabulary of these etchings was very limited: the path as the path of life, the foliage as the life-force, the withered branch as mortality, the pine-tree as the symbol of Christ, the rock as a symbol of faith, the water signifying death, and the bridge as the triumph of Christianity over death. He fused all these individual signs into a comprehensive statement by his treatment of light and the careful spatial

6
Rock Gateway in the Uttewalder Grund,
dated 28 August 1800, pencil,
37.6 x 23.5 cm.
Mannheim, Kunsthalle

construction of the composition. During this early period Friedrich was able to forgo colour almost entirely, due to the fact that he was able to express his religious view of the world and the extremes of the earthly and the supernatural purely in terms of the contrast between light and shade.

At the beginning of 1800 Friedrich resumed his studies from nature. However, in the following winter he was unable to show any results comparable to the etchings of the previous year. Nevertheless, a number of large sepia drawings can be dated to 1800. That year also saw the *Self-portrait* (fig. 7), now in the Royal Museum of Fine Arts, Copenhagen, which demonstrated his surprisingly mature approach to that genre. Though it is in parts very sketchily executed and has often been described as a studio exercise because of the rapidly scrawled signature, Friedrich nevertheless sent it to his friend Johan Ludwig Gebhard Lund (1777–1867), a former fellow-student in Copenhagen, as a substitute for a painting. The portrait's power lies in its openly serious air, and shows clearly the extent to which Friedrich's art is related to his own problems. The other eight portraits he executed before 1810 – not counting those incorporated in landscapes – confirm this compulsion to reflect on his own existence.

The Copenhagen *Self-portrait* is mentioned in letters Friedrich wrote to Lund in 1799 and 1800 which paint a graphic and by no means dismal picture of his life at that time. A gay sense of humour, at times verging on a self-irony which suggests hidden depth, emerges from all his letters, which display a total lack of concern with grammar and spelling. Sentences like this are typical: 'Otherwise I am very gay and often don't know what on earth to do with myself, a little while ago I had a great idea, I wanted to know if by throwing myself on my bed it would break, I tried it and it broke, however the landlady was understandably a little annoyed at this frivolity.' Even much later on in his career there are reports of Friedrich's great sense of humour, a surprising aspect of his otherwise serious nature. In his autobiography, published in 1855, Gotthilf Heinrich von Schubert, who had met Friedrich for the first time in 1806, wrote of him: 'The sad, serious features of his forehead were softened by the naive and candid expression of his blue eyes. Around his mouth there hovered a hint of grief. His was indeed a strange mixture of temperament, his moods ranging from the gravest seriousness to the gayest humour, as one not infrequently finds combined in the most extreme melancholics and comics ... But anyone who knew only this side of Friedrich's personality, namely his deep melancholic seriousness, only knew half the man. I have met few people who have such a gift for telling jokes and such a sense of fun as he did, providing that he was in the company of people he liked. With the most serious expression imaginable he used to tell stories that would set everyone laughing endlessly. If he felt at ease with a gathering, he always brought with him high spirits and a happy manner.'

In the spring of 1801 he went back to Greifswald, travelling via Neubrandenburg, and stayed there until the summer of 1802. This sojourn was to prove more productive for him than all the impressions he had received in Dresden. The drawings he did on a visit to the island of Rügen in June 1801 demonstrate a new eye for the breadth of the landscape (fig. 10). He is now no longer so interested in the individual objects he had observed and sketched in his notebooks the previous year; rather he is fascinated by the often scarcely interrupted outlines formed by the rolling landscape and the horizon. Vegetation and architecture are related to space in a way that stresses their

7
Self-portrait,
1800, chalk,
42 x 27.6 cm.
Copenhagen,
Royal Museum
of Fine Arts,
Department of
Prints and Drawings

8 *Stubbenkammer on Rügen*, 1801/02, pen and ink, 23.5 x 36.8 cm. Dresden, Kupferstichkabinett

9 *Ruin at Eldena*, dated 5 May 1801, pen and ink, wash, 17.5 x 33.3 cm. Stuttgart, Staatsgalerie

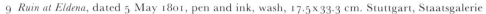
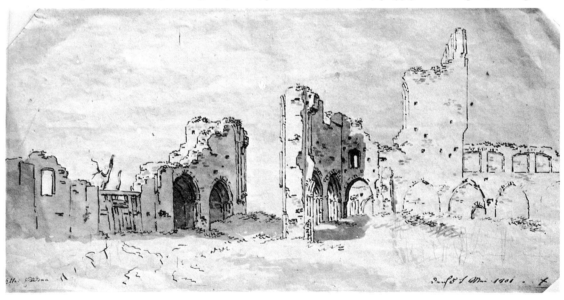

insignificance in relation to the space of the landscape as a whole. In May 1802 he made another excursion to Rügen. During these two trips to the island he experienced nature in a way that was to contribute vitally to the development of his own highly individual style. Several of the large-scale sepia works of the following years are based on drawings made during this period.

It should be noted, however, that he executed two totally different groups of drawings almost simultaneously, which indicates his uncertainty about his future development as well as his intense search for his own personal mode of expression.

18

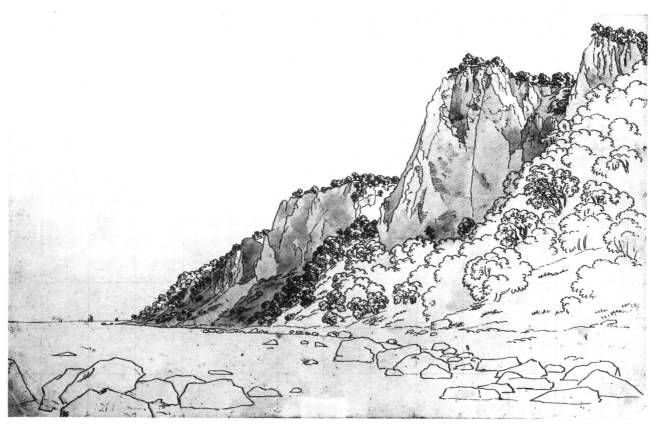

10 *Landscape on Rügen: the Jasmunder Bodden* (bay), dated 16 June 1801, pen and ink, 23.7 x 36.7 cm.
Frankfurt-on-Main, Städelsches Kunstinstitut

11 *Study of Plants*, dated 12 June 1801, pen and ink, wash, 15.3 x 23 cm. Essen, Museum Folkwang

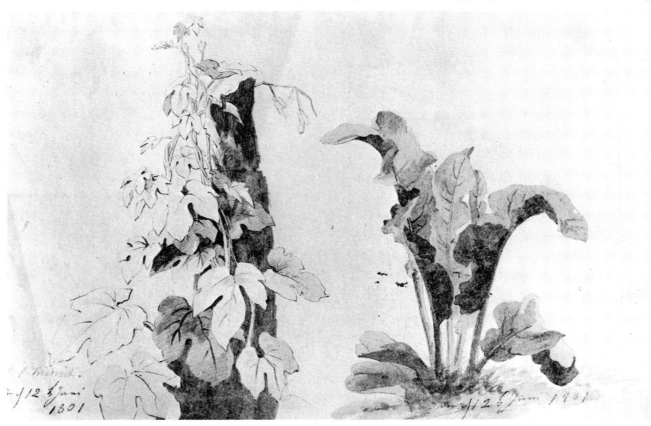

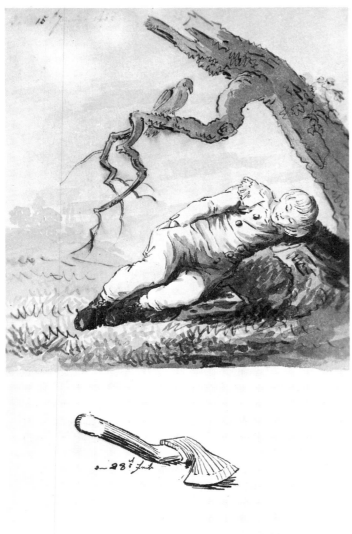

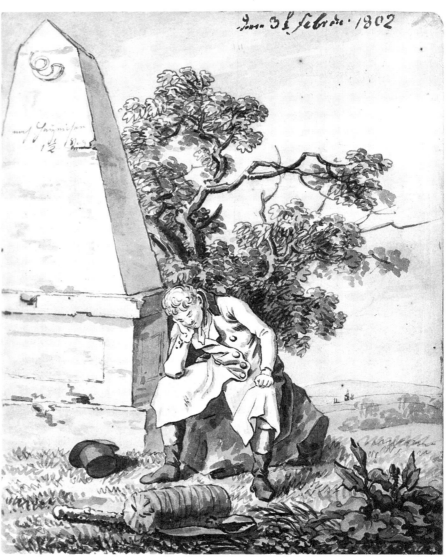

12 *Sleeping Boy*, dated 15 January 1802, pen and ink, wash, 18.1 x 11.6 cm. Formerly Bremen, Kunsthalle

13 *Traveller at the Mile-stone*, dated 3 February 1802, pen and ink, wash, 18.5 x 11.7 cm. Munich, Staatliche Graphische Sammlung

In the autumn and winter of 1801 he filled the so-called Mannheim sketchbook with a large number of figure subjects, partly studies of movement and expression, but partly with a pictorial effect and symbolic content (fig. 12, 13). With some alterations, three of these drawings were made into woodcuts (fig. 14, 15) by his brother Christian, who was a joiner. The intellectual content of the *Woman at the Precipice* is more apparent than in the etching of 1800. The woman's past and future are symbolized by the upright fir-tree that is still living and the uprooted one that is dead. The flowers signify the rapid passing of life, while the mountains on the other side of the ravine symbolize the promise of life after death. The unrest of the forms, the emphasis on sculptural values and psychological expression, as well as the way she turns towards the spectator full of fear and despair, all display a pathos which is lacking in later works.

A third group of drawings is also devoted to representing the fate of the individual. This group consists of portraits, mostly of members of Friedrich's family; they express

his sense of belonging to a family and his interest in the lives of others, a characteristic that is always mentioned in contemporary accounts. His great charity emerges from the following comment explaining his permanent state of poverty: 'He and his family could have lived without any problems if he had not been so excessively charitable towards anyone in need, and so often abused too.' A feeling of responsibility towards his fellow men was combined with a distinct awareness of the uniqueness of each individual.

The portrait of his father (fig. 16), dating from 1802, is a typical example of this group. It is not limited to the faithful rendering of the physiognomy and the intellectual effort involved in reading. The book his father holds is apparently the Bible, clearly establishing a religious undercurrent, so that in this respect the portrait is not in fact essentially different from his later landscapes. Nevertheless this preoccupation with portraits was only temporary, and he apparently did no more after 1810. As he became more absorbed in his increasingly profound landscapes, it was inevitable that

14 *Woman with Spider's Web between Bare Trees*, 1803–04, woodcut, 17 x 11.9 cm

15 *Woman at the Precipice*, 1803–04, woodcut, 16.9 x 11.9 cm

he should consider portraits, by their very nature outward-going, as contrary to his aims.

In the summer of 1802 Friedrich returned to Dresden, where he translated all the impressions he had received from his native country into a series of carefully executed sepias. He was clearly so fascinated by the images nature had confronted him with that he hardly had to alter them in order to bring out the desired allegorical meaning. These early works in sepia recall Schubert's account of Friedrich's walks on Rügen. 'The quiet, peaceful wilderness of the chalk hills and oakwoods . . . were his constant haunt in summer, and still more during the stormy days of late autumn and in the spring when the ice melted on the marshy land along the coast. He spent most of the time in Stubbenkammer where there were no modern inns. The fishermen used to watch him, sometimes fearing for his life, as he clambered around on the jagged rocks of the hills and chalk cliffs that jutted out into the sea, as if he were voluntarily seeking a grave in the waters below. When a storm was raging fiercely and the foam-crested waves were at their highest, he would stand there, soaked to the skin by the spray or a sudden shower of rain, simply gazing at it all with a passionate expression on his face as if he could never get his fill. Whenever a storm with thunder and lightning moved over the sea he would hurry out to the top of the cliffs as if he had a pact of friendship with the forces of nature, or even went on into the oakwood where the lightning had split a tall tree from top to bottom, which led him to murmur: "How great, how mighty, how wonderful".

His emotional outbursts in the face of nature were counteracted by his tremendous self-discipline as far as work was concerned. Painstakingly he laid layer after layer of diluted sepia over the preparatory drawing in which all the details were based on studies from nature, so that the dark areas emerged from the basic colour of the paper in carefully controlled stages. Light, the divine foundation of visual imagery, was his starting point. The artistic skill consisted in painting in the solidity of the forms and the shadows they cast. For him painting meant the transformation of an emotion into a definite poeticized form, thereby overcoming the self and achieving peace of mind. It was a process of spiritual cleansing with religious implications and was intended to affect the observer accordingly. Nothing could have been more alien to Friedrich than the mere spontaneous release of his emotions.

The sepia drawings of scenes on Rügen were much admired by the public. Runge, who himself acquired two, mentioned them in a letter to his brother Daniel: 'Here is young Friedrich from Greifswald, a landscapist who has exhibited a couple of views of Stubbenkammer in sepia, notably large, and very beautifully conceived, illuminated and executed. They are generally acclaimed and deserve to be so.'

The art critics who reviewed the exhibition confirmed Friedrich's success, so it can be said that the year 1803 marks a break-through and turning point in his development. Runge may have contributed indirectly to this as well, for in 1803 he published his etchings of the times of the day and the seasons which probably inspired Friedrich to depict the same cycle in sepia, a cycle unfortunately now lost (fig. 17). The times of the day and the seasons are harmonized with the various ages of man so that death appears to be embedded in a cosmic rhythm. It was a theme to which he was to return many times in the course of his career. Even earlier than this, distance had been used to signify the future. Similarly, his symbols of death had introduced the

16 *Adolf Gottlieb Friedrich*, 1802, chalk, 34.6×32 cm. Mannheim, Kunsthalle

element of time with their allusions to the threat constantly posed by death. It was only after his return from the Baltic, however, that the changing face of the countryside dictated by the rhythm of the times of day and the seasons seems to have become the central theme of his art.

Thus, each object that Friedrich depicts must be judged not only on the basis of its outward appearance but also by the changes it has undergone or is yet to undergo. The observer is required to see beyond the visible appearance of an object and to reflect on its underlying meaning.

In the years that followed Friedrich perfected his sepia technique and continued to concentrate on themes with strongly religious undertones. In 1805 his efforts were rewarded by the approval of Goethe and the Swiss artist Heinrich Meyer (1760–1832)

17 *Spring*, 1803, sepia, 19×27.5 cm. Formerly Göttingen, E. Ehlers Collection

18 *Landscape*, dated 25 May 1803, sepia. Lost, dimensions unknown

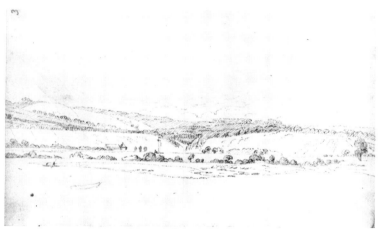

19 *Landscape on the Elbe*, 1804, pencil, 11.8×18.5 cm. Karlsruhe, Private Collection

who organized an annual art competition in Weimar. Friedrich had entered two large sepia drawings in the seventh – and as it turned out the last – of these competitions, and although he had not depicted the set subject he was nonetheless awarded half the prize offered (fig. 20). It was principally his careful execution which won the organizers' praise, for it was evident from Meyer's comments about the pictures that their intellectual content had not been taken into account.

Friedrich's association with Weimar lasted for about ten years. The artist Luise Seidler repeatedly acted as his agent there. He was respected there and often sent paintings and drawings to the Court, where he was able to sell some of his work; in

1810 as many as five of his paintings were it seems purchased by the Grand Duke himself (pl. 9, 10). Friedrich, however, did not enjoy full recognition in Weimar. Heinrich Meyer, in particular, criticized the liberties he took with nature. A typical reaction is found in the conversation between Goethe and Meyer in April 1815 while examining a portrait of Countess Julie von Egloffstein sketched by Friedrich von Müller. Goethe: 'Here is this small sketch . . . seemingly unfinished, as if it had been extracted from a larger work; at the same time a reminiscence, a trial piece – it really is my favourite of all. Does Friedrich ever do better?' To which Meyer replied: 'And not nearly so gracefully'. Goethe was able to appreciate the inherent quality of Friedrich's art far more than Meyer, despite the insurmountable difference between their respective approaches to nature, and he actually defended Friedrich against Meyer's attacks on several occasions. When Friedrich tried in vain to sell some drawings in Weimar during the French occupation in 1812, Goethe remarked in a letter to Meyer: 'I am very sorry that we have not been able to see them together, for how exceptional

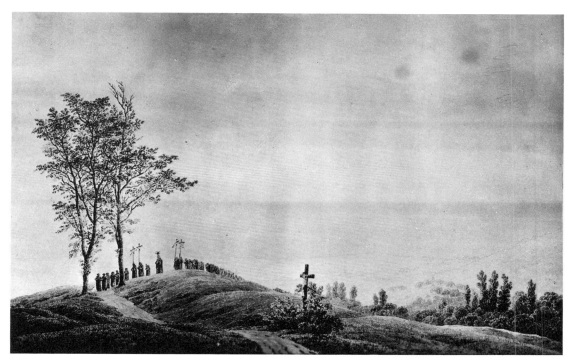

20 *Procession at Dusk*, 1805, sepia, 40.5×62 cm. Weimar, Staatliche Kunstsammlungen

are the finished results!' As before, Goethe seems to have been moved by the technical mastery of Friedrich's works – which of course for Friedrich himself was not an expression of sheer virtuosity. For him technical perfection was merely a sign of his strict conscientiousness in respect of the underlying message of his paintings.

In 1812 he also sent two sepia drawings to Weimar. They had in fact been executed in 1805/6 and show two views seen from his studio (fig. 21, 22). They are of interest in that they demonstrate to what extent he had already developed the formal construction of space into an inherent element of his pictorial language. In these two pictures Friedrich depicted the two windows of his studio from exactly the same point in the

room. As a result the left-hand window is seen in sharp perspective, whereas the right-hand one is seen frontally and creates a peaceful impression. The relationship between these contrasts contains the meaning of the works. The River Elbe in the background of the one on the left signifies the river of life, carrying traffic to and fro. However the boats crossing from the distant shore to the near side of the river indicate that it is also a symbol of death. Half of a mirror can be seen on the wall to the right of the window in which one can see the door in the back of the room behind the observer. Beneath it hangs a key. This picture is a symbol of the active life still inspired by the

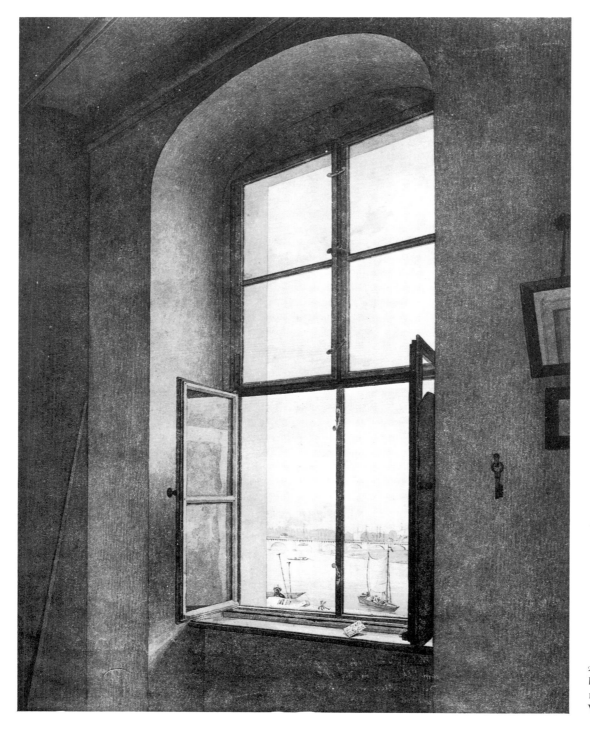

21
View from the Studio Window (left),
1805, sepia, 31 x 24 cm.
Vienna, Kunsthistorisches Museum

exuberance of youth and still concerned with the here and now; however, this becomes apparent only when it is compared with the other picture which illustrates existence in the life hereafter. Friedrich admits that he pursues the latter approach to life by showing the top of his head in the lower part of the mirror. Under it hangs a pair of scissors as a reminder of Atropos, one of the Fates, who cuts the thread of life. It is of course the exact opposite of the key in the other picture which symbolizes the entry into life. The river signifies death, and the distant shore is a symbol of paradise.

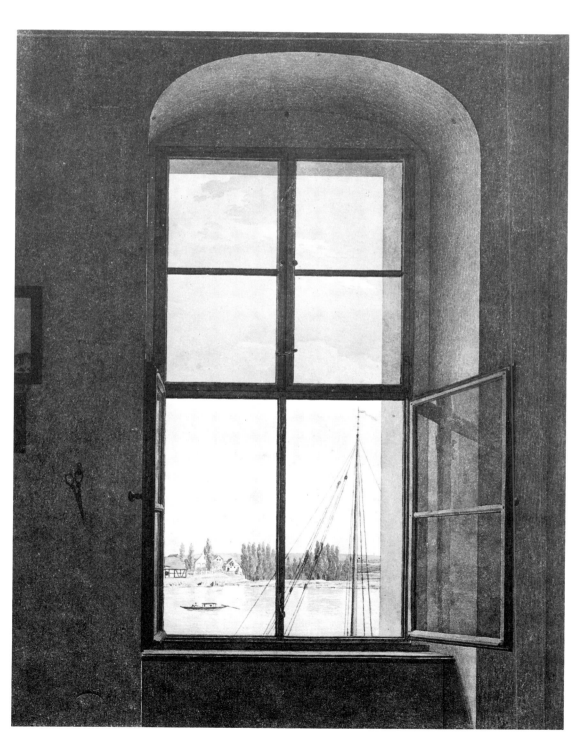

22
View from the Studio Window (right), 1805, sepia, 31 x 24 cm. Vienna, Kunsthistorisches Museum

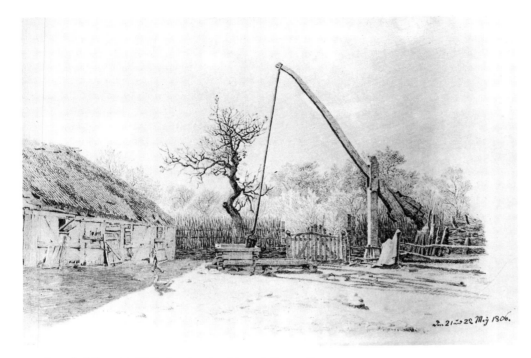

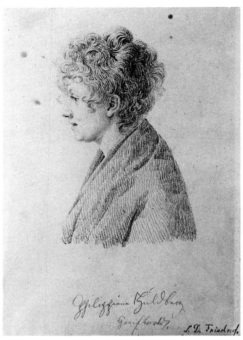

23 *Farm Building with Well*, dated 21/22 May 1806, pencil, 24.3×35.1 cm. Obbach bei Schweinfurt, Dr Georg Schäfer Collection

24 *Philippine Huldberg*, 1806, pencil, 17.8×12.8 cm. Mannheim, Kunsthalle

From May to June 1806 Friedrich paid another visit to his home town. Judging from a letter written to Runge by the artist and writer Friedrich August von Klinkow-ström (1778–1835), Friedrich wanted to recuperate from an illness which he had apparently 'brought upon himself because of his patriotic anger at events in Germany'. Friedrich's friend, the philosopher Schubert, also remarks upon his passionate patriotism and the fact that he simply could not accept Napoleon's victory. A small sketchbook and several larger sheets (fig. 23) resulted from this journey. They demonstrate that he had now fully developed his technique for making studies from nature. He varied the structure and shading effects of the various objects depending on whether his pencil was freshly sharpened or not, and according to whether he used pressure or not. For each effect he developed a specific draughtsman's short-cut.

As in 1801/2, the confrontation with the Baltic landscape supplied him with fresh inspiration and helped him to sort out his artistic aims. He seems to have tried out this new approach for the first time in the *Dolmen by the Sea* (fig. 26), which was acquired by the Weimar Court. A narrow strip of foreground is cut off from the background by a grid-like row of oak-trees. The oaks are rendered so precisely that they almost seem to be substitutes for human beings. They are in a precarious position in that they belong to the foreground, which is a symbol of this world, while at the same time being confronted by the endless background, which represents the world to come. The tension thus created between what is close up and what is in the distance instantly negates every line that would seem to be connecting the two. The result of this spatial structure is that the picture surface is geometrically organized or at any rate concentrated in the centre of the composition. Friedrich had at last discovered the pictorial form that approximated to his fixation with the contrast between the earthly and

supernatural spheres. His problem in the years that followed was to develop this idea still further and to work out as many variations as possible of the basic formula.

The next year, 1807, Friedrich began to paint in oils, thus introducing colour for the first time. At first, however, he restricted himself to the light shades of body-colour used in old-fashioned views still popular at the time. In 1807 he was awarded the

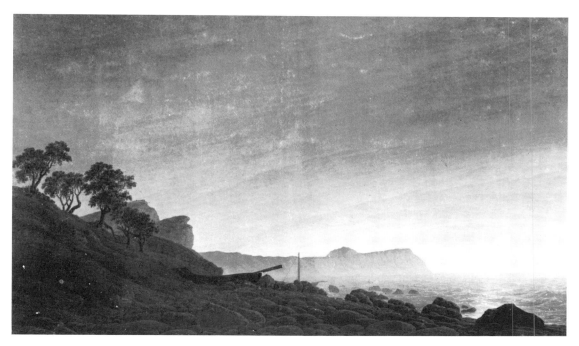

25 *View of Cape Arkona on Rügen*, 1806, sepia, 60.9 x 100 cm. Vienna, Albertina

26 *Dolmen by the Sea*, 1807, sepia, 64.5 x 95 cm. Weimar, Staatliche Kunstsammlungen

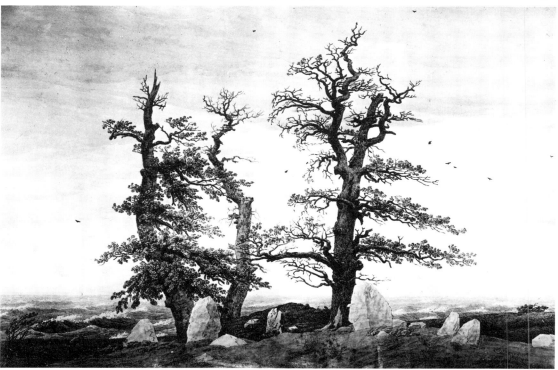

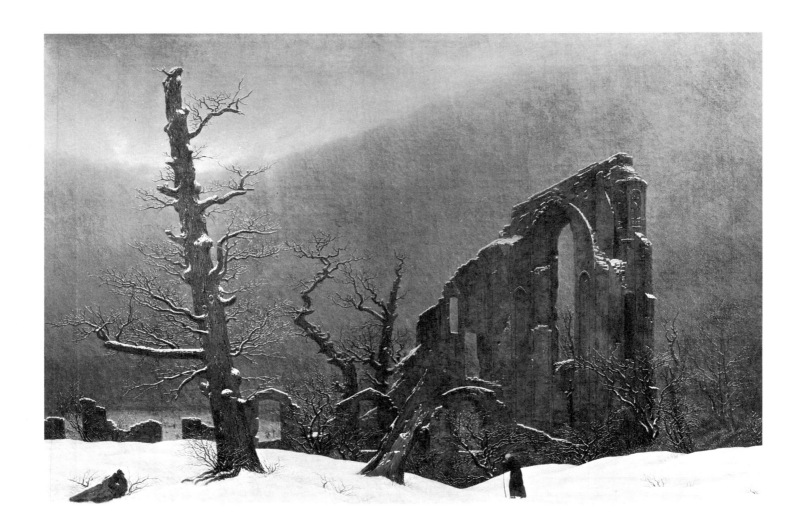

commission for the *Tetschen Altar* (*The Cross in the Mountains*); this involved the highly unusual task of painting a landscape that was to be used as an altarpiece (fig. 28; pl. 6). The mere fact that Friedrich was awarded the commission proves the general confidence in his abilities as a painter. What we do not know is whether he began to paint in oils as a result of this commission, or whether he won it on the basis of his first oil paintings.

The *Tetschen Altar* was completed only towards the end of 1808. Its final form was the result of prolonged, painstaking labour. Similarly, the *Monk by the Sea* (pl. 7) with its revolutionary depiction of empty space lay around in Friedrich's studio for almost two years before he agreed to part with it, and then only after he had radically altered it three times. The reason for this extended maturing process lay in Friedrich's intention to create the most intense, concentrated statement possible with nothing whatever in the picture that did not contribute essentially to the whole.

This economy derives from the same ethical attitude that determined the precise, clean-cut execution of his paintings. This precision could easily be mistaken for pedantry unless we see it in relation to his own inner tension. The tension between life and death that dominated his thought is largely counteracted by that between sensibility and discipline. The uniform quality of his individual works can largely be attributed to this inner structure.

27
Winter, 1807–08,
oil on canvas, 73 × 106 cm.
Formerly Munich, Neue Pinakothek;
destroyed by fire, 1931

28
The Tetschen Altar (including frame),
1808; cf. pl. 6. Dresden,
Staatliche Kunstsammlungen

The radical novelty of the *Tetschen Altar*, in terms of both content and conception, aroused a mixture of admiration and violent criticism. The most outspoken critic was undoubtedly Friedrich Wilhelm Basilius von Ramdohr, who at the beginning of 1809 published an essay in the *Zeitung für die elegante Welt* entitled 'Über ein zum Altarblatte bestimmtes Landschaftsgemälde von Herrn Friedrich in Dresden, und über Landschaftsmalerei, Allegorie und Mystizismus überhaupt'. Various friends of Friedrich's wrote replies defending him, and the repercussions of this debate can be seen in many contemporary letters and memoirs. Subsequent works by Friedrich elicited equally violent approval or rejection; indifference was the one reaction that was impossible when viewing them.

In 1810 when, as a result of the success of his *Monk by the Sea* (pl. 7) and *Abbey in the Oakwood* (pl. 8), Friedrich was proposed for membership of the Berlin Academy, five artists voted for and four against the proposal, while others were accepted unanimously. Even as recently as 1947 the eminent art historian Max J. Friedländer thought very little of Friedrich's art, and opinion was divided on the occasion of the first major exhibition of his work in London in 1972. In both the English and the German press there was a mixture of adulatory and extremely derogatory reviews – an indication that Friedrich's art, despite its tranquil air, still possesses the power to stimulate and provoke.

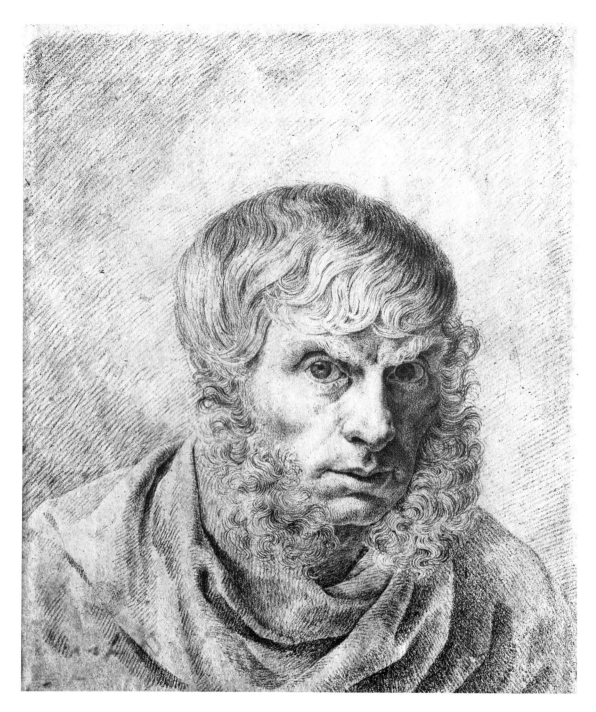

29 *Self-portrait*, c. 1810, pencil and chalk, 23 x 18.2 cm. Berlin (East), Staatliche Museen

· After completing the *Tetschen Altar* Friedrich increased his efforts and set to work on *Monk by the Sea* and *Abbey in the Oakwood*, which proved to be his greatest works to date. The self-portraits in these two paintings demonstrate the connection between his painting and his own existential problems in the most explicit manner possible. The acquisition of these two works by Friedrich Wilhelm III of Prussia at the instigation of his then fifteen-year-old son, the Crown Prince (later Friedrich Wilhelm IV), marked the zenith of Friedrich's success as an artist. No other work of his was the topic of so much discussion and debate on the part of so many of his famous con-

temporaries – among them Goethe, Clemens Brentano, Heinrich von Kleist and Theodor Körner.

It seems appropriate to include the famous *Self-portrait* (fig. 29) now in the Berlin National Gallery in this period of intense activity. It shows the artist dressed in an old-fashioned gown – perhaps a monk's habit – with an intense, penetrating expression on his face. It is the last known portrait by Friedrich.

In 1809 he paid another visit to Greifswald. The drawings dating from this stay are dominated by a group of studies of oak-trees (fig. 31, 33) which were presumably in preparation for the *Abbey in the Oakwood*. The walking tour through the Riesengebirge which Friedrich undertook with the painter Georg Friedrich Kersting (1785–1847) in July 1810 seems to have made an even greater impression on him. The Riesengebirge had been much visited and its incredible beauty often depicted in both art and literature since the late eighteenth century. Friedrich himself had depicted it in his paintings a couple of years previously, when he had always used it to symbolize the hereafter. For him this walking tour must therefore have seemed like a pilgrimage. To judge from his sketches, he was only interested in trees, various rocks and above all the contours of the mountain ranges.

The most important product of this journey, *Morning in the Riesengebirge* (pl. 11), was executed shortly afterwards. The Harz Mountains which he visited the following year did not take on the same divine significance for him as the Riesengebirge had done. What impressed him most in the Harz were the many ravines and caves which seemed to him to symbolize the limitations of earthly existence and the constant threat of death. He used the studies of the Harz far less in his paintings than those stemming from the Riesengebirge (pl. 13).

After this he planned a trip to Iceland, motivated by the religious significance he attributed to the north – in conscious opposition to the attraction which the south had for his contemporaries. The journey never took place, however, presumably because of the outbreak of war. Until 1814 he hardly painted at all, and the few pictures that he did paint contain patriotic thoughts couched in religious symbols adapted to the political needs of the moment. Hence what had previously stood for

30
The Heldstein near Rathen,
c. 1808, pencil,
25.7 × 35.7 cm;
cf. pl. 44. Formerly
Dresden, Collection of
Friedrich August II

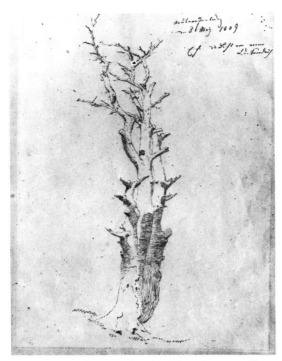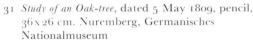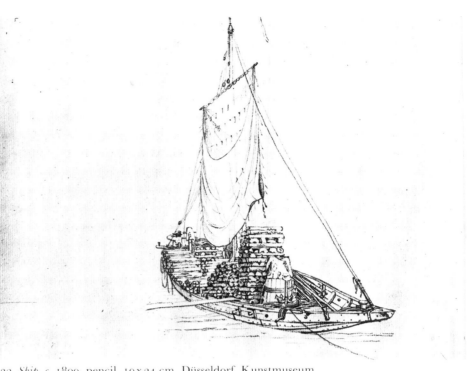

31 *Study of an Oak-tree*, dated 5 May 1809, pencil, 36 × 26 cm. Nuremberg, Germanisches Nationalmuseum

32 *Ship*, c. 1809, pencil, 19 × 24 cm. Düsseldorf, Kunstmuseum

the expectation of eternal life now symbolized the hope of liberation from the French. This kind of reinterpretation was possible because the war against the French was generally regarded as a holy one. Along the same lines his friend, the historical painter Gerhard von Kügelgen (1772–1820), depicted Napoleon as the Antichrist.

The patriotic enthusiasm of these years also found expression in designs for funerary monuments. However, this enthusiasm turned rapidly to disappointment when, after the defeat of Napoleon, the German princes failed to keep their promises to the German people and the restoration was introduced instead. As early as 12 March 1814 Friedrich wrote to his fellow-countryman, the patriot Ernst Moritz Arndt: 'I am not in the least surprised that no monuments have been erected, either in honour of the national cause or of the noble deeds of individual Germans. As long as we remain vassals of the princes, nothing really great can happen. If the people have no voice, the nation cannot be aware of itself and honour itself.'

Political agitation, however, could not really be reconciled for long with Friedrich's idea of art. A typical example of this is to be found in the letter he wrote a few months later to Luise Seidler describing a landscape he had painted showing some mutilated traitors, which he had then painted out because he found the subject so distasteful. He subsequently turned away from political themes altogether. In 1821 and 1828 he even painted new versions of two of his patriotic pictures replacing the political allusions with religious symbolism. At the outbreak of the riots in Dresden in 1830 he wrote a long detailed letter to his brother, but without actually taking sides. He saw the human weaknesses of both sides, but also their respective moral qualities. As a result of this, he no longer considered the mass of the people to be necessarily in the right in every instance.

34

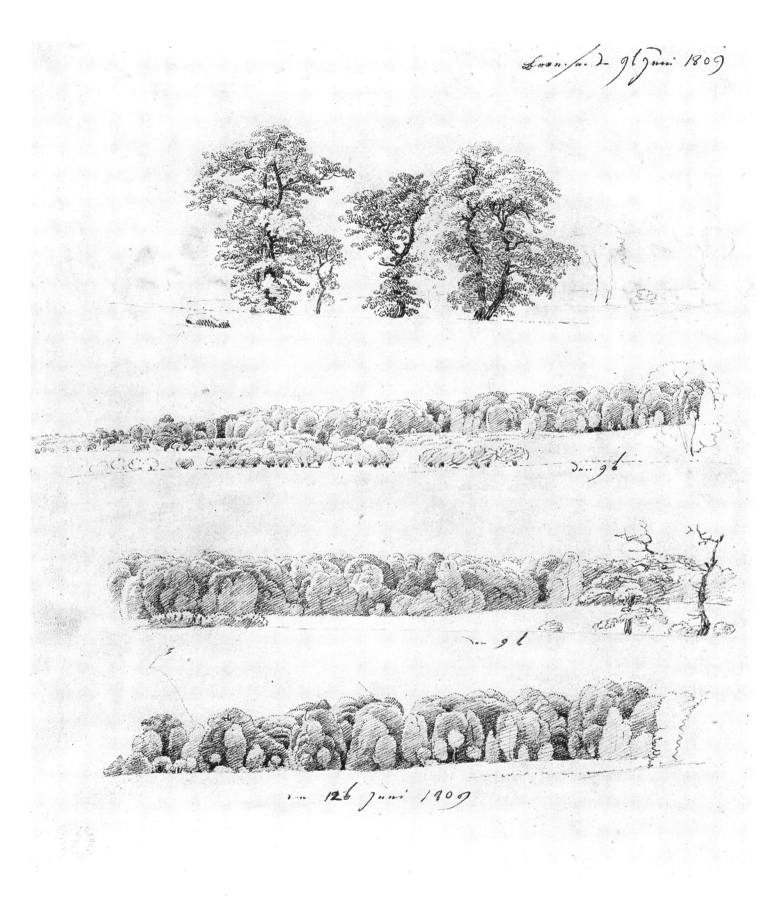

Loen: sa. d. 9t Juni 1809

du... 9t

... 9t

... 12t Juni 1809

33 *Studies of Oaks and Woods*, dated 9 June 1809, pencil, 36.2 x 25.7 cm. Bremen, Kunsthalle

Ruin at Oybin near Zittau,
dated 4 July 1810, pencil and
watercolour, 36 x 25.7 cm.
Hamburg, Kunsthalle

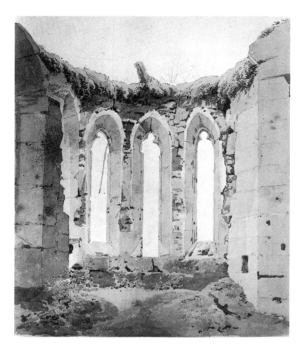

35 *Ruin at Eldena*, January 1814, watercolour, 15.9 x 16.5 cm.
Copenhagen, Royal Museum of Fine Arts, Department of Prints and Drawings

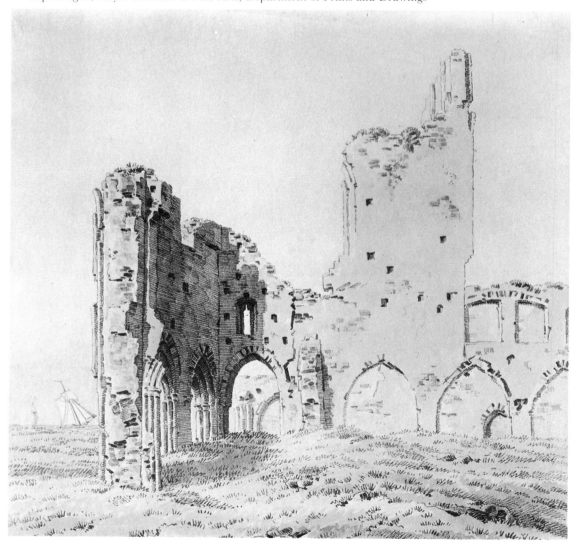

As far as the artistic education of the public was concerned, experience had also changed his attitude. His original idealistic optimism had given way to a form of embittered scepticism. After a conversation with Friedrich in 1818, the Norwegian artist Johan Christian Clausen Dahl (1788–1857) reported enthusiastically: 'He has roughly the same views about art as I, namely that the most important thing about a work of art is that it should have an effect on each person who looks at it, without him being a connoisseur. The technical aspects are more for those artists and others who have a better understanding of these matters.'

Friedrich was to discover, however, that even among educated people there were only a few who could understand his art. The following anecdote told by his friend Schubert is a characteristic and touchingly amusing example of how Friedrich's high expectations were often disappointed, though it also reveals his love for children: 'The small daughter of his neighbour often used to ask him for a present of a picture. And he, who couldn't bear to turn down the request of any child, least of all this one because he was delighted at her liking for art, used to give her small sketches of his. But when she came again and again with the same request, he asked her on one occasion what she did with all the pictures, to which she replied that she wrapped her things in them.'

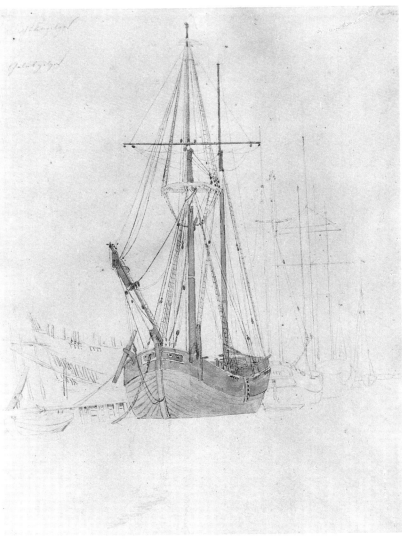

36
Sailing ship, 1815/18,
pencil, 35.8 x 25.4 cm.
Mannheim, Kunsthalle

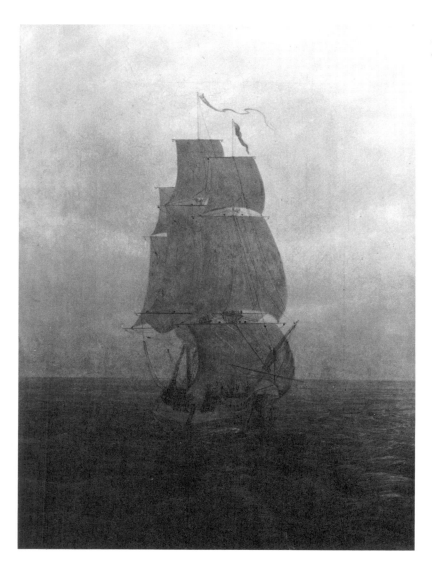

37
Ship on the High Seas, c. 1815,
oil on canvas, 45 x 32 cm.
Hamburg, Private Collection

In the autumn of 1815 Friedrich went back to Greifswald again. Most of the drawings that have survived from this journey are of ships. They were studies for a series of small seascapes which he executed in the course of the next few years. In 1816 he exhibited two large pictures – one a view of a Gothic cathedral, now lost, and the other a harbour scene – with great success in Dresden. As a result, he was elected a member of the Dresden Academy. Following this he exhibited some paintings in Berlin which were bought by Friedrich Wilhelm III as birthday presents for his son, as Schadow reported disapprovingly in a letter to Goethe. The success of 1810 seemed to be repeating itself, but Friedrich did not have any enthusiasm to continue along these lines. In fact he was in the midst of a personal crisis, as can be seen all too clearly from the letter he wrote to Lund in Rome on 11 July 1816: 'For some time I have been feeling very lazy and totally incapable of doing anything. Nothing flowed from inside me any more; the fountain was exhausted, nothing moved me from outside, I was apathetic, so I thought the best thing to do was to do nothing. What is the good of work if nothing is done with it; the seed must lie for a long time under the earth if one expects anything to come of it?'

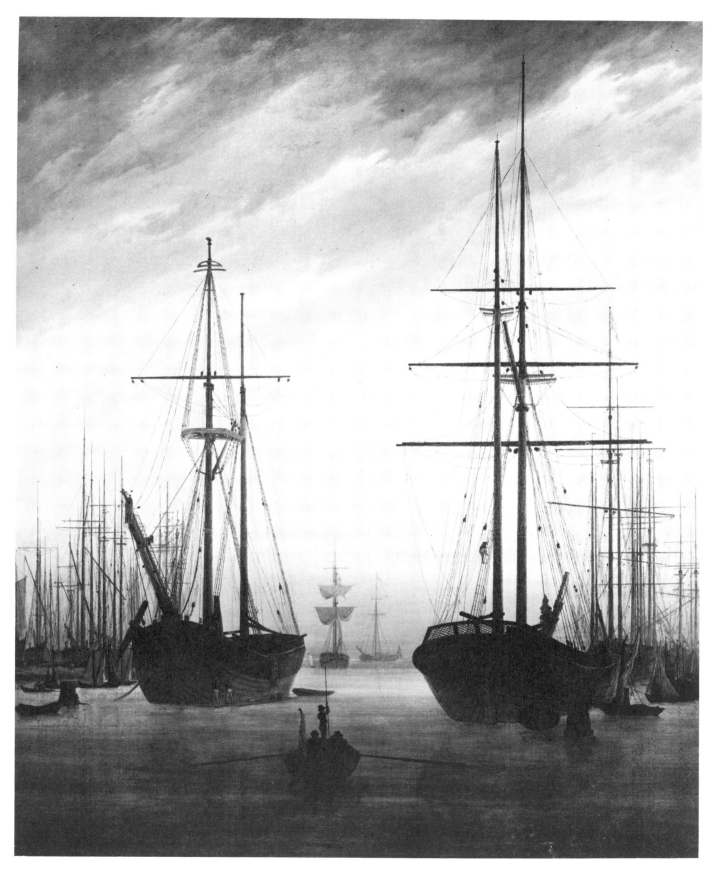

38 *View of a Harbour*, *c.* 1815, oil on canvas, 90×71 cm.
Potsdam (Sanssouci), Staatliche Schlösser und Gärten

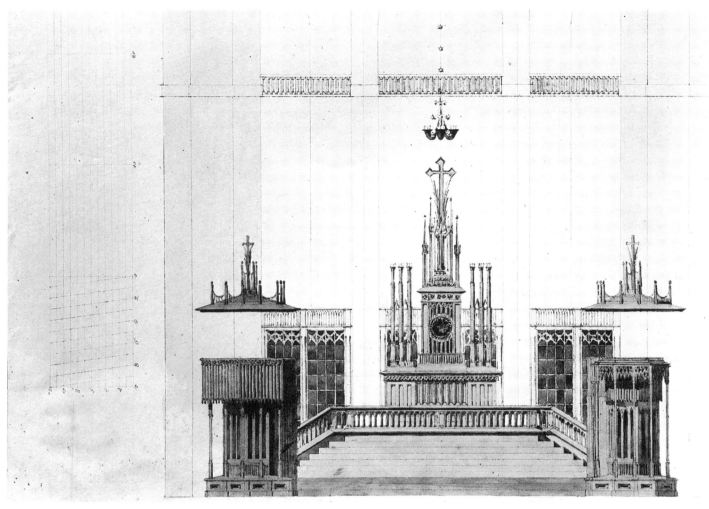

39 *Design for the Interior of the Marienkirche, Stralsund* (detail), 1817, pen and ink, wash, 44 × 56 cm. Nuremberg, Germanisches Nationalmuseum

The following year the town council of Stralsund asked him to draw up plans for the complete renovation of the interior of the Marienkirche, a Gothic church there (fig. 39). Friedrich dropped all other work to devote himself wholeheartedly to the project. Although his plans were never carried out, one result was that the taste for architecture that had been evident in his earlier pictures now returned. One example of this new trend is the painting entitled *The Cathedral* which is in fact a highly idealized representation of the church in Stralsund. Carl Gustav Carus (1789–1869), a doctor and amateur painter, remarked critically on this tendency towards architectonic composition in a letter to his friend Regis dated 3 May 1819. Referring to Friedrich's main work of this period, *Monastery Graveyard in the Snow* (fig. 40) – a variation of *Abbey in the Oakwood* (pl. 8) – destroyed in 1945, he wrote: 'He has now nearly finished the large churchyard in winter. It is impressive and the framework of the oaks is extremely realistic, yet the picture as a whole strikes me as somewhat Baroque and architectonic. Indeed, I believe that his predilection for architecture is too dominating and interferes too much with the natural freedom of the landscape. But apart from this I like him as a person more and more. I have recently discovered several more characteristics of his which gave me great joy . . .'

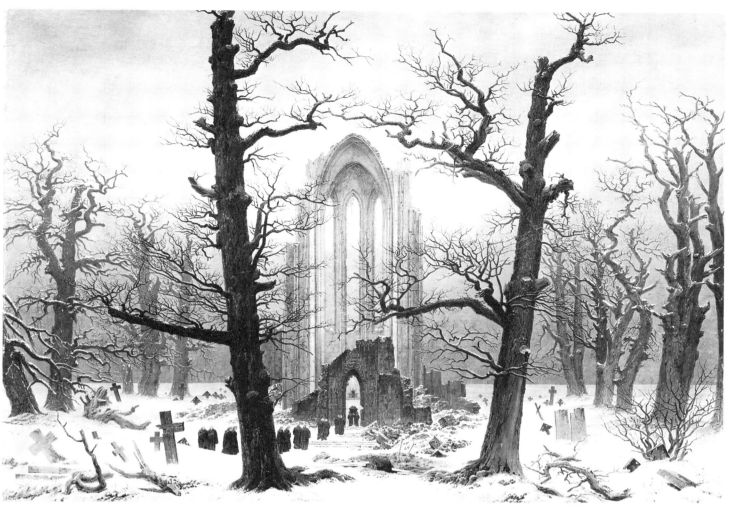

40 *Monastery Graveyard in the Snow*, 1817–19, oil on canvas, 121 x 170 cm. Formerly Berlin, Nationalgalerie; destroyed 1945

Carus had met Friedrich in 1817 and they soon became close friends. In the autumn of 1817 Friedrich found another friend in Dahl, the Norwegian artist, who had just arrived in Dresden from Copenhagen and was to remain a close friend until Friedrich's death. Friedrich was probably able to have such a close relationship with these two men because they were totally different from him – both as artists and as individuals – even though as artists they were both, though Dahl less than Carus, influenced by him. Both men were of a sociable nature and were able to devote themselves without any existential problems to the task of representing or doing research into nature.

At about this time Friedrich must have undergone a radical change in outlook, for on 21 January 1818, at the age of forty-four, he married a simple girl nineteen years his junior. Her name was Caroline Bommer, the daughter of a 'manager at the blue-colour depot', according to the entry on the marriage certificate. A week later he described his new way of life in a letter to a relative in Greifswald as follows: 'It really is a strange feeling to have a wife; strange to have a household, even if it is very small. It's a strange feeling when my wife bids me come to the luncheon table. And finally it is strange staying at home in the evenings instead of rambling around outside as I used to do. And it is also a strange feeling that I must now always take my

wife into consideration whenever I do anything. For instance, if I hammer a nail into the wall, it cannot be just the right height for me, but must also be low enough for my wife to be able to reach it easily too. In short, since the 'I' has changed into 'we', a good many things have changed. More time is spent eating, drinking, sleeping, joking, laughing. And it all costs money. Perhaps we may in future have no lack of worries. May God's will be done. Many things have altered since I have a wife. My former simple household is scarcely recognizable now, and I am glad that it all looks so much cleaner and nicer. Only in the room I use for my work has nothing been changed. By the way, curtains were necessary, also a coffee-tin, a coffee-grinder, a coffee-filter, a coffee-pot and coffee-cups; everything was needed. Large pots and little pots, large dishes, and little dishes, large saucepans and little saucepans, everything was necessary. Everything has changed. Before my spittoon was placed anywhere I wanted in my room; now I am made to spit into small dishes specially acquired for the purpose; my love of cleanliness and neatness gladly complies.'

There is, however, also a certain element of irony in these lines. Some of the paintings of this period, in which female figures – many of them representing his wife – are larger and more dominating in the composition, in fact depict the happiness of his marriage against a background symbolizing death and the hope of a paradise

41 *The Farewell, c.* 1818, oil on canvas, 21 x 29.5 cm. Formerly Gotha, Schlossmuseum; destroyed by fire, 1931

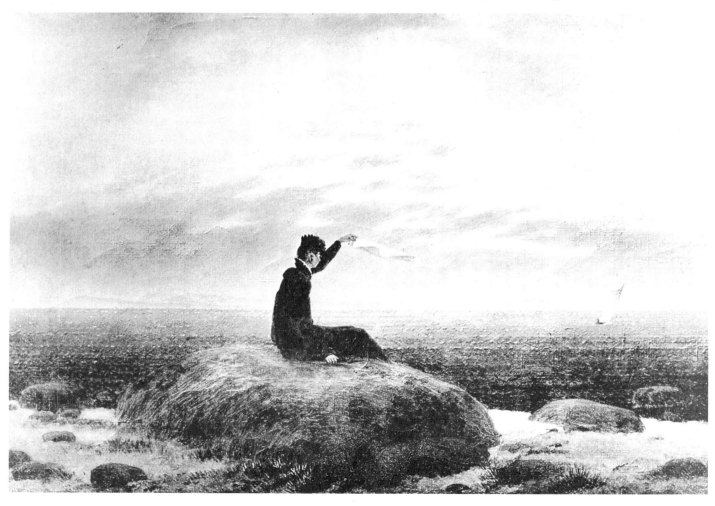

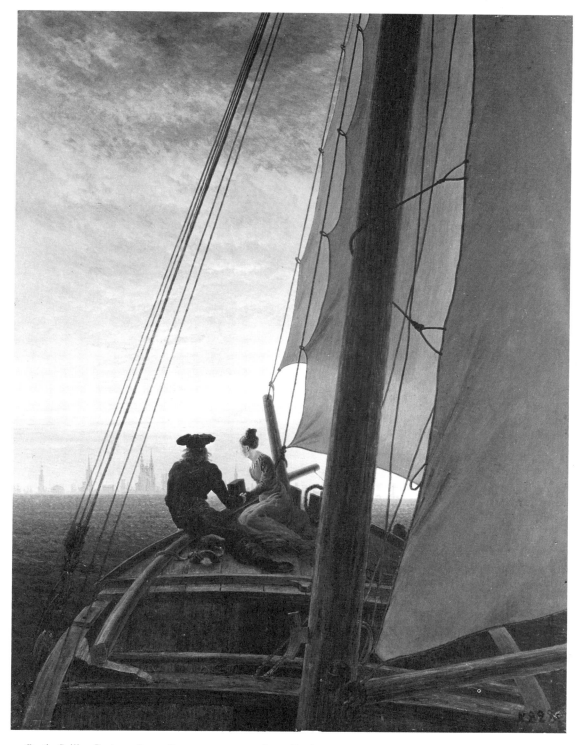

42 *On the Sailing Boat, c.* 1819, oil on canvas, 71 x 56 cm. Leningrad, Hermitage

beyond. Hence *The Farewell* (fig. 41) which he exhibited in Dresden in 1818 – it was destroyed by fire in 1931 – showed a woman, his wife, on the seashore waving to a departing ship; also in a picture, now in Leningrad, painted a little later, a pair of lovers are seen on a ship which is making straight for a distant port, which is a symbol of the hereafter (fig. 42). As Carus remarked in his memoirs, Caroline Friedrich 'did not change his life or personality at all.'

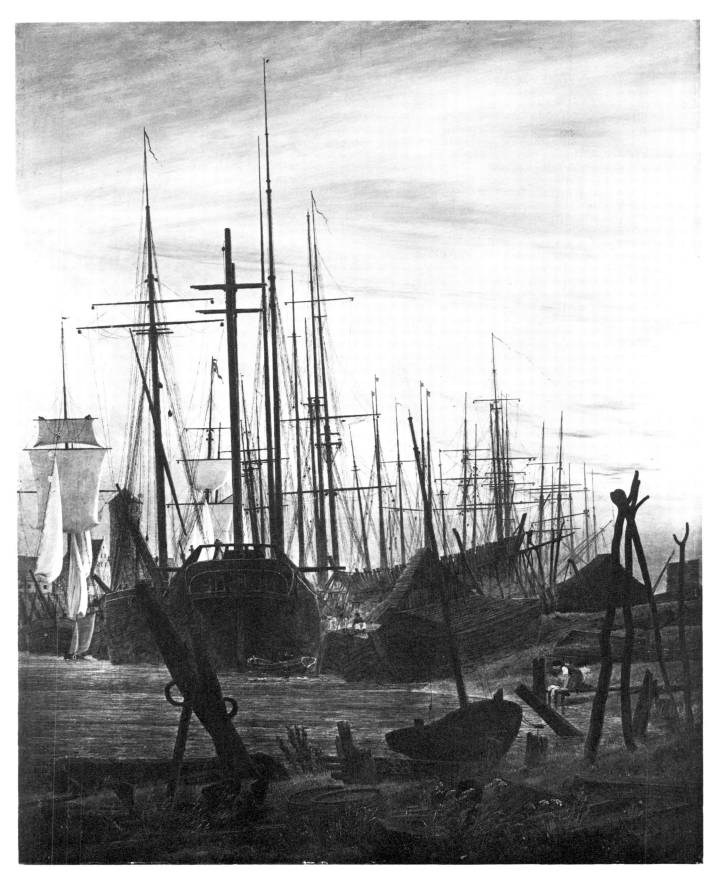

43 *The Harbour at Greifswald, c.* 1820, oil on canvas, 94 × 74 cm. Formerly Hamburg, Kunsthalle; destroyed by fire, 1931

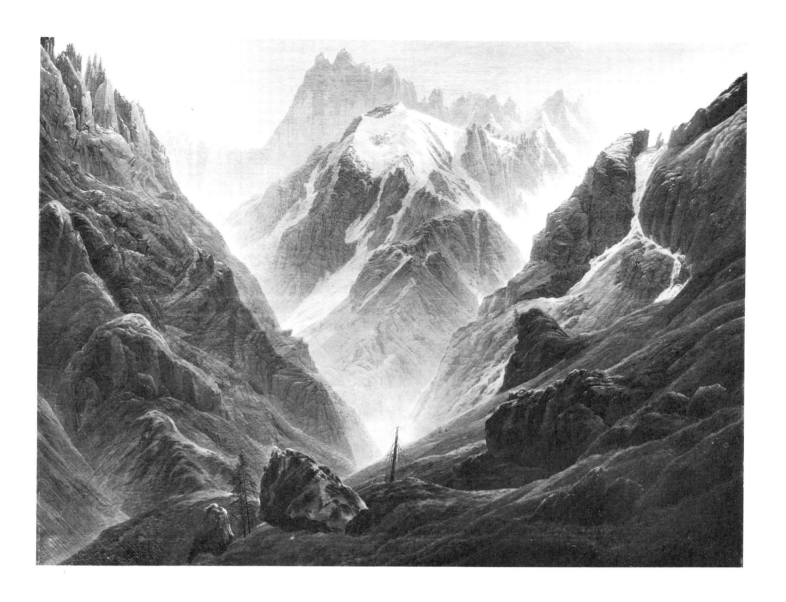

44
Hochgebirge, c. 1824,
oil on canvas,
132 x 167 cm.
Formerly Berlin,
Nationalgalerie;
destroyed in 1945

One feature can be observed in his paintings during these years which might possibly reflect his new approach to the world, namely the way his palette becomes brighter, the compositions looser and more relaxed, and strict symmetry disappears. His paintings become more like direct, faithful impressions of nature, yet all these seemingly uncomplicated pictures are still based on the same underlying thought that had determined his earlier works. The difference is that he no longer talks in riddles which are recognizable as such. Instead he uses an ambiguous language which leaves the observer free to choose whether he wants to pursue the depths of the artist's thoughts or whether he wants to content himself with a superficial impression. The cautious irony that we find in so many of his writings, an irony stemming from his awareness of how difficult it is to convey an emotion without any ambiguity or distortion, now became more evident than before in his paintings too.

The crisis which Friedrich had mentioned in his letter to Lund was overcome by 1818. That summer he took his wife to Greifswald and Rügen to introduce her to his family and relations, as well as to gather fresh inspiration for his work. His painting during this period manifests a great variety of motifs and formal means of expression.

45

He started doing landscapes from the Mittelgebirge as well as the seascapes and flat landscapes that had characterized the earlier period. He also painted some very unusual works such as a tondo, now lost, showing an owl in flight before the full moon. In the 1820s he also painted landscape types he had never seen, such as polar scenes and motifs from mountainous regions. He produced works in both very large and very small format. His style became so flexible that he even absorbed some ideas from another artist, namely Dahl, who in 1823 came to live in the house on the Elbe occupied by Friedrich from 1820. His more fluid way of applying paint and his use of stronger colours from this time on are presumably due to the influence of the Norwegian. Even the subsequent nature studies show him using both pencil and brush with a far lighter touch.

Dahl's naturalism soon found great acclaim not only in Dresden but in Germany as a whole. It was not long before he and Friedrich were considered as the representatives of the two poles of the Dresden school of landscape painting. On a personal level, though, they remained great friends. The reviews of contemporary exhibitions continually refer to this fact and some art lovers even had pairs of paintings executed, one by Dahl and the other by Friedrich.

In 1824 Friedrich was appointed an Associate Professor of landscape at the Dresden Academy. However, when the Professorship of the landscape class fell vacant at the end of that year through the death of Johann Christian Klengel, he did not receive the latter's post. This setback was indicative of the general change of taste, though it

45 *Ruin*, *c.* 1824, watercolour, 18 x 17.5 cm. Dresden, Kupferstichkabinett

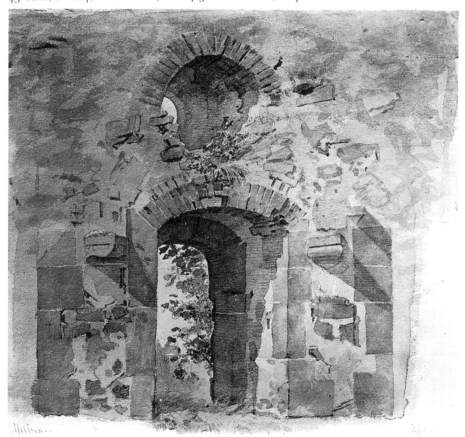

must have been obvious to any sensible, well-informed observer that Friedrich's art was far too subjective to form the basis of a school of landscape painting, since he regarded individuality of style, corresponding to the personality of each individual painter, as paramount. Above all, he despised any kind of slavish imitation. It was for this reason that of his few pupils he admired August Heinrich (1794–1822) most, precisely because Heinrich's devoted attention to all the details in a landscape had so little in common with his own approach.

The artist Georg Heinrich Crola (1804–79) described Friedrich's reserve towards his pupils as follows: 'The old landscape painter Friedrich encouraged me in every way. He never praised any of the works I showed him. He would just look at them for a long time in silence. Then he used to make a few remarks about life and art in general, and left it to me to apply them specifically to my work.' Crola never really fathomed the true significance of Friedrich's own art, for he continued: 'The picture of that man, his domesticity, peace, order and well-being, his modesty and the peaceful serenity which his memory awakens in me, still fills me with respect today [1847/8]. For me he was greater as a man than he ever was as an artist, from which I conclude that art and life do not necessarily merge, despite assumptions to the contrary. His artistic achievements were often mystical, unclear and subjective, and he was ridiculously fond of peculiar and tasteless effects.'

Friedrich's work was seriously disrupted by an illness which he contracted through over-exertion in 1824. From then until 1826 he was hardly able to paint in oils at all.

46 *The Vineyard Gate*, October 1824, watercolour, 12.7 x 20.5 cm. Dresden, Kupferstichkabinett

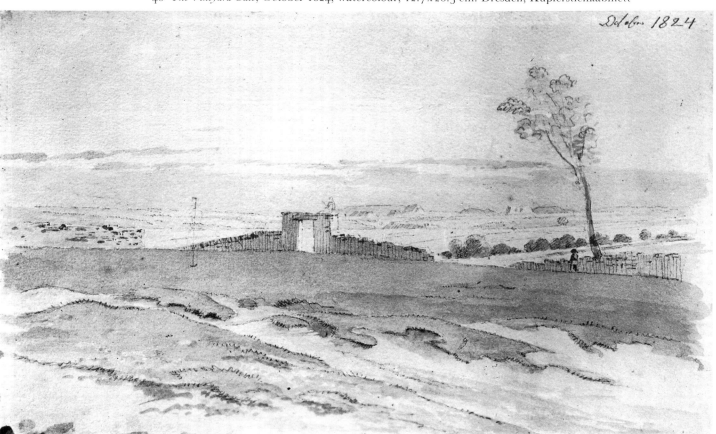

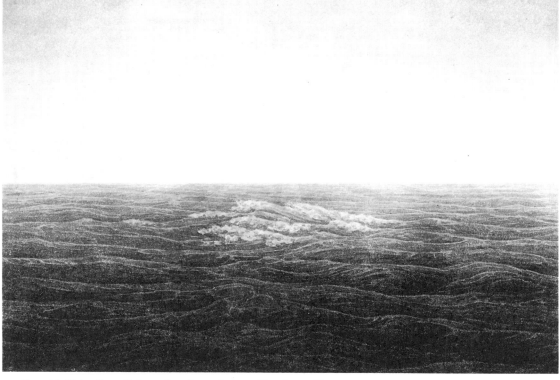

47 *Sea with Rising Sun*, 1826, sepia, 18.7 x 26.5 cm. Hamburg, Kunsthalle

48 *Landscape in Bohemia*, 1828, watercolour, 12.5 x 20.5 cm. Kiel, Stiftung Pommern

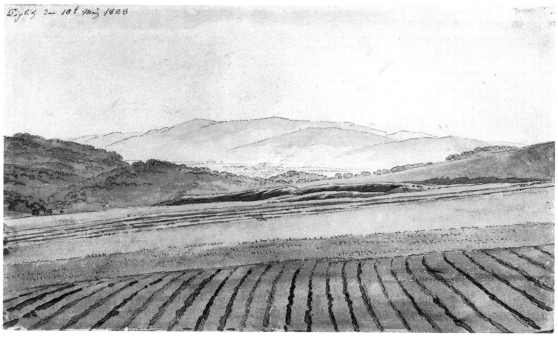

Instead, he turned to drawings and watercolours, concentrating in particular on a series of at least thirty-seven watercolours of views on the island of Rügen which were intended for reproduction as engravings. The set was in fact never published and the watercolours were subsequently dispersed. For most of these works he used earlier

49 *Group of Rocks in the Elbsandsteingebirge, c. 1828,* watercolour, 20.1 x 15.6 cm.
Munich, Staatliche Graphische Sammlung

50 *Landscape in the Riesengebirge*, c. 1828, watercolour, 24.7 x 33.7 cm. Winterthur, Stiftung Oskar Reinhart

studies which he transcribed with the utmost precision. From the few sheets that have survived it is apparent that Friedrich was not interested in depicting just the most famous views of the island, but also wanted to include some of the more modest aspects of the island's serenely beautiful landscape. The project may well have failed because these more intimate views were not of sufficient interest to the average visitor to Rügen.

In the summer of 1826 Friedrich spent several months recuperating in his native town, while continuing his work on the island series. That year he submitted only seven sepia drawings to the Academy exhibition. They were all variations on the theme of the cycle of times of the day, the seasons and the ages of man that he had first worked on back in 1803. This time he added three sheets depicting life before and after death (fig. 47).

After 1826 he began to produce paintings once more. Nevertheless, his illness had apparently brought about a change in his outlook on life and this, needless to say, affected his art too. Apart from a number of large seascapes, the second half of the 1820s also saw the execution of a surprising number of small pictures, upright in format, and depicting, for example, a single large tree seen in close up and silhouetted against the sky (pl. 40, 42). It was if the world had shrunk to the size of a tiny room. This feeling seems to denote fear and makes the longing for freedom all the stronger. In 1828 he also painted a vaulted dungeon. One of the most frequently recurring themes of this period was the winter landscape (pl. 40, 43, 45).

All this indicates a state of general gloom under which his family – and by now he had a son and two daughters – likewise had to suffer. Carus described the change

51 *Schneegruben*, *c.* 1828, watercolour, 25.7 x 35.8 cm. Formerly Dresden, Collection of Friedrich August II

that came over Friedrich in 1829 as follows: 'Certain fixed ideas had developed in his strange, dark mind – presumably the first signs of the brain condition which was later to be the cause of his death. They began to undermine his entire family life, and he, being suspicious by nature, began to torment himself – without any grounds whatever – with the idea that his wife had been unfaithful. These unfounded fears obsessed him totally, and as a result, he sometimes even behaved harshly and rudely towards his family. I talked to him very seriously on the subject and even tried to use my influence as a doctor, but all in vain. And so of course my relationship with him was spoilt too. I hardly ever visited him again until after he had been disabled by the stroke [in 1835], when I tried to help him as much as I could. But I had lost an important friendship which I had valued greatly in every respect.'

This gloom may have been partly due to increasingly strong criticism of his work, which he necessarily felt to be undeserved; but new art movements generally seek to prove that they represent progress by overthrowing existing ideas. Thus, Friedrich was criticized in order to add emphasis to the success of the Düsseldorf School which had been hailed with increasing enthusiasm since the end of the 1820s. The critics were continually declaring that Carl Friedrich Lessing (1808–80) represented the development of Friedrich's art, but on a higher level.

Around 1830 Friedrich wrote a collection of aphorisms entitled 'Äusserung bei Betrachtung einer Sammlung von Gemälden von grösstenteils noch lebenden und unlängst verstorbenen Künstlern' (Observations on a Collection of Paintings Principally by Living or Recently Deceased Artists). These notes were clearly not written with publication in mind, for in them he worked off his anger about the

52
Autumn, *c*. 1834,
sepia, 19.1 x 27.5 cm.
Hamburg, Kunsthalle

artistic developments of his time, drew up some principles of his theory of art, and complained – perhaps exaggeratedly – of the undue wrong he had suffered. Several of his comments, including the following, refer to himself and his own problems, and when reading them one should bear in mind Carus' remarks about his suspicious nature: 'Poor devil! You labour in vain to support yourself! Do you not know that your opponents are legion, and that for them no method is too bad if the damage it causes or the favour it does for another person is to their advantage? Attacking truth with mockery, virtue with scorn, and integrity with derision; and conversely, glossing over lies, treason and calumny. Such things are mere trivialities for these gentlemen. Cunning and underhand tricks are their basic principles. And whoever does not bend to their will is persecuted with mockery and derision or, if it is deemed more appropriate, with neglect and slander. And if that is no good they then set to with that double-edged sword, hunger. It goes without saying that they only go as far as they can without giving themselves away, so as not to jeopardize their semblance of well-meaning benevolence. For such gentlemen appearance is everything. Try as you may, your efforts will never find recognition again. Your works will be censured and despised to the same, perhaps exaggerated, degree that in earlier days they were praised. For you have insulted these honourable gentlemen, and loudly and boldly

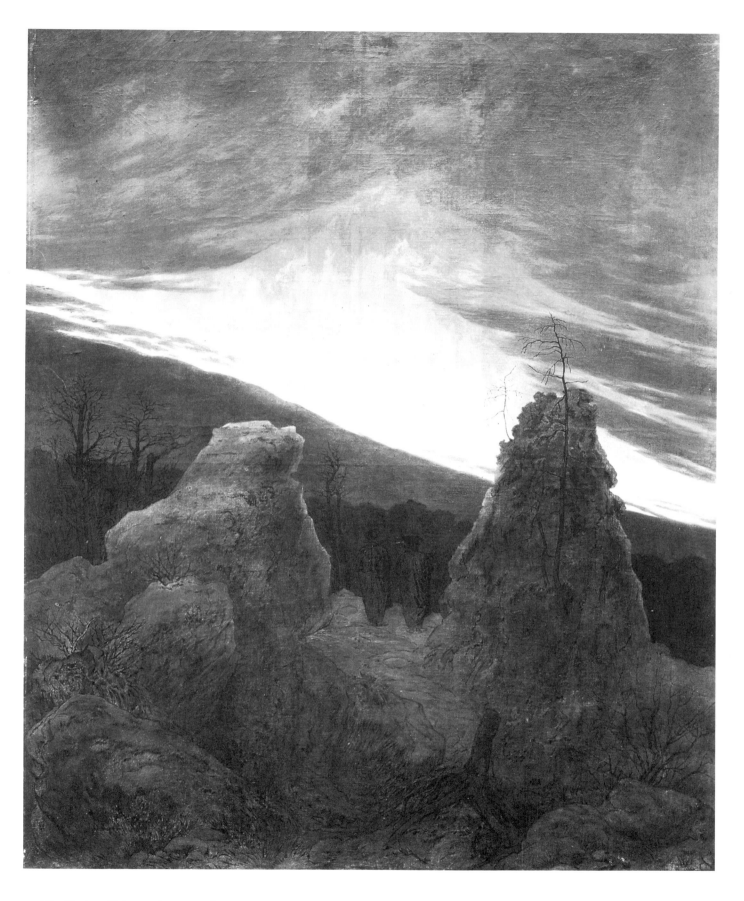

53　*The Northern Lights*, *c.* 1830–35, oil on canvas, 141 × 109 cm. Formerly Berlin, Nationalgalerie; destroyed in 1945

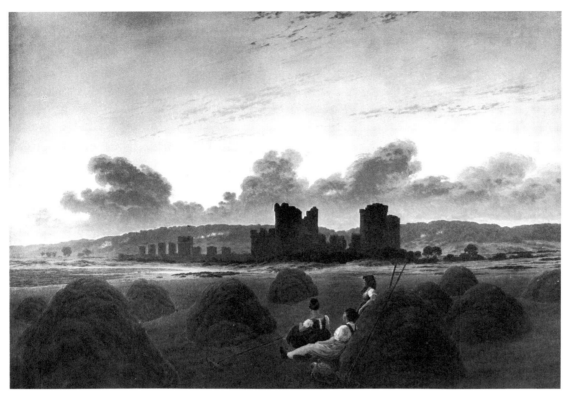

54 *Rest during Haymaking, c.* 1835, oil on canvas, 72.5 x 102 cm.
Formerly Dresden, Staatliche Kunstsammlungen; lost in 1945

called them scoundrels. Even though according to their idea of morality they are committing nothing more than light-hearted boyish pranks, the last thing in the world they want is to actually appear to be scoundrels. In return for your boldness you will end up with a broken neck. They will never forgive you. You poor devil, I pity you, for rest assured, wherever you go or stand or lie, and whatever you do, they will always be there snooping around in the distance (even your desk and letters are not safe from these people), and you cannot say a single thing that these rogues do not know how to twist to your disadvantage and their advantage.'

These outbrusts of bitter disillusionment were not his final word, however. Friedrich's artistic development took a fresh turn *c.* 1830 when he seemed to have regained a certain composure. This is the only possible explanation for the mellowness of his last paintings, seen at its most sublime in *The Large Enclosure near Dresden* (pl. 50). He painted a great variety of subjects in these last years, mountain landscapes, sea pieces, and pictures dominated by either human figures or architecture. He also employed the motif of swans in the rushes several times. In all these objects he expressed his feelings about the nearness of death. He hardly ever did pairs or cycles of paintings in which different perspectives were contrasted. From this time on he could envisage nothing but death and the life to come.

On 26 June 1835 he suffered a stroke, and in August and September that year he visited the spa at Teplitz in Bohemia in the hopes of restoring his health. On his return from Teplitz he wrote to his nephew Heinrich expressing the hope that he would be able to paint again: 'I am now fairly strong again and hope that the effect of the waters will soon make my hand strong enough for work. The whole time we

were in Teplitz we had the most beautiful weather. The countryside around the town is lovely. In spite of my lame hand I managed to make a few sketches which will be useful if I am ever strong enough to paint again.' However, he painted very little in oils from that time on. In 1836 he submitted another large seascape to the Academy Exhibition, and Dahl testifies that it was after the stroke that he started work on a *Rest during Haymaking*, a work which was destroyed in 1945 (fig. 54). Only one of the Teplitz sketches, depicting a mountain range, was actually used – for a sepia based on it.

55 a/b *Landscape with River and Mountains*, c. 1835, transparency, 76 x 130 cm. Kassel,
 Staatliche Kunstsammlungen

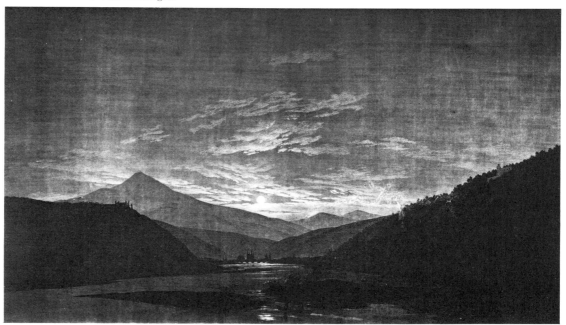

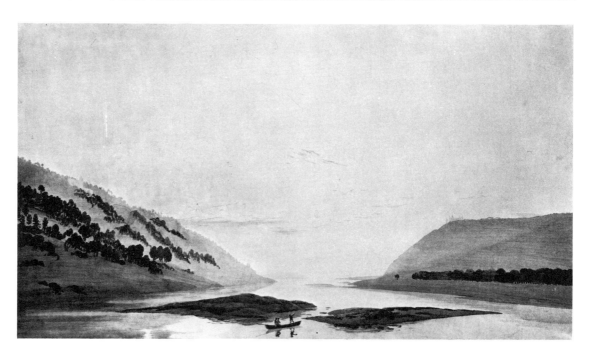

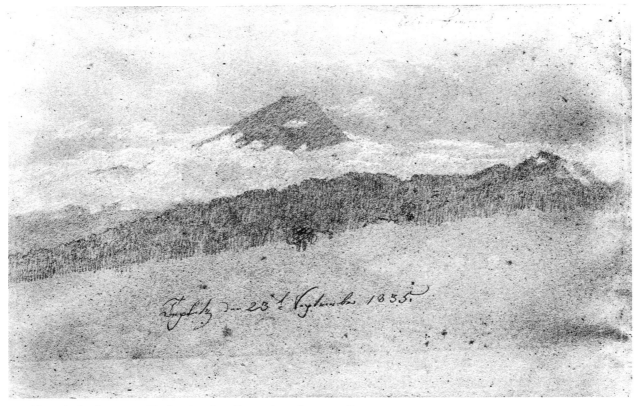

56 *Mountain Landscape near Teplitz*, dated 23 September 1835, pencil, 31 x 20.5 cm.
Nuremberg, Germanisches Nationalmuseum

57 *Seashore with Sailing Ships*, c. 1835–37, sepia, 24.7 x 34.6 cm. Formerly Bremen, Kunsthalle

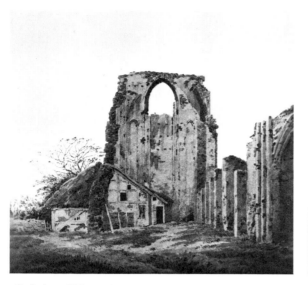

58 *Ruin at Eldena*, 1836, watercolour, 22.7 x 23.5 cm. Dresden, Kupferstichkabinett

59 *Lake Tollense near Neubrandenburg, c.* 1837–38, sepia, 25.2 x 39.3 cm. Leipzig, Museum der Bildenden Künste

That winter Friedrich's health seems to have deteriorated still further, for on 2 March 1836 Wilhelm von Kügelgen, one of the sons of the late Gerhard von Kügelgen, wrote to his brother Gerhard: 'I also visited our old friend Caspar Friedrich. I found him very ill. He has had a stroke and looks as if he will barely survive another six months.' Nevertheless, Friedrich managed to execute a number of sepia drawings and watercolours (fig. 57–62) which give no hint of his disability. Only the very last works dating from 1838 and 1839 betray an increasingly unsteady hand (fig. 63). However, from 1835 on, his intellectual faculties appear to have declined since from that time he was unable to produce a single new idea for a picture and continued to repeat a relatively limited range of well-tried subjects, such as ruins (fig. 58), dolmens (fig. 62), stony shores with or without figures, sometimes with a ship too (fig. 57), landscapes from the Mittelgebirge, caves, and graves with owls perched on them (fig. 60). Mostly they were small excerpts from nature seen in close-up, rather like some of his pictures of the second half of the 1820s. Occasionally he chose a detail from some old study from nature and built it up into a picture in its own right. From these drawings it can be seen that the only things that still existed for Friedrich were the grave and the life after death.

There are two accounts of Friedrich's final days, by Carus and by the sister of the painter Caroline Bardua. Mine Bardua noted in August 1839: 'Caroline found her old friend Caspar Friedrich a broken and sick man. She goes to see him each morning in order to paint him. Yesterday she brought several sepia drawings that he had given her. They will look lovely as a decoration in our house.' And on 8 December 1836 Carus wrote to Regis: 'As for Friedrich, he seems to be fairly well, though paralysed by the stroke and unable to work.'

The world paid little heed to Friedrich's death on 7 May 1840. In 1841 Carus published a short paper in his memory entitled *Friedrich der Landschaftsmaler* (Friedrich as Landscape Painter), but in his memoirs Carus wrote the following criticism of an exhibition held in Dresden in 1842 which included several paintings by Friedrich: 'A number of old, almost forgotten ghosts of pictures by Matthäi, Klengel and Hartmann

60 *Owl on a Grave*, *c.* 1836–37, sepia, 25.9 x 22.2 cm. Moscow, Museum of Fine Arts

rose again and stared at each other in a bored way. Even some of Friedrich's looked rather odd, as did some of my own early works.'

In landscape painting a more or less pathetic naturalism had established itself as the norm. The ideal landscape was now associated exclusively with historical painting. There was such conviction that art had progressed since the 1830s that early romanticism was considered to be nothing more than a preparatory stage that had been overcome. It would be unjust, however, to blame the generation born after 1800 for neglecting Friedrich, for his art was really far less an expression of his time than it was the attempt of one individual to come to terms with the problems of his own existence. His art was embedded in his time, yet it is also characteristic of a

61 *Rocky Crag in the Harz Mountains, c.* 1837–40, watercolour, 22.5×26.5 cm. Formerly Dresden, Collection of Friedrich August II

62 *Dolmen, c.* 1835–37, sepia, 22.6×30.5 cm. Formerly Dresden, Collection of Friedrich August II

63 *Landscape in Bohemia, c.* 1837–40, watercolour, 14.2 x 20.6 cm. Dresden, Kupferstichkabinett

certain type of artist who may stand out in isolation even today. This ensures for his painting a certain timeless quality, but at the same time limits the circle of people who can respond to it. By its nature, Friedrich's art cannot be a magnificent cultural heritage with a direct appeal for all. Rather, it is a document of humanity, calling the individual to reflection and contemplation.

Chronology

1774 Caspar David Friedrich born, 5 September, at Greifswald in Pomerania (the area, then under Swedish rule, was ceded to Prussia in 1815); the sixth of the ten children born to Adolf Gottlieb Friedrich and his wife, formerly Sophie Dorothea Bechly, both originally from Neubrandenburg.

1781 Friedrich's mother dies, 7 March; the children are subsequently cared for by a housekeeper ('Mutter Heiden').

1782 His sister Elisabeth dies, 18 February.

1787 Friedrich's brother Christoffer (b. 1775) is drowned in an accident, 8 December, while trying to save him.

1791 His sister Maria dies, 27 May.

1794 Friedrich begins his studies at the Copenhagen Academy; continues until 1798.

1798 Returns to Greifswald; in October pays a brief visit to Berlin and then goes to Dresden which is to become his permanent home.

1799 Enters works for the exhibition of the Dresden Academy; he is visited by his friend, the painter Johan Ludwig Gebhard Lund.

1801 Friedrich visits Neubrandenburg and Greifswald in the spring; while in Greifswald he meets the painter Philipp Otto Runge; visits the island of Rügen in June. Friedrich's brother Adolf is married 13 November at Neubrandenburg.

1802 Friedrich visits Rügen again in May; Runge reports his return to Dresden 28 July in the company of the painter Friedrich August von Klinkowström.

1803 Friedrich occupies his summer residence at Loschwitz near Dresden; Runge leaves Dresden.

1805 Gerhard von Kügelgen, the portrait and history painter, arrives in Dresden in May and soon befriends Friedrich. In August Friedrich enters two sepias in the annual competition held at Weimar by Goethe and Heinrich Meyer and is awarded half the prize.

1806 After an illness Friedrich travels to Neubrandenburg, Greifswald and Rügen, returning to Dresden in August. In October the philosopher Gotthilf Heinrich von Schubert arrives in Dresden.

1807 Friedrich travels to northern Bohemia, returning on 8 September; his first regular use of oils dates from this year.

1808 Second visit to northern Bohemia; also considers trip to Switzerland. Friedrich's sister Catharina Dorothea Sponholz dies 22 December. The *Tetschen Altar* (see pl. 6) is exhibited over Christmas at Friedrich's studio; it arouses both favourable and unfavourable criticism, notably an attack on it by Friedrich Wilhelm Basilius von Ramdohr.

1809 Friedrich visits Greifswald where his godson (his brother Adolf's son) is born 24 April; Friedrich goes on to Neubrandenburg, May-July; his father dies at Greifswald 6 November.

1810 With the painter Georg Friedrich Kersting, Friedrich goes on a walking tour in the Riesengebirge in July. In autumn Friedrich is visited by Johanna Schopenhauer, by Goethe (18 September), and by the Jena publisher Karl Friedrich Frommann (24 September). Essay on Friedrich's *Monk by the Sea* (pl. 7) by Kleist appears in the *Berliner Abendblätter* on 13 October. Friedrich is elected to membership of the Berlin Academy on 12 November.

1811 In June Friedrich tours the Harz Mountains with the sculptor Gottlieb Christian Kühn. On the return journey stays with the Bardua sisters at Ballenstädt. With Goethe at Jena 9/10 July. Plans for a journey to Iceland.

1813 The patriotic writer Ernst Moritz Arndt arrives in Dresden 8 April for a month's stay, during which he and Friedrich become acquainted. When the French forces occupy Dresden, Friedrich leaves to stay in the Elbsandsteingebirge, June-July.

1814 Following the liberation of Dresden a patriotic exhibition is held there in March; Friedrich sent two works.

1815 Friedrich visits Greifswald, August-September.

1816 Friedrich elected to membership of the Dresden Academy 4 December, with an annual stipend of 150 thalers.

1817 Designs (never executed) for the renovation of the Marienkirche, Stralsund (fig. 39). Friedrich meets the doctor and amateur painter Carl Gustav Carus and, in the autumn, the Swedish poet Per Daniel Atterbom.

1818 Friedrich marries Caroline Bommer 21 January, and in June they travel to Greifswald; during the summer they visit Wolgast, Stralsund and Rügen, returning to Greifswald in August. They return to Dresden 28 September.

1819 Friedrich receives a visit from Prince Christian Frederick of Denmark on 12 July. Friedrich's first child, a daughter (Emma), is born 30 August.

1820 Friedrich moves to a larger house, also overlooking the Elbe. In December he is visited by the Grand Duke Nicholas (the future Nicholas I) of Russia.

1821 Friedrich is visited by the Russian poet V. A. Zhukovsky; during the summer Friedrich's brother Heinrich comes to stay.

1822 Friedrich is visited by the poet La Motte Fouqué.

1823 In April the Norwegian painter Johan Christian Clausen Dahl comes to live at Friedrich's house. Friedrich's daughter Agnes Adelheid is born on 2 September.

1824 Friedrich is appointed Associate Professor at the Dresden Academy on 17 January. Visits Meissen in October. His son Gustav Adolf is born on 23 December. Friedrich taken ill.

1826 In order to restore his health Friedrich travels to Rügen (his last visit to the island) in June, after which he returns to Dresden for several months' rest.

1827 Friedrich becomes godfather to Sigwald Dahl 26 August.

1828 Friedrich visits Bohemia in May, staying at Teplitz.

1830 In March Friedrich is visited by Crown Prince Friedrich Wilhelm (later Friedrich Wilhelm IV) of Prussia. Riots occur in Dresden, 9-13 September.

1834 The French sculptor David d'Angers visits Friedrich on 7 November.

1835 Friedrich's nephew Heinrich (son of his brother Heinrich) comes to stay in the summer. Friedrich suffers a stroke 26 June, and from mid-August takes a rest cure at Teplitz.

1836 Friedrich is reported to be still very ill, in a letter written by Wilhelm von Kügelgen to his brother.

1838 Friedrich's brother Adolf dies at Greifswald, 23 June. On 13 November Friedrich's daughter Emma is married to Robert Krüger, a fisherman.

1839 Friedrich is visited by Caroline Bardua in August.

1840 Friedrich dies in Dresden, 7 May, and is buried there three days later.

Biographical Notes on Friedrich's Contemporaries and Associates

Extracts from Friedrich's personal correspondence and other writings can be found in S. Hinz, *Caspar David Friedrich in Briefen und Bekenntnissen*, Berlin 1968. Other associations between Friedrich and certain of the individuals listed below, especially in the context of his artistic output, are dealt with in greater detail in the catalogue by H. Börsch-Supan and K. W. Jähnig, *Caspar David Friedrich, Gemälde, Druckgraphik und bildhafte Zeichnungen*, Munich 1973.

ARNDT, Ernst Moritz (1769–1860), patriotic writer. In 1800, at Greifswald, he married a daughter of Johann Gottfried Quistorp (see below). Apart from one letter, dated 12 March 1814, from Friedrich to Arndt, there is little evidence of note that sheds light on the relations between the two men. Cf. Arndt, E. M., *Nothgedrungener Bericht aus seinem Leben*, vol. II, Leipzig 1847.

BARDUA, Caroline (1781–1864), painter and friend of Friedrich. She painted his portrait on two occasions: in 1811, when Friedrich visited the Bardua sisters at Ballenstädt; and in 1839, in Dresden. Cf. Werner, J., *Die Schwestern Bardua. Bilder aus dem Gesellschafts-, Kunst und Geistesleben der Biedermeierzeit*, Leipzig 1929.

CARUS, Carl Gustav (1789–1869), doctor, natural scientist, writer on art, and amateur painter. Born and educated at Leipzig, he came to Dresden as Professor of Gynaecology in 1814. Became friendly with Friedrich in 1817, when the artist encouraged him with his own paintings and had a considerable influence on his style. After Friedrich's death he published a short work in memory of the artist, *Friedrich der Landschaftsmaler*, Dresden 1841. Cf. also his *Lebenserinnerungen und Denkwürdigkeiten*, Leipzig 1865–66; for his letters to his friend Regis, cf. Börsch-Supan and Jähnig, op. cit.

CHÉZY, Helmina von (1783–1856), writer dedicated to Romanticism. She lived at various times in Berlin, Dresden, Vienna, Munich and Geneva.

DAHL, Johan Christian Clausen (1788–1857), Norwegian landscape painter. A friend of Friedrich's from 1818, he came to live with the Friedrich family in Dresden in 1823, after they had moved to a new house overlooking the Elbe. Friedrich's style in the 1820s was influenced by Dahl. Dahl's estate included various works by Friedrich, including eleven paintings; his collection formed the basis of the National Gallery in Oslo. Cf. Börsch-Supan and Jähnig, op. cit.

FÖRSTER, Karl (1784–1841), literary historian and translator in Dresden. Cf. L. Förster (ed.), *Biographische und litera-* *rische Skizzen aus dem Leben und der Zeit Karl Förster's*, Dresden 1846.

FOUQUÉ, Friedrich de la Motte (1777–1843), writer and poet of the Romantic period. He first championed Friedrich in 1810. Cf. F. de la Motte Fouqué and C. de la Motte Fouqué, *Reise-Erinnerungen*, Dresden 1823.

FROMMANN, Karl Friedrich (1765–1837), bookseller in Jena. Cf. Börsch-Supan and Jähnig, op. cit.

GOETHE, Johann Wolfgang von (1749–1832). Friedrich first encountered the famous poet in 1805. Goethe frequently expressed views on Friedrich's work, at first praising and later criticizing it. Goethe visited him in Dresden in 1810, and in the following year Friedrich returned the visit in Jena. With Heinrich Meyer (see below) Goethe organized an annual art competition at Weimar, at which Friedrich, in 1805, entered two sepias and was awarded half the prize. Cf. M. Hecker, 'Goethes Briefwechsel mit Heinrich Meyer', in *Schriften der Goethe-Gesellschaft*, vol. 34, Weimar 1919.

HEINRICH, August (1794–1822), an artist from Dresden. He became a pupil of Friedrich, who regarded him with great favour.

KERSTING, Georg Friedrich (1785–1847), painter from Pomerania. Like Friedrich, he attended the Copenhagen Academy, and later lived in Dresden. His style was much influenced by Friedrich's art. In 1810 the two men went on a walking tour of the Riesengebirge together.

KLEIST, Heinrich von (1777–1811). The poet lived in Dresden from 1807 to 1809, and probably became personally acquainted with Friedrich at that time.

KLENGEL, Johann Christian (1751–1824), leading landscape painter in Dresden. His works combined realism in the tradition of Dutch painting with idealizing tendencies in the manner of Claude Lorrain.

KLINKOWSTRÖM, Friedrich August von (1778–1835), painter and writer. Born in Pomerania, he is known to have been in Dresden in the early years of the 19th century, at the same time as Friedrich and Runge (see below).

KÖRNER, Theodor (1791–1813), a Dresden poet. He was especially known for his patriotic songs, and was killed during the Wars of Liberation. Friedrich was on friendly terms with the Körner family.

KOSEGARTEN, Gotthard Ludwig (1758–1818), poet and theologian. He was active in Wolgast, on Rügen, and in

Greifswald. He influenced both Runge (see below) and Friedrich, and also owned works by Friedrich.

KÜGELGEN, Gerhard von (1772–1820), successful portraitist and history painter. From 1805 he lived in Dresden and became friendly with Friedrich. His son Wilhelm (1802–67) was also a painter, and is best known through his memoirs, *Zwischen Jugend und Reife des Alten Mannes*, Leipzig 1925.

KÜHN, Gottlieb Christian (1780–1828), a Dresden sculptor. He became a friend of Friedrich's, and in 1811 the two men travelled together to the Harz mountains.

LESSING, Carl Friedrich (1808–80), one of the outstanding figures of the Düsseldorf school, he was a well-known landscape and history painter. He was a great-nephew of the great eighteenth-century German playwright Gotthold Ephraim Lessing (1729–81).

LUND, Johan Ludwig Gebhard (1777–1867), history and portrait painter. A friend of Friedrich's and, like him, a former student of the Academy in Copenhagen. He was in Dresden with Friedrich before 1800.

MEYER, Heinrich (1760–1832), Swiss-born painter and art connoisseur. He was director of the Weimar Academy and a friend of Goethe (see above), with whom he organized an annual art competition. His lack of sympathy with the art of the Romantic period led to his failure to appreciate Friedrich's work.

QUISTORP, Johann Gottfried (1755–1835), architect and university teacher at Greifswald. He was Friedrich's first drawing master, and in later years remained on friendly terms with his former pupil.

RAMDOHR, Friedrich Wilhelm Basilius von (1752 1835), writer and painter. His critical appraisal of the *Tetschen Altar* (pl. 6), which created a considerable controversy in art circles in Dresden, Berlin and Weimar, appeared in the *Zeitung für die elegante Welt* in 1809.

REIMER, Georg Andreas (1776–1842), publisher and bookseller in Berlin. Like Friedrich, he was born in Greifswald. His wide-ranging art collection included no less than thirty-three works by Friedrich.

RICHTER, Ludwig (1803–84), Dresden painter. Known particularly as an illustrator, he was one of the most popular

German artists of the nineteenth century. Friedrich seems to have had little regard for his work.

RUNGE, Philipp Otto (1777–1810), painter born at Wolgast in Pomerania. Like Friedrich, he became a student at the Academy in Copenhagen. He probably met Friedrich first in 1801, and is known to have been in contact with him in 1802–03 in Dresden.

SCHADOW, Johann Gottfried (1764–1850), sculptor and director of the Berlin Academy. He was critical of Friedrich's work, as is shown in a letter to Goethe; his letters to Goethe are dealt with in Börsch-Supan and Jähnig, op. cit. Cf. also J. G. Schadow, *Kunst-Werke und Kunst-Ansichten*, Berlin 1849.

SCHUBERT, Gotthilf Heinrich von (1781–1860), natural philosopher. He was in Dresden from 1806 to 1819, and was closely acquainted with Friedrich during this period. His *Ansichten von der Nachtseite der Naturwissenschaft*, published in Dresden in 1808, contained a detailed interpretation of one of Friedrich's sepia cycles.

SEIDLER, Luise (1786–1866), painter in Weimar. She was a friend of Goethe (see above), and played the role of intermediary between the artists of Dresden and Weimar. Two letters from Friedrich to Luise Seidler are known. Cf. H. Uhde-Bernays (ed.), *Erinnerungen der Malerin Luise Seidler*, Berlin 1923.

SEMLER, Christian August (1767–1825), writer. From 1800 he was secretary of the Public Library in Dresden.

TIECK, Ludwig (1773–1853), poet regarded by the Romantics as one the most important German writers. He had a considerable influence on Runge (see above), but appears in Friedrich's case to have been no more than a sympathetic defender of his art. Cf. L. Tieck, *Eine Sommerreise*, 1834.

WEGENER, Wilhelm (1812–79), animal and landscape painter in Dresden. He was a pupil of Dahl (see above), and was acquainted with Friedrich from *c*. 1835.

WINCKEL, Therese aus dem (1779–1867), Dresden painter and harpist. She was best known for her copies of old and modern masters. She was a friend of Duke Emil August of Sachsen-Gotha-Altenburg, who was a devotee of the arts and a somewhat eccentric character. Cf. W. von Metzsch-Schilbach, *Briefwechsel eines deutschen Fürsten mit einer jungen Künstlerin*, Berlin 1893.

The Plates

1 *Landscape with Pavilion* (*c.* 1797)

Pen, wash, and watercolour, 16.5 x 22 cm
Hamburg, Kunsthalle

There are only a few known drawings and watercolours dating from Friedrich's period of study, from 1794 to 1798, at the Copenhagen Academy. *Landscape with Pavilion* is one of a group of five watercolours depicting motifs from the landscaped gardens in and around Copenhagen (fig. 1). The pavilion shown here is a belvedere situated at Klampenborg, north of Copenhagen, from the roof of which there was a beautiful view over the nearby Öresund.

This is apparently a faithful rendering of a given location. Yet Friedrich uses the objects he depicts to express certain ideas, as had become the tradition in the landscaped gardens of the late eighteenth century. The humble thatched hut in the foreground stands in striking contrast to the noble architecture of the pavilion. The dense foliage of the trees in the background contrasts starkly with the dying trees beside the hut. A path leads up to the pavilion over a small wooden bridge which, however, is barricaded by a stout gate.

By all these means the foreground is cut off from the background, which remains a source of unattained desire. It is an allegory of paradise, while the foreground signifies the poverty and meagreness of earthly existence. The dying trees are symbols of death, while the bridge indicates the possibility of crossing into the world beyond. The hut with its open door can only serve as a temporary shelter; it cannot offer any permanent refuge. In contrast, the cubic form of the pavilion expresses solidity and durability. It is the focal point of the composition.

The nervous pen-strokes and the delicate colouring are still very much in keeping with the sentimental tendency of the late eighteenth century. And in the agitated drawing of the branches of the dying trees we still find traces of the Rococo love of ornamental designs.

2 *Seashore with Fisherman* (1807)

Oil on canvas, 34.5 x 51 cm
Vienna, Kunsthistorisches Museum

3 *Mist* (1807)

Oil on canvas, 34.5 x 52 cm
Vienna, Kunsthistorisches Museum

Apart from a couple of isolated attempts before 1800, Friedrich began painting in oils only from 1807 onwards. These two paintings are among his first works in this medium. In them he combined the careful formation of superimposed layers of colour that he had employed when working in sepia with the precise, draughtsman-like handling of colour that characterizes his gouaches. The fresh colouring of the *Seashore with Fisherman* is particularly reminiscent of the gouaches. The foreground objects are based on a lost study of Lake Tollense near Neubrandenburg. Significantly, they are all aligned along one plane rather like the words in a line of print. Bushes, eel-pots, the fisherman with his tackle slung over his shoulder, a wooden rack for drying hay, rather like a small thatched hut in appearance, and some nets hung out on stakes to dry. A small stream flows past these objects into the sea, symbolizing the immersion of the individual in the infinite universe. As early as 1803 Friedrich had executed a cycle of sepia drawings depicting the ages of man, comparing the course of life from birth to death with the course of a river from its source to the sea. The stream represents the life of the fisherman who gazes towards the distant ship, implying his own longing for death. The hay reminds us that human life fades and passes away just like the fresh green growth. The fisherman's tackle is an allusion to the world of human labour and, by extension, civilization. It symbolizes the terrestrial sphere and as such occupies only a small part of the picture surface in comparison with the far larger area taken up by the sky, which is a symbol of the heavenly sphere. The picture's composition can be seen as a preparatory stage for the *Monk by the Sea* (pl. 7), and differs from the latter largely in terms of the fluency with which thoughts about death and eternity are expressed.

The companion piece is almost identical in mood. It is morning. The translucent background suggests that any moment the sun will break through the mist. If *Seashore with Fisherman* represents the expectation of death, *Mist* can be described as an allegory of death itself. A small boat has left the rocky shore that symbolizes the terrestrial world and is bringing a passenger to the ship anchored a little farther out which is about to set sail. The anchor lying on the shore denotes the hope of life after death. Lying on the ground to the right there are two poles like those used by fishermen to string up their nets to dry. They are a sign that the time of work and

effort is over. It is presumably no coincidence that the poles resemble discarded crutches, a motif that Friedrich used again later to indicate man's liberation from the problems and difficulties of life. Death is conceived as a breakthrough to a happier existence, and for this reason it is compared with an awakening morning landscape.

Friedrich frequently produced pairs of pictures or cycles since they provided him with the opportunity to convey a development or progression. Comparison pieces are therefore as a rule not equivalent in the sense that they would be suitable for a decorative scheme or interior design, but rather one picture follows from another in an irreversible sequence. The prescribed progression is always an intensification and a turning to affirmation. In his preference for pairs or series of works Friedrich's meaning is expressed in a temporal manner; this is to be seen in each individual work in the differentiation of the foreground and the background which generally represent the present and the future respectively.

Pl. 2

Pl. 3

4 *Summer* (1807)

Oil on canvas, 71.4 x 103.6 cm
Munich, Neue Pinakothek

Like other Romantic painters, Friedrich often compared the stages of human life with the times of day and the changing seasons. This idea stems from the desire to see man's birth and death as a cosmically regulated cyclical process on which to base the hope of a resurrection.

The companion piece, *Winter*, a dismal allegory of death, was destroyed by fire in Munich in 1931 (fig. 27). *Summer*, by contrast, depicts the abundance of life. The numerous plants in the foreground signify the abundance of vegetation, and are only partly intended to be interpreted in a symbolic way. The lily signifies innocence, the rose love, and the sunflower, constantly turning its face to the sun, man's longing for the divine. The view opens out over a wide, fertile river valley. The river stands for the passage of life. A pair of lovers is seen embracing in a leafy bower in the right-hand foreground. A pair of cooing doves perched in the trees behind the bower emphasize the idyllic motif of love, an unusual feature in Friedrich's work. This mood is taken up in the group of trees consisting of a birch, the white trunk of which corresponds to the girl's white dress, and a poplar, which is related to the man. The two trees are merged into one formal entity.

Yet in Friedrich's mind this symbol of earthly love contains a certain religious ambiguity. Just as the flowers symbolize not only the blossoming of life but equally its transient nature, so too the group of trees has an eschatological meaning. For in Friedrich's work the poplar is always a symbol of death, whereas the birch, being a tree of springtime, denotes resurrection. Love, death and resurrection are fused, and the gay summer landscape assumes a paradisical character. Previously, men thought of paradise as an image of nature; for Friedrich, nature becomes an image of paradise.

5 *Morning Mist in the Mountains* (1808)

Oil on canvas, 71 x 104 cm
Rudolstadt, Staatliches Museum, Schloss Heidecksburg

A visitor to Friedrich's studio in 1808 wrote in the journal *Prometheus* the following description of a picture he had seen there: 'A towering mountain swathed in clouds, on the highest peak of which a cross can be seen silhouetted against the clear blue sky'. This description probably refers to the painting which was discovered only in 1941 in the reserve collection of Schloss Heidecksburg at Rudolstadt.

Many of Friedrich's compositions remind us of motifs in Dutch Baroque landscape painting; others are inventions for which there is no known antecedent. The Rudolstadt picture belongs to the latter category. In this bird's-eye view the regular conical shape of the mountain emerges from the swirling mist. We are given no definite indication of where the observer might be standing, and this is what gives the picture its visionary quality, in spite of the minute observation of nature. Naturalism is used here to emphasize a religious truth.

Though the cross on the summit is so small that it is barely visible, it still provides the key to the picture. For it projects against a patch of blue sky framed by a nimbus-like wreath of clouds, proclaiming that Christ has opened the heavens to mankind. The mist implies that the truth is obscured by the limitations of human intellect. The smooth shape of the mountain, probably based on sketches made in the Elb-sandsteingebirge, is a symbol of Christianity. The traditional comparison of the church with a rock has been completely rethought. Rooted in these rocks are the pines and fir-trees which, as Friedrich himself explained with reference to the *Tetschen Altar* (pl. 6), are to be interpreted as Christians. The large fir in the middle, which is the same distance from the right-hand edge of the picture as the cross itself is from the left-hand side, corresponds formally to the larger triangle of the mountain. These formal relationships elucidate the meaning of the composition. The tops of the trees protrude from the mist, implying the participation of Christians in the divine Revelation.

The Rudolstadt painting was executed at the same period as the *Tetschen Altar*. Both display similar motifs and a similar spiritual essence, but whereas the *Tetschen Altar* points to the metaphysical aspect of Christian teaching, the Rudolstadt painting is first and foremost a scene from nature which appeals to us initially because of its true-to-life realism. Only on closer observation do we notice its underlying meaning.

6 *The Cross in the Mountains* (*The Tetschen Altar*; 1807–8)

Oil on canvas, 115 × 110.5 cm
Dresden, Gemäldegalerie

The *Cross in the Mountains* was commissioned by Count Franz Anton von Thun-Hohenstein as the altarpiece (cf. fig. 28) for his private chapel at Schloss Tetschen in northern Bohemia.

According to a report by Friedrich's friend, Rühle von Lilienstern, the Count's wife, Maria Theresia (born Countess Brühl), saw a sepia drawing at an exhibition at the Dresden Academy in March 1807 depicting a cross in the mountains in a horizontal format. As a result, she is said to have suggested having the same subject executed in oils. It seems doubtful, however, that the Countess herself would have thought up the highly unusual idea of making a landscape into an altarpiece.

Back in 1805, according to Daniel Runge, the poet and theologian Gotthard Ludwig Kosegarten had drawn up a plan for either Friedrich or Philipp Otto Runge to paint an altarpiece for a fishermen's chapel at Vitt on the island of Rügen. Since Friedrich was painting nothing but landscapes at that time, Kosegarten must have had something like the *Tetschen Altar* in mind. In any case, Kosegarten himself practised a kind of nature worship which may well have given him the inspiration. The commission for the altarpiece at Vitt finally fell to Runge, who painted a *Christ Walking on the Water*. The picture was in fact never finished and now hangs in the Hamburg Kunsthalle.

In Friedrich's own work the idea of a landscape with a cross on a rock can be traced back to 1805. What is not clear is how Kosegarten envisaged the technical execution of the altar, for at that time Friedrich had not yet begun to paint in oils. The same question arises in connection with Rühle von Lilienstern's remarks about the altarpiece being commissioned in the spring of 1807, for even at that point Friedrich had not produced any oil-paintings. His initial preoccupation with this medium could therefore be linked directly with the commission for the altarpiece.

In April and May 1807 Friedrich did a series of studies of fir-trees, some of which were used for the altarpiece. It would seem that by this time he had definitely won the commission and was already working on the painting, even though it was completed only the following year.

On 25 November 1808 Friedrich wrote the following to his brother Christian with reference to the altarpiece: 'At Christmas I hope to receive two hundred thalers for a picture which I have nearly finished.' It was exhibited in his studio during the the Christmas season. On 28 December Marie von Kügelgen, the wife of Friedrich's painter friend, Gerhard von Kügelgen, recorded her impression of the scene: 'I went out for the first time yesterday and crossed over the other side of the Elbe to Friedrich's studio to see his altarpiece. I found many friends there, including Chamberlain Riehl and his wife, Prince Bernhard, Beschoren, Seidelmann, Volkmann and the Bardua sisters, to name but a few. Everyone who came into the room was as moved as if they were entering a temple. Even loudmouths like Beschoren spoke seriously and in quiet tones as if they were in church.'

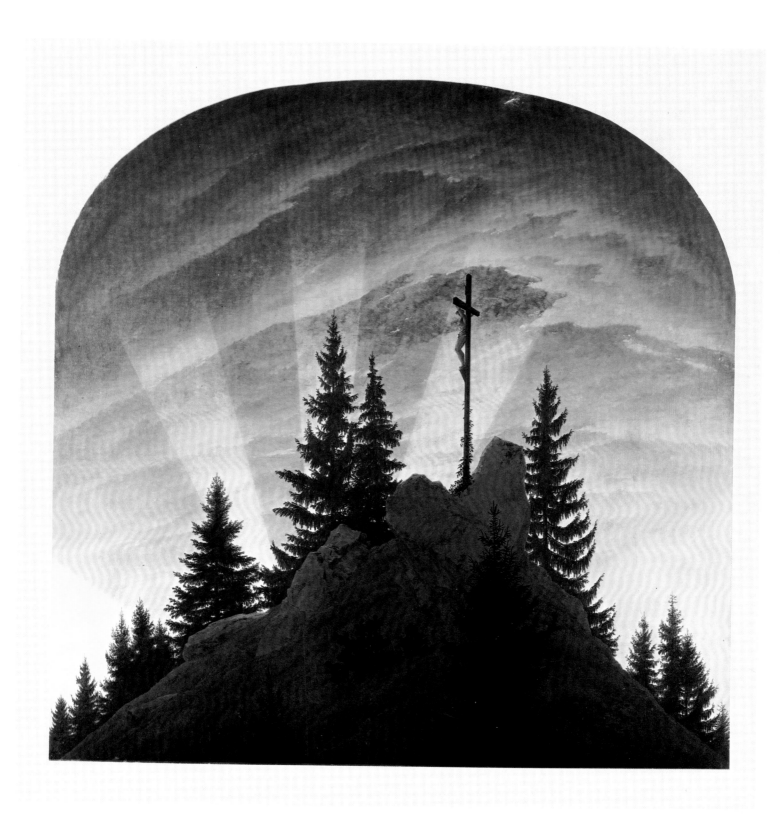

The picture was also the subject of considerable controversy, however. The painter and art critic Friedrich Wilhelm Basilius von Ramdohr wrote a long article rejecting the very idea of using a landscape for an altarpiece, and criticized the composition from a rationalistic point of view. Friedrich's friends publicly defended him against Ramdohr's attack, and Friedrich himself drew up a statement giving his own interpretation of the picture: 'Jesus Christ, nailed to the tree, is turned here towards the sinking sun, the image of the eternal life-giving father. With Jesus' teaching an old world dies – that time when God the Father moved directly on the earth. This sun sank and the earth was not able to grasp the departing light any longer. There shines forth in the gold of the evening light the purest, noblest metal of the Saviour's figure on the cross, which thus reflects on earth in a softened glow. The cross stands erected on a rock, unshakably firm like our faith in Jesus Christ. The firs stand around the cross, evergreen, enduring through all ages, like the hopes of man in Him, the crucified.' These words are extremely important for an understanding of Friedrich's art, offering a unique insight into his own approach to his art.

In contrast to *Morning Mist in the Mountains* (pl. 5), where a similar motif is depicted, we are immediately aware that the *Tetschen Altar* is much more than a mere representation of nature, since it is a skilfully constructed ideal landscape with symbolic implications. The composition is flat and permits the viewer only a very limited feeling of space. The few individual forms are all moulded into an almost architectonic design. The top of the cross almost touches one of the gable-shaped cloud formations. The tree-trunks and the cross are arranged in a rhythmical pattern over the picture surface. By concentrating the composition in this way Friedrich is acknowledging the demands of an altarpiece that is intended to help focus the thoughts of the beholder.

The frame, which was carved by the sculptor Gottlieb Christian Kühn from a sketch by Friedrich, is an inherent part of the formal and symbolic content of the picture (fig. 28). The triangle with the eye of God in the centre and rays emanating all round is a symbol of the Trinity, and corresponds formally to the rocky mountain-top silhouetted by the rays of the setting sun. The clouds echo the curving form of the palm branches round the upper edge of the frame, which are a symbol of peace. The silvery evening star shines in the sky, yet at the same time it is also the morning star and thus a reminder of the Resurrection. The gilt of the frame is taken up in the painted gold of the cross. The five cherubs' heads along the upper arch of the frame correspond to the five rays of light from the sun. The ears of corn and the grapes are eucharistic symbols, linking the painting directly to the altar over which it hangs.

Picture and frame combine to give the viewer the impression of looking through a window, particularly where the fir-trees are cut off by the lower edge of the frame. This window-frame effect calls to mind two sepia drawings executed by Friedrich in 1806 (fig. 21, 22) of the view through his studio window. The altarpiece is thus to be understood as a glimpse out of the confined space of earthly existence into a wide sphere of spiritual freedom, and it must be envisaged in a modest interior setting which itself makes no claim to be a reflection of the supernatural.

7 *Monk by the Sea* (1809–10)

Oil on canvas, 110×171.5 cm
Berlin, Schloss Charlottenburg

8 *Abbey in the Oakwood* (1809–10)

Oil on canvas, 110.4×171 cm
Berlin, Schloss Charlottenburg

Although the two pictures display a totally different formal construction, Friedrich did actually paint them as a pair. He submitted them to the 1810 exhibition at the Berlin Academy and as a result they were bought by Friedrich Wilhelm III of Prussia at the instigation of his fifteen-year-old son, the Crown Prince. The pictures are described in the catalogue of that exhibition simply as 'landscapes'. They were the most important pictures that Friedrich had so far painted.

Some of the visitors to the exhibition had already seen and commented on them while they were still in the artist's studio. The *Monk by the Sea* was first mentioned by the critic Christian August Semler in an article in the *Journal des Luxus und der Moden* in which he described a visit to Friedrich's studio in February 1809. Friedrich must have begun work on it shortly after completing the *Tetschen Altar* (pl. 6) in December 1808, if not earlier.

On 22 June 1809 Marie Helene von Kügelgen expressed her objections to the picture in a letter to her friend Friederike Volkmann. 'I also saw a large painting in oils which did not appeal to me at all. It shows a wide, endless expanse of sky, under it a stormy sea, and in the foreground a strip of white sand, along which the darkly shrouded figure of a hermit is seen creeping. The sky is clear and indifferently calm. There is no storm, no sun, no moon and no thunder. Yes, even a thunderstorm would be a consolation and pleasure, for then one would at least see some kind of movement and life. For there is no boat or ship, indeed not even a sea monster to be seen on the endless sea. And in the sand there is not even one blade of grass. Nothing but a few seagulls flitting around, which makes the loneliness of the scene all the more grim and desolate.'

She clearly did not know that Friedrich had originally planned to include two ships heading towards the shore, keeling over under the force of the storm, but these were only carried out in the under-drawing – as can be seen in infra-red photographs. Both Semler and Marie von Kügelgen refer to the uniform colour of the sky, which does not apply to the picture in its present state.

Goethe also saw this picture, together with the *Abbey in the Oakwood*, when he visited Friedrich's studio on 18 September 1810. In his diary entry for that day he noted: 'To Friedrich. His wonderful landscapes. A cemetery in fog and an open sea.' Johanna Schopenhauer, the mother of the philosopher, also appears to have seen the pictures at about the same time. In the article she wrote subsequently she made

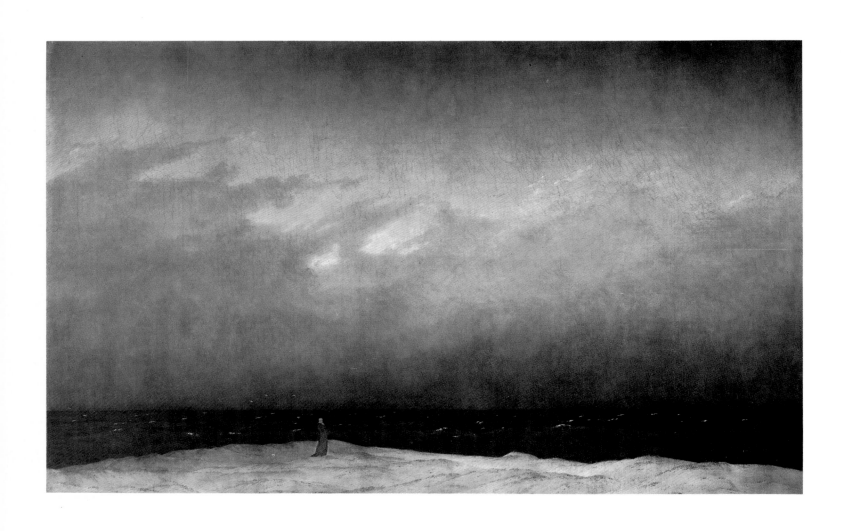

Pl. 7

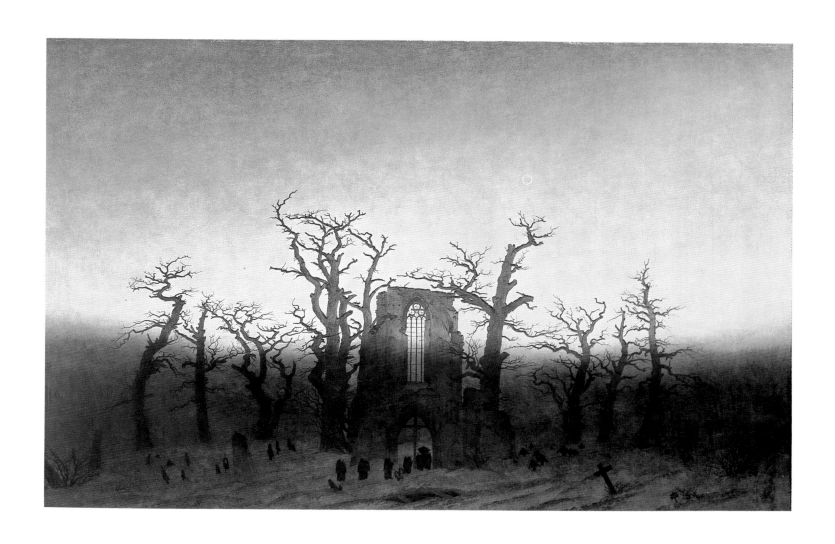

Pl. 8

only a brief mention of the *Monk by the Sea* and dealt at greater length with the *Abbey in the Oakwood*.

The last account we have of the pictures while they were still on view in Friedrich's studio is to be found in the diary of Karl Friedrich Frommann, the Jena publisher and friend of Goethe. On 24 September 1810 he noted: 'In the morning I visited Friedrich, saw various paintings... two quite large landscapes in oil, one of them a winter scene with six or eight bare trees round a chapel in the depths of which a lamp casts a pleasant glow over the surrounding mist. The second is a view of the Baltic, the waves sparkling gently in the light of the waning moon and the faint glitter of the morning star . . . [illegible word] in the dark with a . . . [illegible word, presumably 'likeness' or 'portrait']. Weak application of colour. How long will these fine paintings survive?'

Frommann thus saw the *Monk by the Sea* as a night scene with the waning moon and the morning star, and the monk presumably waiting to see the dawn. Frommann also noticed that the monk with his clearly rounded skull and his long blond hair is in fact a self-portrait of the artist, as can be seen from a comparison with any of the known portraits of him. Frommann's description of the painting as a night scene is also confirmed if we examine the picture surface: the present pale tones were painted over a much darker blue which is still visible in the sky areas at the upper edge and on the horizon.

Friedrich must have repainted the picture for a third time just after Frommann's visit. It had already reached Berlin by the beginning of October 1810, for as early as 13 October Heinrich von Kleist published his famous essay 'Empfindungen vor Friedrichs Seelandschaft' (Feelings occasioned by Friedrich's Seascape) in the *Berliner Abendblätter*. Basically, it was a hasty reworking of a short review by Clemens Brentano, combining some extremely perceptive remarks by Brentano with some striking thoughts of his own. 'How wonderful it is to sit completely alone by the sea under an overcast sky, gazing out over the endless expanse of water. It is essential that one has come there just for this reason, and that one has to return. That one would like to go over the sea but one cannot; that one misses any sign of life, and yet one senses the voice of life in the rush of the water, in the blowing of the wind, in the drifting of the clouds, in the lonely cries of the birds. But in order to experience this, the picture must appeal to one's heart and one's natural prejudices. In front of this painting, that is an impossibility. Instead of finding this reaction in the picture itself, I sensed it between me and the picture, so that I found myself identifying with the monk. All I saw of the picture was the sand dunes. The sea, towards which I should have been gazing, was simply not there. No situation in the world could be more sad and eerie than this – as the only spark of life in the wide realm of death, a lonely centre in a lonely circle. With its two or three mysterious objects, the picture appears like the Apocalypse, as if it were dreaming Young's *Night Thoughts*, and because of its monotony and boundlessness, with nothing but the frame as a foreground, one feels as if one's eyelids had been cut off. Nevertheless, this definitely marks a totally new departure in Friedrich's art, and I am convinced that he would be able to depict a square mile of Brandenburg sand with one sprig of barberry on which a solitary crow is ruffling its feathers, and that this picture would have a truly Ossianic or Kosegarten-like quality. Indeed, if one were to paint this landscape with

its own chalk and water I believe one could reduce the foxes and wolves to tears, which is without doubt the highest form of praise that one could adduce for this type of landscape painting. But my own feelings about this wonderful painting are too confused, so I propose to start by quoting the reactions and comments of some of the people who have been filing past it in two's and three's from early morning until late at night.' Brentano at this point included some amusing conversations which had taken place in front of the picture between visitors to the exhibition, which Kleist omitted.

For all our admiration for Kleist's inspired words it must be noted that his comments reflect his own emotional reaction and that he makes no mention of Friedrich's religious motives or his use of allegory.

It is significant that both Brentano and Kleist concentrated on the more daring of the two paintings, while others were attracted more by the *Abbey in the Oakwood*, for instance, Johanna Schopenhauer; Theodor Körner; and later Carl Gustav Carus, who called it 'perhaps the most intensely poetic work of art in all recent landscape painting'.

One of the oaks in the background is based on a study (fig. 31) that Friedrich drew from nature on 5 May 1809 in Neubrandenburg, from which we can deduce that he started work on this picture only after he had completed the first version of *Monk by the Sea*. The execution of the *Abbey in the Oakwood* was apparently less fluctuating and dramatic than was the case with its companion piece, which dragged on for nearly two years and shows how greatly Friedrich struggled over this seemingly simple composition.

The originality of *Monk by the Sea* lies in the tension created by the void: both monk and viewer are confronted with an infinite space. The narrow strip of beach is sharply outlined against the sea which occupies the same amount of surface area as the beach, yet seems far larger and more distant. This visual paradox points to the metaphysical problem of the picture which cannot be grasped by the intellect. The decisive factor about the background is not its physical size as such but its immeasurable quality. Man is unable to orient himself in the infinity that confronts him and makes him painfully aware of his own insignificance and powerlessness.

The foreground clearly symbolizes the here-and-now of this world, but it is by no means clear what is meant by the sea. In the first version of the picture with the two ships, the sea probably signified life, for ships in Friedrich's works generally refer to human existence. The end of their journey indicates that death is imminent. In this context the white beach can only represent the life hereafter. The meaning of the background becomes clearer if we examine the sky, the third and largest area of the picture. It shows the clash between darkness and light which, since the sky in Friedrich's works always symbolizes the religious sphere, is to be interpreted as the divine promise of salvation and eternal life. The night sky showing both the morning star and the crescent moon – a combination which is visible only in the early hours of the day – signifies something similar, namely the expectation of daylight which will conquer the darkness. In this sense the sea is a symbol of the menacing vastness of the universe as well as the superiority of death over life. The monk is seen in the classical gesture of mourning, with his head buried in his hand, reflecting over the metaphysical meaning of the world which this landscape reveals to him – Friedrich's

sole aim as a landscape painter is to reveal the symbolic quality of the landscape. For this reason he is totally justified in treating the figure of the monk as a self-portrait, and in so doing he reveals both his complete preoccupation with what lies beyond death as well as his extreme isolation. In 1809 Marie von Kügelgen called him 'the oddest of the odd'.

Many critics have remarked on the departure from conventional perspective in this picture, the calculated mastery of space, and the way he depicts the conquest of infinity. Through this inconceivable endlessness Friedrich is also expressing man's experience of his own inner depths when threatened by death. For the endlessness of the landscape also symbolizes man's spiritual self, a concept that Friedrich was later to express in one of his aphorisms: 'The artist should not only paint what he sees before him, but also what he sees in himself. If, however, he sees nothing within him, then he should also refrain from painting what he sees before him.'

These reflections about death as the dominant element in *Monk by the Sea* bring us to its companion piece, *Abbey in the Oakwood*. Despite the bizarre forms of the bare oak-trees, the solemn symmetry of the composition imparts an air of calm to the scene. Some monks are carrying a coffin through the portal of a ruined church, in which a crucifix flanked by two lights can also be seen. The procession is going past the open grave towards the crucifix and into the mist-shrouded background, a sign that the grave itself is not the ultimate goal of this life, but something beyond. As the companion piece to *Monk by the Sea* it is not difficult to interpret this scene as the funeral procession of the monk in the former picture, in other words of Friedrich himself. He had in fact already expressed this idea in a large sepia drawing done in 1804 entitled *My Funeral*, which is now lost.

The architecture is based on a lost drawing of the west wall of the ruined Cistercian monastery at Eldena near Greifswald which Friedrich also used for several other works. He made liberal changes to the original. For example, he ignored the fact that the west window had been bricked up, added a large doorway, and omitted other remains of walls adjoining and near the west wall.

Bearing in mind that the ruin of the Cistercian monastery at Eldena is situated right beside the Baltic, the two paintings *Monk by the Sea* and *Abbey in the Oakwood* do seem to belong together. Allusions of this kind, which the casual observer cannot possibly understand, are typical of Friedrich's method of conveying his most intimate thoughts by means of a kind of code.

The ruin and the oak-trees form a barrier between the foreground and background. Their function as a kind of grid is emphasized by their flat, silhouette-like forms. This linear tracery that Friedrich has devised symbolizes the disciplining of the passions and the now clearly deteriorated traditional Christian order. It stands in direct contrast to the strange ornamental effect of the trees. Friedrich uses oaks as symbols of the pagan way of life and often combines them with dolmens. The bizarre, twisting shapes of the branches suggest a passionate and indomitable force, even though the combination of various individual studies of oak-trees has resulted in a certain artistic order among the web of lines formed by the trunks and branches. The violence of this growth represents the antithesis of the Christian ethos for which Friedrich uses the symbol of the evergreen fir-tree. In this picture the calculated rhythm of the funeral procession is contrasted with the ghost-like unrest of the oaks.

The crescent of the waxing moon is a symbol of Christ as the light which illuminates the night of death. The outline of the whole moon is already visible, indicating the promise of a brighter future.

The Gothic ruin stands among a row of pagan symbols, signifying that the piety of the middle ages also had a past. For Friedrich the unfathomableness of nature serves the same purpose that the church had done in earlier centuries. The picture is often unjustly described as a depiction of the absolute rigidity of death, but any such interpretation totally neglects Friedrich's explicitly stated Christian approach to life.

9 *Landscape with a Rainbow (c. 1810)*

Oil on canvas, 59 x 84.5 cm
Formerly Weimar, Staatliche Kunstsammlungen. Now lost

This landscape was probably among the group of five paintings by Friedrich acquired in 1810 by Duke Karl August of Sachsen-Weimar on the recommendation of Goethe. The motif is taken from the island of Rügen. In terms of content and composition this picture is unique among Friedrich's works in that it is an illustration of Goethe's poem 'Schäfers Klagelied' (Shepherd's Lament) of 1802. It is a visual counterpart to the thoughts expressed in the poem, so the shepherd is depicted three times with his flock, illustrating the various stages of the poem. The following translation is taken from *The Poems of Goethe*, translated in the original metres by Edgar Alfred Bowring (London 1891).

On yonder lofty mountain
A thousand times I stand,
And on my staff reclining,
Look down on smiling land.

My grazing flocks then I follow,
My dog protecting them well;
I find myself in the valley,
But how, I scarcely can tell.

The whole of the meadow is cover'd
With flowers of beauty rare;
I pluck them, but pluck them
 unknowing
To whom the offering to bear.

In rain and storm and tempest,
I tarry beneath the tree,
But closed remaineth yon portal;
'Tis all but a vision to me.

High over yonder dwelling,
There rises a rainbow gay;
But she from home hath departed,
And wander'd far, far away.

Yes, away hath she wander'd,
Perchance e'en over the sea;
Move onward, ye sheep, then, move
 onward
Full sad the shepherd must be.

The poem is a nostalgic reminder of the pastoral verse of the Rococo period. The rainbow is a symbol of peace, consolation and the conciliatory power of memory, and thus unites the shepherd with his distant lover. Whereas the motif of the rainbow makes only a fleeting appearance in Goethe's poem, it completely dominates Friedrich's picture. According to Friedrich the shepherd's melancholy derives from a different source. This is intimated by the dead tree-trunk and withered branches in the foreground which are unmistakable symbols of the transience of life. Friedrich does not even hint at the shepherd's lovesickness. The rainbow which links him with the source of his longing in eternity is not so much a cosmic as a Christian symbol. Hence the painting is not just a rendering of Goethe's appreciation of nature but is simultaneously imbued with Friedrich's own thoughts about death and salvation.

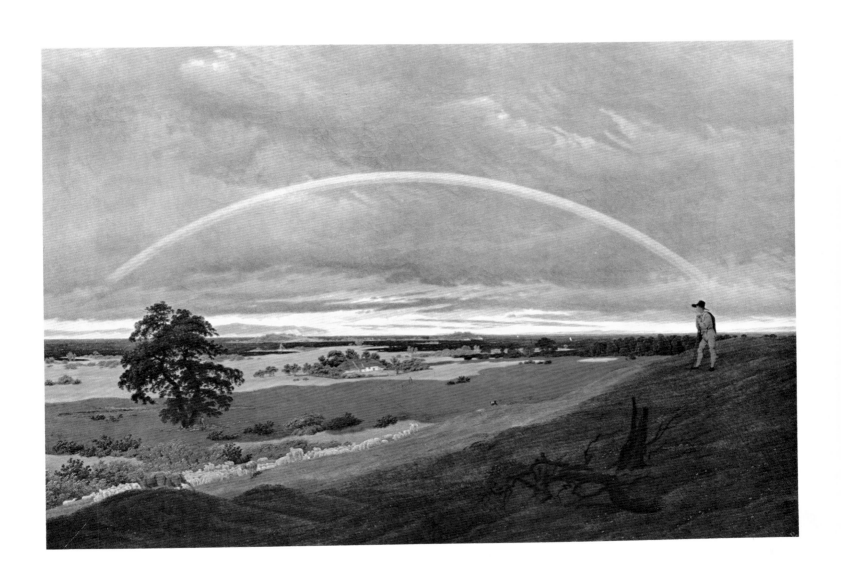

10 *Mountain Landscape with Rainbow* (*c.* 1810)

Oil on canvas, 70 x 102 cm
Essen, Museum Folkwang

This picture is thought to have belonged to the same group of paintings acquired by Duke Karl August in 1810 already mentioned in connection with the *Landscape with a Rainbow* (pl. 9). At all events it was in the Weimar Collection before coming to Essen. The Duke's cousin, Duke Emil August of Sachsen-Gotha-Altenburg, criticized what is presumably this picture in a letter dated 9 October 1810 to the Dresden artist, Therese aus dem Winckel: 'I have seen some paintings by Friedrich which captivated and astonished me, even though I did not really find them pleasing. But I also saw some unfinished sepias, light, beautifully poetic, drawn with the utmost delicacy, yet profound. These sepias greatly aroused my interest in Friedrich. But not so the paintings, those garish, harsh, contradictory affectations, those peepshows purporting to be mystical allegories – especially the rainbows which remind one of a confectioner's handiwork, and the foregrounds like mosaics and the backgrounds like maps. No, all this forced me to the conclusion that these by no means totally undeserving things are not to be taken seriously.'

What the Duke objected to, as Ramdohr had done over the *Tetschen Altar* (pl. 6), was the lack of naturalism. What they failed to see, of course, was that Friedrich used this effect deliberately in order to illustrate the metaphysical aspect of nature. It seems that the picture was originally planned as a night scene with the moon half concealed by clouds, for the rainbow itself was only painted in thinly over the clouds after the rest of the picture had been completed. The fact that the rainbow can be seen at all is completely illogical, for it would normally be visible only if the source of light was behind the observer.

The traveller in the foreground is clearly a stranger to the country, for he is dressed in city clothes. He is leaning against a large rock, the symbol of faith. Once again, it is presumably a self-portrait of the artist. His hat lies on the ground beside him as a sign of humility, and he gazes out over a valley whose lower regions are shrouded in mist. On the distant side of the valley rises the smooth silhouette of a mountain for which Friedrich used a study of the Rosenberg in northern Bohemia. In abstract terms this mountain is a divine symbol that lies beyond the valley of death. The traveller has to cross over this valley if he wishes to reach the goal of his journey. The rainbow hovers over the scene as a symbol of peace.

Friedrich seems to have painted this picture as a kind of confession of faith and his own conception of nature. It was also intended to define the difference between his conception of nature and Goethe's, which is depicted in the lost *Landscape with a Rainbow* (pl. 9). *Mountain Landscape with Rainbow* with its severe composition differs from the *Landscape with a Rainbow* in the same way that the *Tetschen Altar* differs from *Morning Mist in the Mountains* (pl. 5).

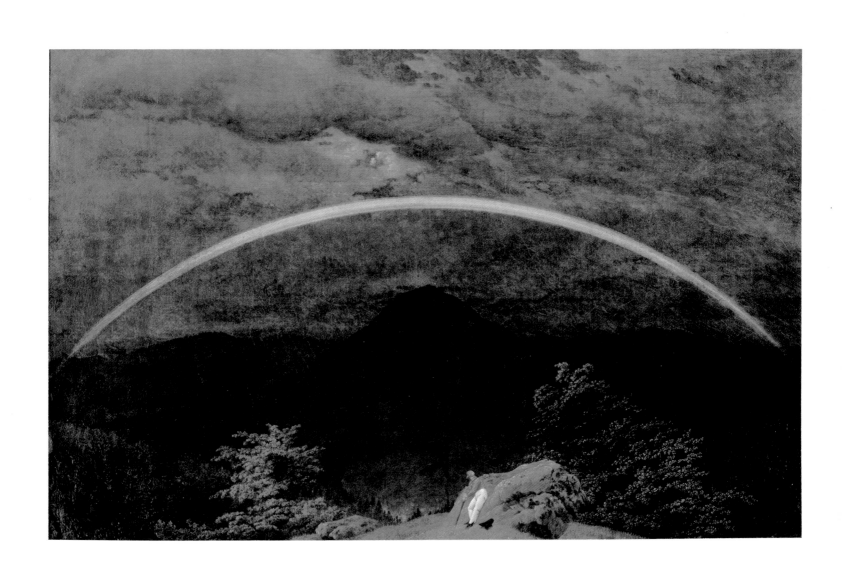

11 *Morning in the Riesengebirge* (1810–11)

Oil on canvas, 108 x 170 cm
Berlin, Schloss Charlottenburg

Friedrich began this painting soon after his return from a walking tour in the Riesen-gebirge with the painter Georg Friedrich Kersting in July 1810. The background is based on the drawing – now in Karl-Marx-Stadt (formerly Chemnitz) – made on 11 July 1810 while coming down from the Schneekoppe. The rocky areas in the foreground were taken from various different sketches. When the publisher Karl Friedrich Frommann visited Friedrich's studio on 24 September 1810, he mentioned this Riesengebirge landscape as well as the *Monk by the Sea* (pl. 7) and the *Abbey in the Oakwood* (pl. 8): 'Draft for another large landscape of the Silesian Riesengebirge. The scene is viewed from the summit of the snow-capped mountains and shows a female figure beside the cross on the highest peak, drawing the artist up to her. The lower part of the mountains is to be almost entirely covered by clouds, while the cross and the two figures are to be illuminated by a continuous ray of sunlight.'

Friedrich worked on the picture until March 1811, for it was too late to be put on show for the opening of the exhibition at the Dresden Academy on 5 March. When it did appear, it caused a great stir, as can be seen from contemporary reviews of the exhibition. According to one of these reviews, the figures were painted by Kersting; it also confirms that the male figure is Friedrich himself. The treatment of the group of figures differs from Frommann's description, and Kersting may have changed the original draft with Friedrich's approval, though this seems highly unlikely. The light effects also differ from the original plan as described by Frommann. The sun is rising from the left where it forms a focal point on the horizon. The cross is the only object in the foreground to cut across the horizon and project against the sky, and hence strikes a balance between the two halves of the picture. In this way Friedrich connects the cross which symbolizes the sacrificial death of Christ with the rising sun which symbolizes the promise of resurrection and God's eternal power; between them lies the valley of death. Compared with the fresh morning atmosphere of the fore-ground, the mountain landscape in the background has an almost paradisical character. The ethereal, white-robed female figure is not intended to represent a real person, but is an allegory of faith or religion, since these are the forces that enable mankind to rise to the greatest heights and see paradise.

Friedrich painted a companion piece to the picture, which is lost. It was exhibited together with *Morning in the Riesengebirge* in Weimar in 1811. It showed a dramatic evening landscape with a waterfall and a navigable river, denoting that life in this world is determin by the forces of nature and human labour, and must have formed a striking antithesis to the calm mood of the companion piece. In the lost work a man lifting a woman from one rock to another symbolized man's superior strength in the practical aspects of life.

Oil on canvas, 32.5 x 45 cm
Winterthur, Stiftung Oskar Reinhart

The hunter, scarcely visible in the foreground thicket, is aiming his gun at some birds. It is a very unusual subject in Friedrich's *oeuvre*. He represents the man who lets himself become entangled in the battles of life and whose eye is distorted by the material demands of everyday life. He embodies the opposite of the traveller gazing into the distance in a mood of religious contemplation. In relation to the hunter, the oak-trees symbolize the pagan attitude to life. The dramatic forms and the contrast between the dead branches and those covered in foliage symbolize the interweaving of life and death in the world, and correspond to the hunter's action in killing so that he may live. The pulsating white clouds harmonize with this expression of vital energy which Friedrich is questioning.

Of all Friedrich's pictures, none is so reminiscent of the seventeenth-century landscapes of Jacob van Ruisdael as this one. The way the oaks are drawn, the emphatic mixture of green, white and blue, and the relationship of the figure to the landscape recall the seventeenth-century Dutch artist. Friedrich had in fact already come to terms with Ruisdael earlier on. No other old master was so close to him. In this picture, however, he seems to have been not only comparing himself with Ruisdael, but simultaneously distancing himself, for the message of the picture is distinctly critical.

13 *Old Heroes' Graves* (1812)

Oil on canvas, 49.5 x 70.5 cm
Hamburg, Kunsthalle

This picture is one of a series of patriotic paintings that Friedrich executed under the influence of the uprising against Napoleon in 1812–14. The cave and the steep rock-face above it originally appeared in a sketch made in 1811 near Rübeland in the Harz Mountains. In the foreground there is a dilapidated monument on which can be seen the inscription 'Arminius'. Over it slithers a snake (in the colours of the tricolour) symbolizing evil. A tree is growing out of the grave and nearby there are some flowering bushes representing the revival of national sentiment for which Arminius had been a symbol ever since Klopstock, and even more so since the publication of Kleist's *Hermannsschlacht*. Several other tombstones also bear inscriptions referring to heroes who had died in the cause of freedom and justice. A brand-new obelisk bears the inscription 'noble youth, deliverer of the fatherland'; the initials 'G. A. F.' above it remain a mystery, though they probably refer to some soldier who died in the battles against the French. The painting is possibly dedicated to this man's memory. Behind this tomb the eye is led into the opening of the cave inside which another sarcophagus can be seen. Two French soldiers are standing at the entrance to the cave awed by the magnetic power that emanates from the dark interior of the cave. The sky is not visible, suggesting the oppression suffered by the German people under the French occupation. However, some light is entering the scene from above, indicating that there is an opening to the sky, which implies the hope of liberation. The roots and tree-trunks just visible at the upper edge of the painting also indicate that the landscape continues upwards. Fir-trees, which in Friedrich's works normally symbolize the Christian's hope of eternal life, are to be understood here as symbols of the patriotic confidence that Germany would eventually be liberated. The fusion of Christian and political allegory corresponds to the religious motivation of the German rising against Napoleon. Thus, Friedrich's placing of the two soldiers outside the cave containing the tomb is presumably a reference to the Roman soldiers at Christ's tomb. The spring vegetation in the foreground would be appropriate to an Easter theme of that kind.

The movement downward into a bottomless abyss as an image for the threat of death was already intimated in the *Mountain Landscape with Rainbow* (pl. 10).

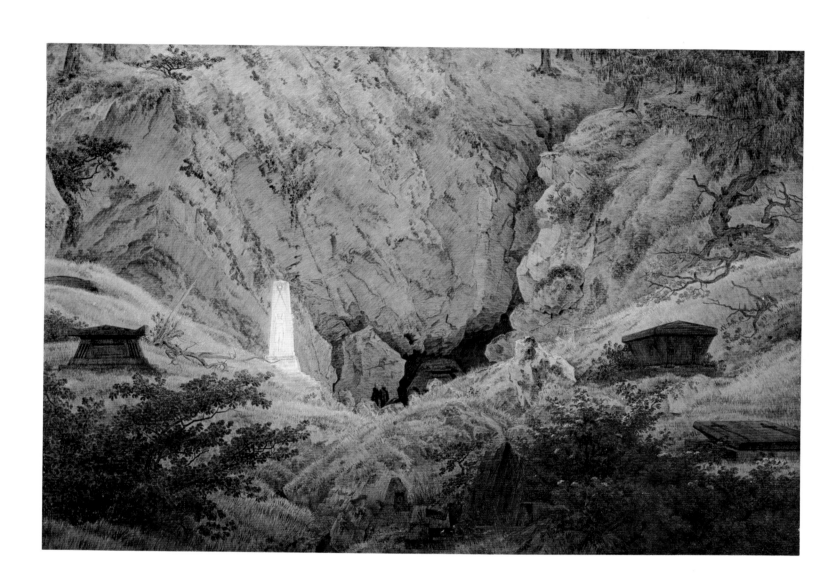

14 *The Cross on the Baltic* (1815)

Oil on canvas, 45 x 35.5 cm
Berlin, Schloss Charlottenburg

The Cross on the Baltic is one of the few pictures by Friedrich for which we possess a personal interpretation by the artist. On 9 May 1815 he wrote to Luise Seidler, a young artist friend of Goethe's: 'The picture for your girl friend is already begun, but it will not contain a single church, tree, plant, nor even a single blade of grass. The cross is erected on the bare seashore; to some a symbol of consolation, to others simply a cross.'

We can only conjecture that Luise Seidler's friend is the Dresden artist, Therese aus dem Winckel. Friedrich's words contain a careful reference to the symbols of death. The ship pressing on towards the shore signifies the life that is approaching death, already orienting itself towards the cross which is the symbol of Christ's death. The rock is a symbol of faith. The hope of resurrection is symbolized by the anchor. The poles lying in front of the cross are like those used by sailors to test the depth of the water and to manoeuvre their boats; here they represent the security which faith offers the Christian at the moment of death. The full moon is a symbol of Christ and casts a gentle glow over the cross and the sea. The grey water and the brown rocks provide a subtle contrast to the muted but vivid colouring of the sky. The paint is applied very thinly and cautiously, yet the forms are drawn with the same precision found in the sepia sketches. The subject-matter, mood and painterly technique are in perfect harmony.

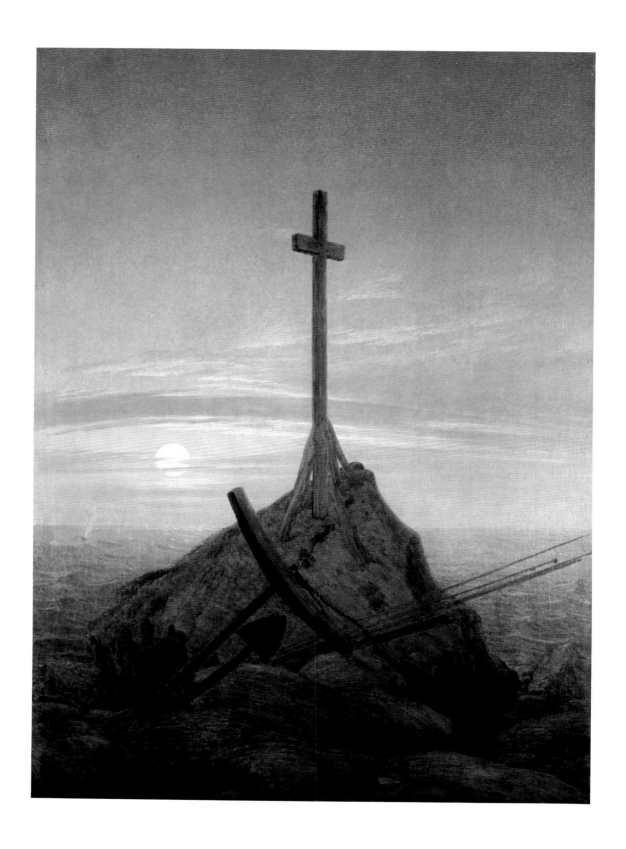

15 *Two Men by the Sea at Moonrise (c. 1817)*

Oil on canvas, 51 x 66 cm
Berlin (West), Nationalgalerie

The two men depicted have found their way to the two rocks furthest out in the water to watch the rising of the full moon. Their heads are silhouetted against the sky, uniting the three separate areas of shore, sea and sky. The moon is placed exactly midway between them, and the stones and clouds are arranged in a symmetrical fashion that conveys a feeling of peace and emphasizes their concentration as they contemplate the moon. Only the gentlest hint of movement is suggested by the waves. The foreground and background, the earthly and the supernatural, man and Christ – symbolized by the moon – are drawn together by the symmetry of the composition. By placing each of the figures on a separate rock – the symbol of faith – Friedrich makes it clear that they are only united by their mutual interest in infinity. Like most of the figures in Friedrich's landscapes after 1815, they are dressed in Old German costume as a sign of nationalist sentiment.

The striking gable-shaped formation of the clouds recalls the *Tetschen Altar* (pl. 6). It is an example of the analogies that Friedrich frequently drew between natural and architectural forms, in this instance illustrating his vision of nature as a church.

Nowhere is his method of using geometrical logic to express metaphysical insights more successful than in this picture.

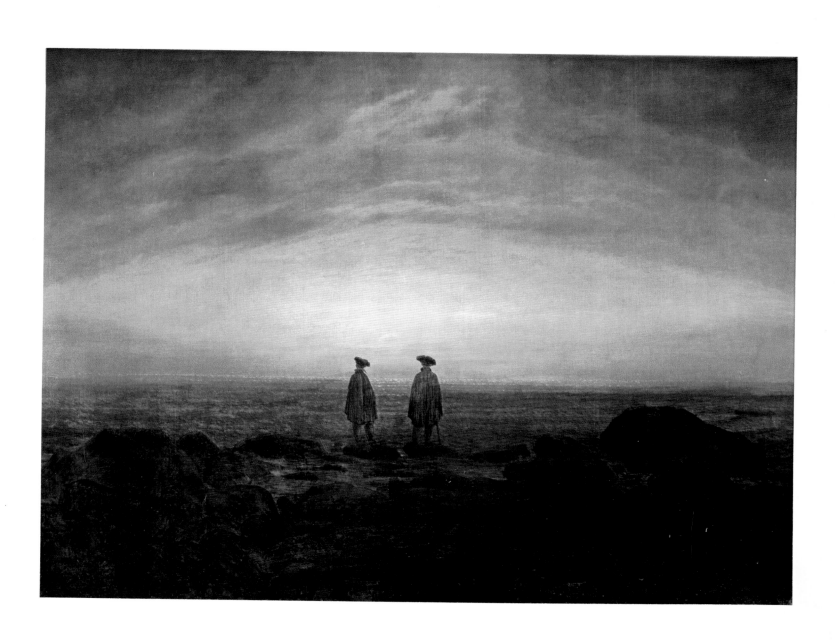

16 *Neubrandenburg (c. 1817)*

Oil on canvas, 91 x 72 cm
Kiel, Stiftung Pommern

Friedrich's grandparents on both sides came from Neubrandenburg, so that he regarded the town as his second home and frequently stopped off there when travelling between Dresden and the Baltic. Friedrich always associated home with the life to come, hence dying can be seen as a homeward journey. The two travellers in this picture are gazing towards the distant town which in this eschatological sense is the ultimate goal of their lives. In the background the sun is setting behind the hills which frame the silhouette of the town. These hills, a symbol of God, are based on a sketch Friedrich made in the countryside round Dresden in 1804, and here transposed to the Mecklenburg area. Friedrich often combined motifs from different geographical regions in his landscapes, a fact which confirms the visionary intentions of his pictures. In this case he also altered the appearance of the town itself, in that he added a Gothic spire to the principal church, the Marienkirche. At precisely this time Friedrich was occupied with plans for restoring the interior of the Marienkirche in Stralsund in the neo-Gothic style. In this picture Gothic emphasizes the transcendental character of the town as a vision of the hereafter. The dolmen, on the other hand, which in Friedrich's day was still preserved at Gützkow near Neubrandenburg, is a reminder of the pagan attitude to death. The autumnal setting implied by the birds of passage combines with the evening atmosphere to conjure up a feeling of melancholy which is checked by the magnificent light effects of the setting sun. The picture is a particularly good example of Friedrich's love of depicting light phenomena from 1814 onwards.

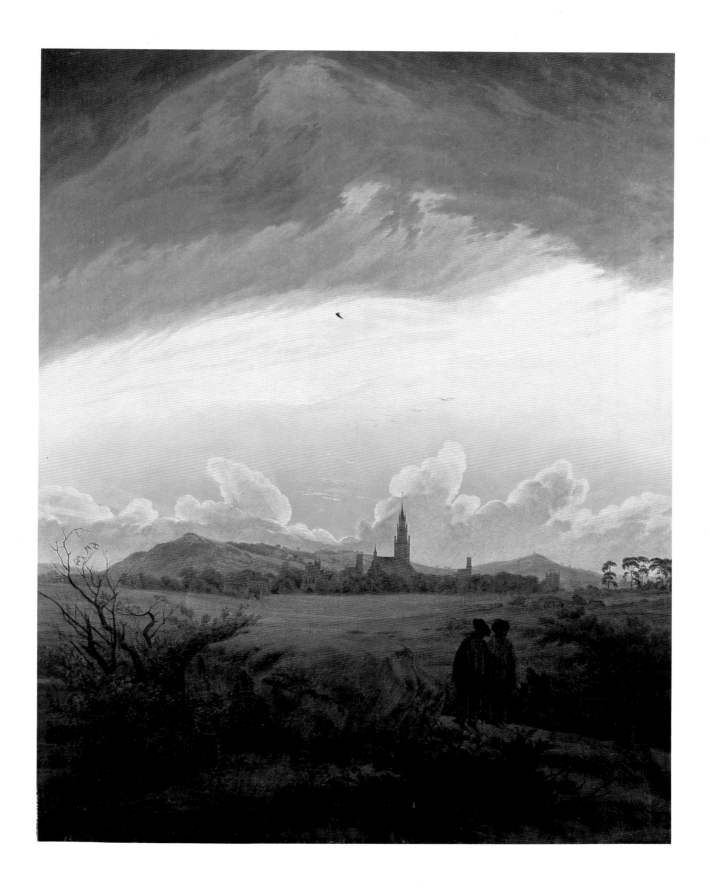

17 *Picture in Remembrance of Johann Emanuel Bremer* (1817)

Oil on canvas, 43.5 x 57 cm
Berlin, Schloss Charlottenburg

The Berlin doctor and pharmacologist Johann Emanuel Bremer died on 6 November 1816. He is chiefly remembered for his work on vaccination. Virtually nothing is known about Friedrich's connection with him. In fact his name is only mentioned once, in the letter Friedrich wrote to his brother Christian on 24 November 1808. Friedrich may simply have esteemed the doctor on account of his social involvement, but both men were natives of Pomerania.

Bremer's name is inscribed on the wrought-iron gate, from which we can deduce that the picture is a kind of painted memorial to him. Friedrich painted several pictures of this kind. The twilight atmosphere is both mysterious and gentle. The formal symmetry and the way the picture is divided into a kind of triptych by the foremost supports of the pergola gives the composition a feeling of peaceful gravity, though the undulating rhythm of the poplar trees, church spires and ships' masts in the background adds a lively, musical element. The bare foreground is separated from the rest of the scene by a wall, reminiscent of a cemetery wall. The dark, bleak space thus created lies in the shade cast by the pergola. Friedrich intended this as a symbol of the poverty of earthly existence, which gains a new, more profound dimension through the eucharistic symbol of the vines. Small pyramid-shaped conifers immediately in front of the wall and the flowers in tubs on the gateposts lead the eye back to the gently undulating shore dotted with poplar trees. The wrought-iron gate is a symbol of death, uniting foreground and background. Through its bars a faint glow of moonlight, symbolizing Christ, falls on the dark garden. The Gothic city across the water represents the dwelling place of the soul after death. The ships lying in the harbour denote, as always in Friedrich's works, the termination of life. The colour scheme is very similar to that in *The Cross on the Baltic* (pl. 14).

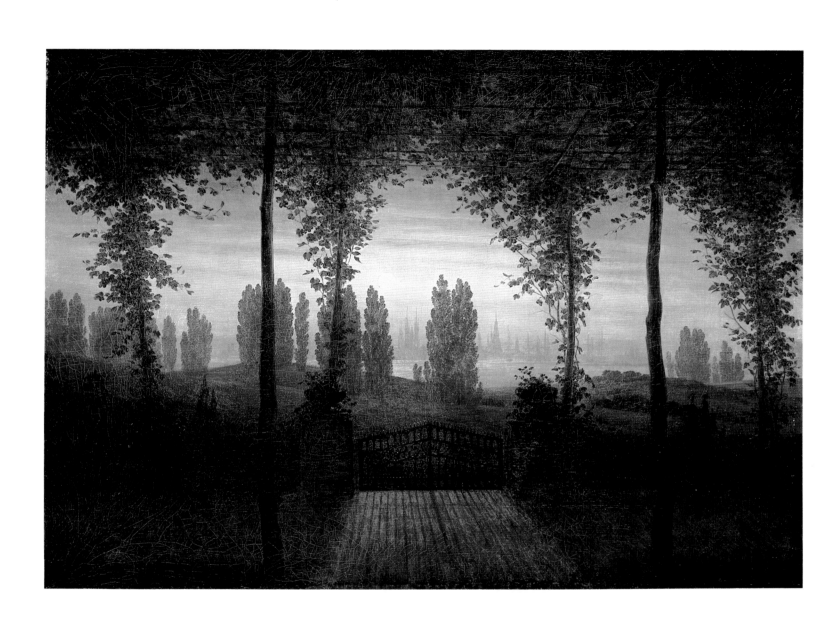

18 *Morning* (*c.* 1816–18)

Oil on canvas, 22 x 30.2 cm
Hanover, Niedersächsisches Landesmuseum

This picture belongs to a dispersed cycle of seascapes depicting the four times of day. One, *Afternoon*, is lost, and *Evening* and *Night* are in private collections in Switzerland and Germany respectively. In contrast to his earlier cycles on this theme, Friedrich is not concerned here with the various stages of life from birth to death. Instead, he traces the spiritual development from the life-affirming impulse for activity and research to the introversion that prepares one for death. This train of thought probably reflects the political disappointment following the Wars of Liberation. The flag on the stern of the boat is a reference to contemporary political problems. A couple wearing Old German costume are seated in the boat. The anchor, a symbol of Christianity, remains on the shore. The orderly row of fishing boats heading out to sea conveys a sense of imminent departure. The accompanying feeling of gaiety and confidence is echoed in the ring of birds circling in the sky above. A direct contrast to the distant sweep of the row of boats is offered by the more complicated rhythm of the stakes on which the fishermen's nets and yarn are hung out to dry. Despite the small format and the humble objects depicted, the composition achieves an effect of richness and clarity through the symmetrical and geometrical organization of similar objects both leading into the distance and parallel to the picture surface.

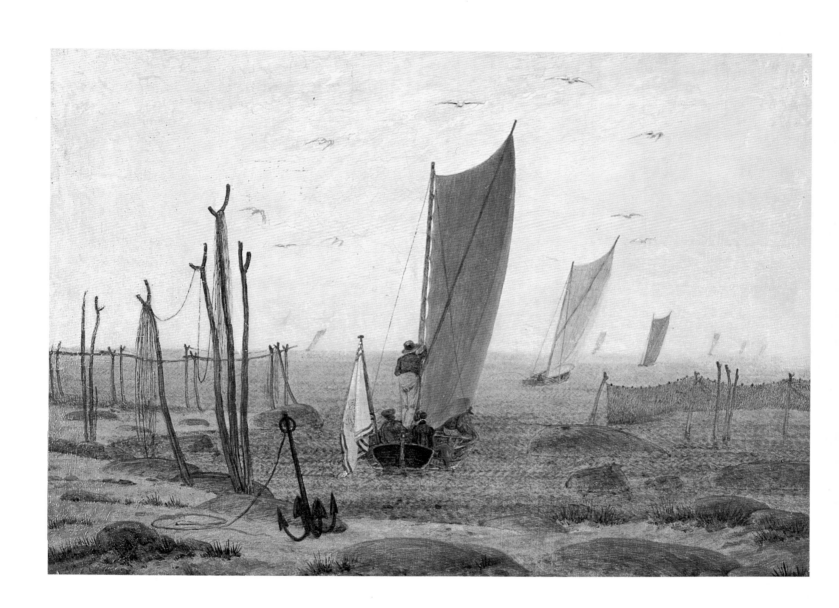

Woman by the Sea (c. 1818)

Oil on canvas, 21 x 29.5 cm
Winterthur, Stiftung Oskar Reinhart

Following a stay on the Baltic in the autumn of 1815 Friedrich painted a large number of small seascapes, of which *Woman by the Sea* is one. In the background are the chalk cliffs of Rügen with Cape Arkona. The white cliffs combine with the white sails of the ships on the horizon to suggest the bright world to come. The row of five fishing boats with dark sails is placed diagonally to the parallel formed by the cliffs and boats on the horizon. The dark fishing boats in turn run parallel to the strip of shore in the foreground of the picture which represents this world. The forward movement of the boats converges with the gaze of the woman sitting on the shore staring dreamily into space. She is seated on a stone which forms part of a row of rocks which traces a counter-diagonal to the line of boats. The woman's head coincides with the row of nets hung up to dry, forming a rhythmic flow which merges with the ripple of the waves. The composition thus has a rich yet clear structure in which symbols of this life and the life to come are interwoven and not, as in earlier versions, placed in juxtaposition to each other. The nets and fishing boats, which unlike the ships farther out have to stay within the protection of the coastline, belong to this world, the world of work. The rocks signify faith and are also the basic element of the cliffs on the horizon. In contrast to the two standing figures in the *Two Men by the Sea at Moonrise* (pl. 15), the reclining woman in this picture is more closely connected with the earth. The red of her dress is the colour of love, a motif that also occurs in *Chalk Cliffs on Rügen* (pl. 22).

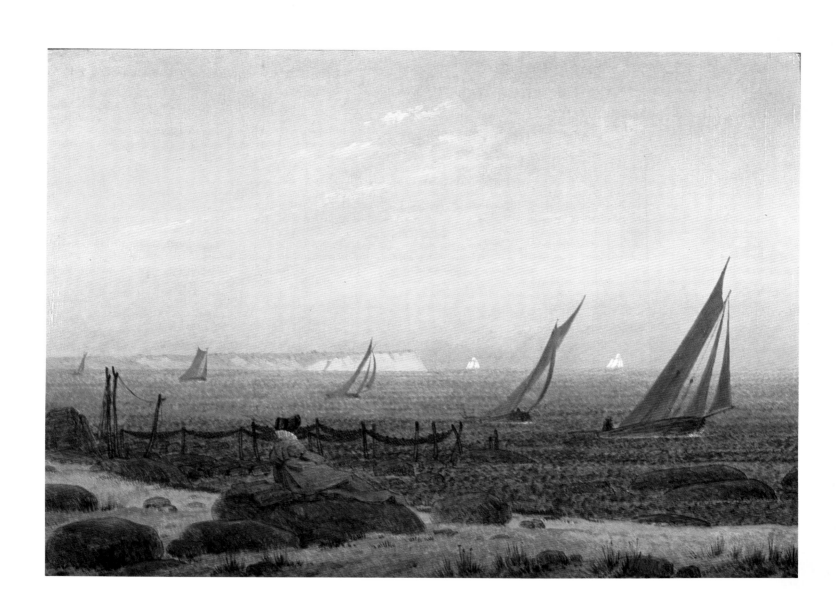

Oil on canvas, 22 x 30 cm
Essen, Museum Folkwang

Women feature more frequently in Friedrich's landscapes in the years leading up to 1820, the figures sometimes being fairly large in relation to the rest of the picture. This tendency is presumably connected with his marriage in 1818; at no time previously had he painted such a large figure as that in the *Woman in front of the Setting Sun*. At the same time she seems ethereal and silhouette-like, emphasizing her spiritual being.

In the more recent literature on Friedrich it has been assumed almost without exception that the time of day depicted here is morning. However, the misty atmosphere as well as the intellectual association of the objects make it seem far more likely that the scene in fact represents sunset rather than sunrise. The path on which the woman is standing, symbolizing life, ends abruptly. The woman is pointing at two rocks on either side of the path as a sign of her belief in eternal life. The religious meaning of the picture is also confirmed by the presence of a church in the background on the left. The woman's outstretched arms complement the arc of rays from the sun and thus unite the darkest and lightest areas of the picture – in other words, this world and the world hereafter. In this way Friedrich stresses man's inherent affiliation to God. The broad sweep of the mountain in the background is also a symbol of God. In reality the mountain is in the vicinity of Dresden, and Friedrich sketched it on 19 August 1806. The large boulders on either side of the woman look as if they originally formed part of the mountain; they resemble small mountains and suggest that faith is a divine source of strength for man. The setting sun and the coming of the night of death also assume the certainty of a new sunrise symbolizing eternal life. The formal clarity of the scene signifies man's absolute trust in God.

Few of Friedrich's pictures are conceived in such simple and yet majestic terms. This grandeur makes itself felt despite the small format and can thus be described as an inner quality of the work not necessary for representational purposes.

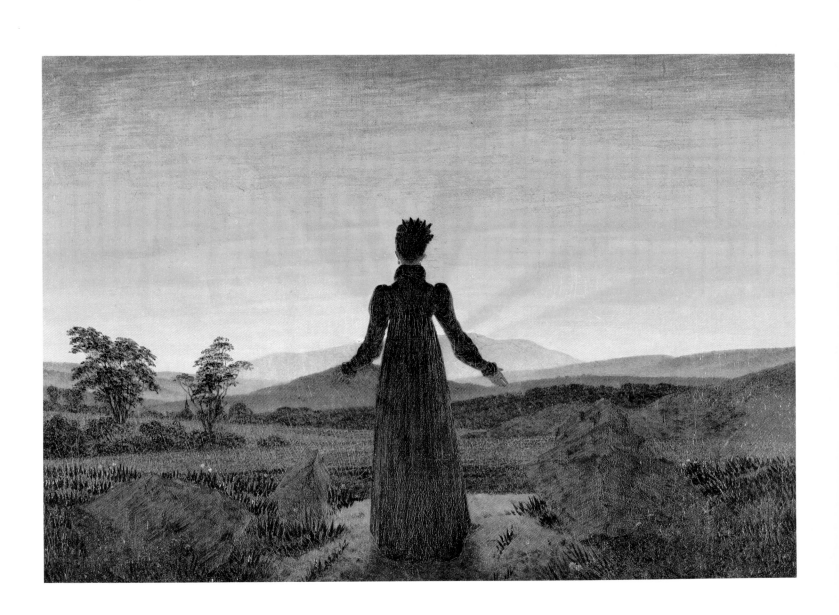

Traveller looking over the Sea of Fog (c. 1818)

Oil on canvas, 94.8 x 74.8 cm
Hamburg, Kunsthalle

According to tradition, the figure depicted here is a certain Herr von Brincken. Since the figure cannot be identified with certainty, we are led to conclude that this picture is a memorial to someone who had recently died. This is the only way we can explain the almost statuesque appearance of the man – so very different from the self-portrait in the *Mountain Landscape with Rainbow* (pl. 10). The traveller in this picture has left the fog-shrouded depths behind him and has climbed to the summit of the mountain. He symbolizes the man who has reached the ultimate goal of his life. The mountain peaks he sees jutting out of the fog are symbols of God. The slight turn of his body to the left indicates that he is facing the large, conical peak in the background, the same Rosenberg that Friedrich had already used in the *Mountain Landscape with Rainbow*. The shape of this mountain is anticipated in the man's sloping shoulders and the other rock formations are also related to the figure. He stands at the point where all the diagonals in the picture converge. His head echoes the strange protruding crag on the right. The row of sandstone rocks, taken from Saxon Switzerland (a mountainous area south of Dresden), are a formal continuation of the hem of his coat. The figure is linked to the landscape in a way similar to the *Woman in front of the Setting Sun* (pl. 20), and has a distinct air of finality about it; this landscape is even less conceivable without a figure than the preceding plate. In this way Friedrich represents the state of eternal life and the fact that man is created in the image of God. This is an extraordinarily daring thing to attempt, and it explains the forcefulness of the composition, especially the way in which the mountain ranges and the bold shapes of the individual peaks are built up.

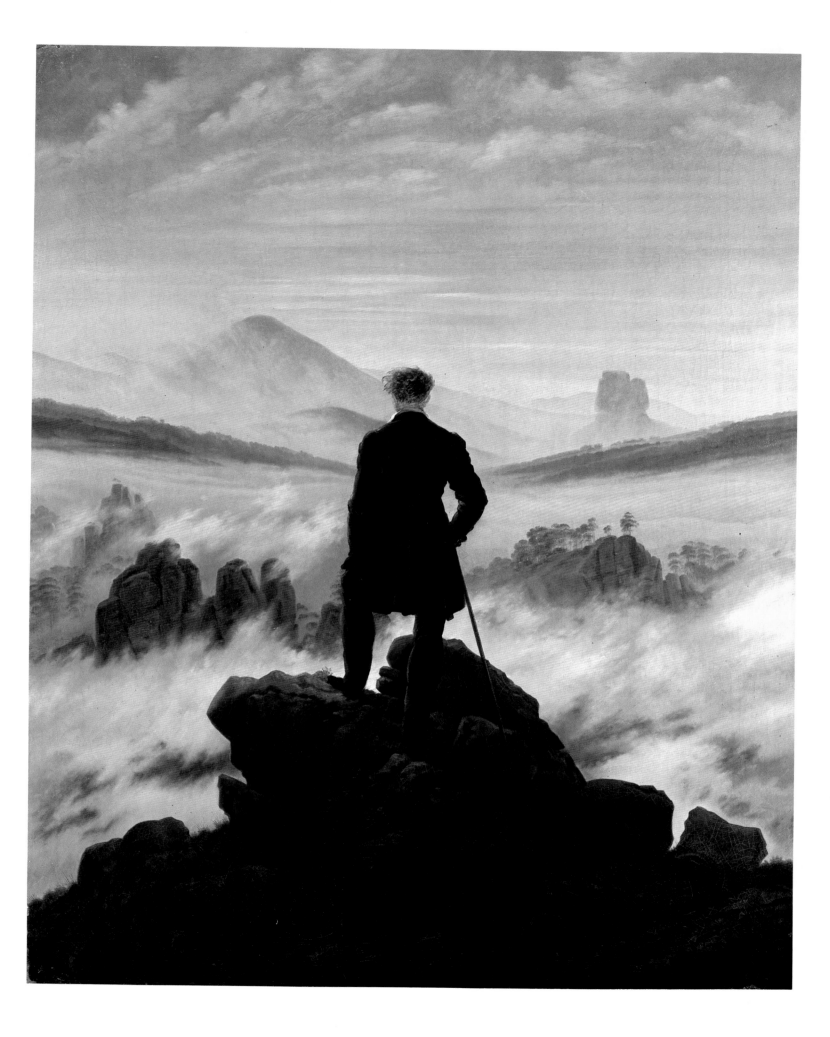

22 *Chalk Cliffs on Rügen (c. 1818)*

Oil on canvas, 90.5 x 71 cm
Winterthur, Stiftung Oskar Reinhart

The view depicted is of the chalk cliffs at Stubbenkammer on the island of Rügen, one of the island's most outstanding views. By adding the trees on either side Friedrich has created the impression of looking through a window-frame.

The picture was executed as a result of the journey he made to Greifswald in the summer of 1818, shortly after his marriage. From there he visited Rügen with his wife, his brother Christian, and his sister-in-law. The three figures in city dress strike one at first sight as tourists simply enjoying the view. The gay colours make one feel that it was intended to be a straightforward souvenir of the honeymoon. The central figure can be identified as Friedrich by means of his lean proportions and his hair style. His hat lies on the ground beside him as a sign of humility, recalling the *Mountain Landscape with Rainbow* (pl. 10). He is gazing over the precipice into the abyss of death, while holding fast to the grass which symbolizes the transience of life. The blue of his coat, the colour of faith, unites him with the sky and its reflection in the sea.

We know from remarks by his contemporaries that Friedrich developed a system of colour symbolism towards the middle of his career. The woman is presumably Friedrich's wife Caroline, and is dressed in red, the colour of love. She has found herself a more secure place to sit and is holding fast to an almost totally withered bush, the few remaining leafy branches of which frame her head. It is not quite clear whether she is pointing down into the abyss or at the flowers growing along the edge of the cliff, emphasizing the precariousness of life in this world. At any rate, her gesture indicates that she is communicating with the others, whereas Friedrich himself is completely absorbed in the view below. The third figure illustrates yet another attitude, for he is standing with great daring, arms crossed, on the branches of a small bush growing on the very edge of the cliff. He is leaning against a tree-stump which signifies death; he gazes out over the abyss to the distant sea, where two boats can just be seen, symbolizing the soul seeking eternal life. He is dressed in green, albeit broken with grey, which is the colour of hope. Thus, each of the three figures embodies one of the Christian virtues. The man standing on the right is presumably Friedrich's brother, Christian.

It is characteristic of Friedrich that he should record his attitude to death in a painting so soon after his marriage and the beginning of a new period of his life. In this picture he depicts the threat to life posed by death with an unprecedented explicitness, though at the same time in an unusually gay mood.

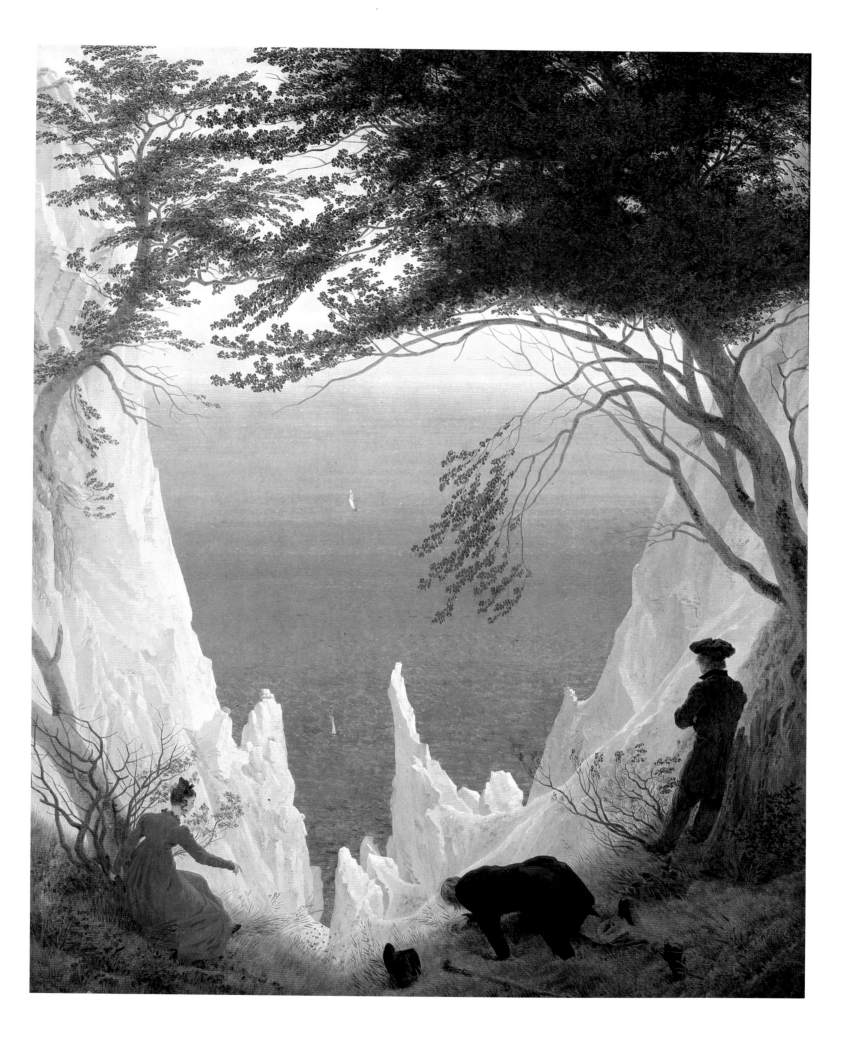

23 *Swans in the Rushes* (*c*. 1820)

Oil on canvas, 35.5×44 cm
Frankfurt-on-Main, Freies Deutsches Hochstift

After visiting Friedrich's studio on 19 April 1820, the writer Karl Förster reported the artist standing in front of this picture and saying: 'The divine is everywhere, even in a grain of sand. Here I depicted it for once in the rushes.' When the poet La Motte Fouqué saw a similar painting two years later in Friedrich's studio, he described it in a sonnet, and coined the apt metaphor of the 'daringly sinuous cathedrals' of rushes. For the bending and crossing of the rushes does indeed create a pattern reminiscent of Gothic architecture. The lack of a definite foreground and the unreal angle of vision chosen imply that the thicket is to be interpreted as a symbol of the hereafter. The swans, because of their characteristic of singing most beautifully of all just before they die, symbolize the joyful expectation of death as the path to eternal life. Similarly, the evening star, being one and the same as the morning star, indicates the association between death and resurrection.

For a long time the picture was attributed to Carl Gustav Carus, and it has only recently been accepted as the work of Friedrich, who later depicted swans in the rushes on several occasions.

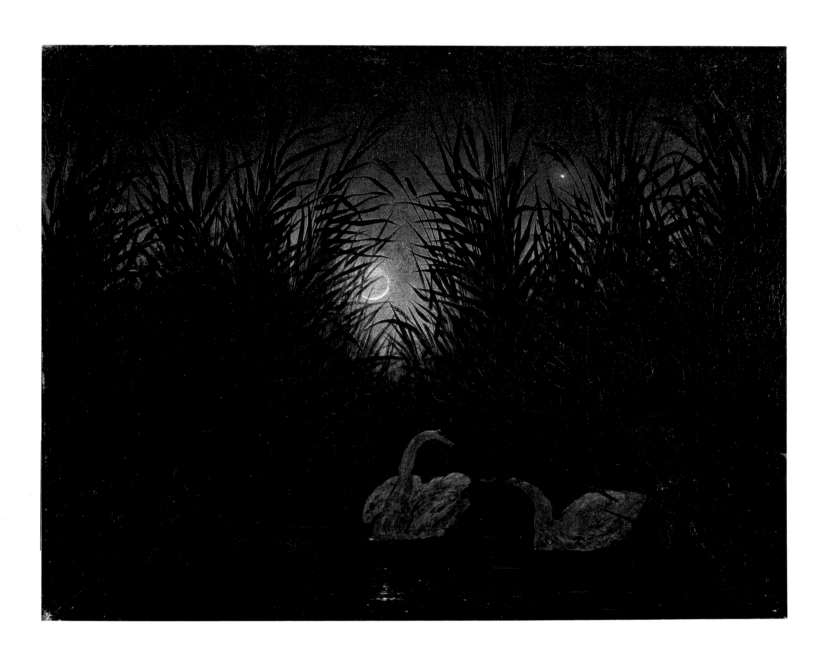

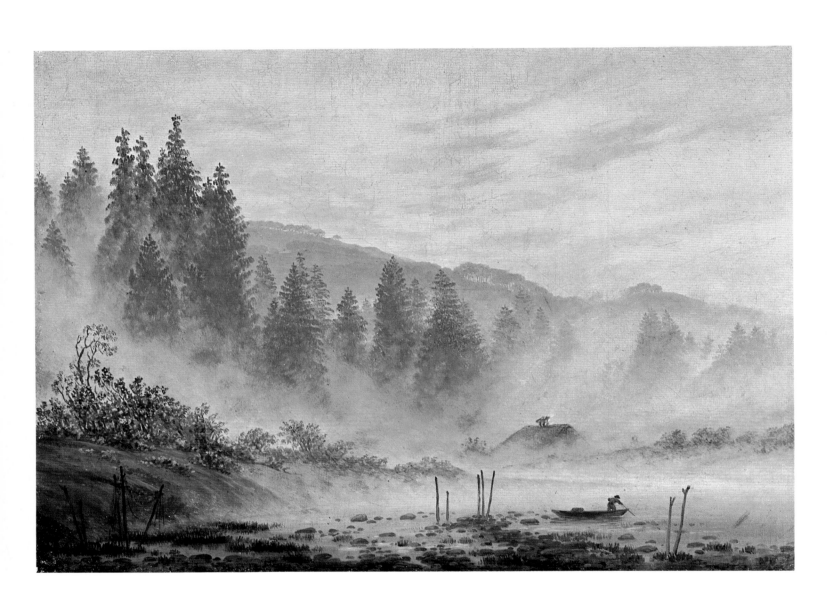

Pl. 24

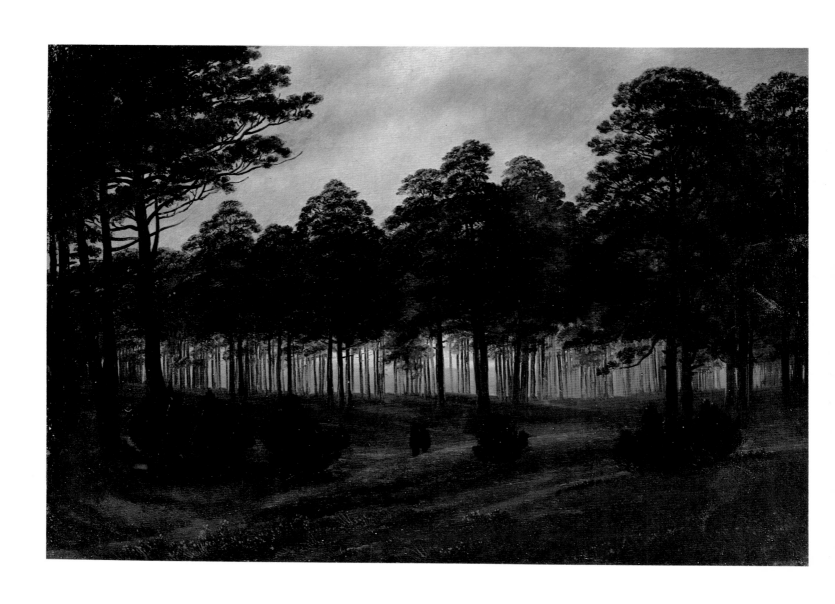

Pl. 25

24 *Morning* (*c.* 1820)

Oil on canvas, 22 x 30.5 cm
Hanover, Niedersächsisches Landesmuseum

25 *Evening* (*c.* 1820)

Oil on canvas, 22.3 x 31 cm
Hanover, Niedersächsisches Landesmuseum See pp. 116, 117

Friedrich painted this pair of pictures for the art collector Dr Wilhelm Körte of Halberstadt. As on other occasions, Friedrich has reduced the cycle of the four times of day to the contrast between morning and evening. *Morning* depicts the shore of a lake with a fisherman in a small boat. To the left nets can be seen hung on poles to dry, implying the daily toil involved in earning a living. The house represents the small area of security that man succeeds in creating for himself in this world, but it is almost enveloped in morning mist which has risen from the lake and blocks the view into the distance. The mist also signifies the narrowness of thinking only about the material things of life. In the middle distance a row of fir-trees tower upwards like the Christian way of life they symbolize. They are held in from behind by a range of mountains. It would seem that for once Friedrich painted a scene taken directly from nature with virtually no important changes. The sloping contour of the mountains in the background, the receding curve of the shore, and the casually distributed poles and stones strewn haphazardly about the lake all strike the observer as completely spontaneous and do not invite one to reflect on any deeper significance the composition might have.

Evening, on the other hand, is a carefully thought-out composition. The trunks of the pine-trees are arranged in a rhythmic sequence like the uprights of a fence, while the young pines dotted around the foreground create a slightly slower rhythm. The two travellers in the centre are integrated into this rhythm and almost seem to take the place of a couple of small pine-trees.

In Friedrich's works the pine-tree plays the same role as the other evergreen he often uses, namely the fir. Evergreens symbolize the Christian hope of eternal life. The fact that the two men here are almost interchangeable with the young pine-trees makes this symbolic relationship quite explicit. The wood behind the travellers is in no sense gloomy or threatening. Instead, the glow of the evening sky – denoting the promise of life after death – can be seen through the maze of trunks. The path is the path of life, cutting diagonally across the earthly sphere towards the horizon and the sky beyond. This upward movement is echoed in the diagonal of the branches of the trees on the left. In *Morning* the emphasis of the composition is downward.

The flowers in the foreground remind us of the blossoming and decay of life. In contrast to the fisherman in *Morning*, the two men here are people with no definite abode for whom the here-and-now is nothing more than a period of transition and whose chief activity, apart from moving towards their goal, lies in watching and waiting. Friedrich is not alone in giving the traveller this meaning, for it is a motif that appears in the works of many other painters and poets of the Romantic period.

26 *Midday* (1821)

Oil on canvas, 22 x 30 cm
Hanover, Niedersächsisches Landesmuseum

27 *Afternoon* (1821)

Oil on canvas, 22 x 31 cm
Hanover, Niedersächsisches Landesmuseum

See pp. 120, 121

To judge from a letter written by Friedrich to Dr Wilhelm Körte in Halberstadt on 21 July 1821, these two paintings were executed to complete the cycle begun with *Morning* and *Evening*. The original idea of simply contrasting morning and evening would have been upset by the inclusion of a representation of night which normally belongs to the complete cycles. *Midday* and *Afternoon* serve to link *Morning* and *Evening* both in mood and subject, and are intended as variations on a pictorial theme, rather than as vehicles for contrast. *Midday* shows a wide path sweeping back from the foreground to the extreme left-hand edge of the canvas from where it turns sharply inwards and leads away into the distance. The eye is led in a wide curve past the little clump of pine-trees. A woman is proceeding along the path, which is the path of life, while the shepherd on the right leans on his staff and watches his sheep. The contrast between the active and the passive outlooks on life already depicted separately in *Morning* and *Evening* are now fused, though simultaneously weakened in effect. The repetition of the clump of pine-trees on the horizon is an allusion to transcendence. The contour of the hills in the background sinks somewhat towards the right but not so dramatically as in *Morning*. The motif of the flowers that first appeared in *Evening* is taken up in both *Midday* and *Afternoon*, and with greater emphasis and a more defined rhythm. The atmosphere is misty. It is striking that even in the depiction of *Midday* Friedrich avoids the effects of full sunlight. The morning mists have not yet vanished entirely. The sun only asserts itself in *Evening*.

In *Afternoon* Friedrich introduces a farmer in a horse-drawn cart moving from right to left across the picture, in other words against our normal way of reading a picture. The path in the foreground also leads away in the same direction, suggesting hesitation, hindrances and the difficulty of making any real progress. The thought conveyed by the flowers along the edge of the path, namely the short blossoming of life, is emphasized by the ploughed field next to the ripe cornfield. The corn, almost ready for harvesting, signifies maturity and hence the nearness of death. The bare ploughed field next to it symbolizes death, though at the same time it is the prerequisite for new life. The three groups of pine-trees in the middle distance seem to prepare the eye for the closed rows of trees in *Evening*.

Like *Morning*, both *Midday* and *Afternoon* strike the viewer as being directly experienced scenes with very little alteration by the artist. In the case of *Afternoon*, this can be proved by a nature study in the National Gallery in Oslo, on which the painting is clearly based.

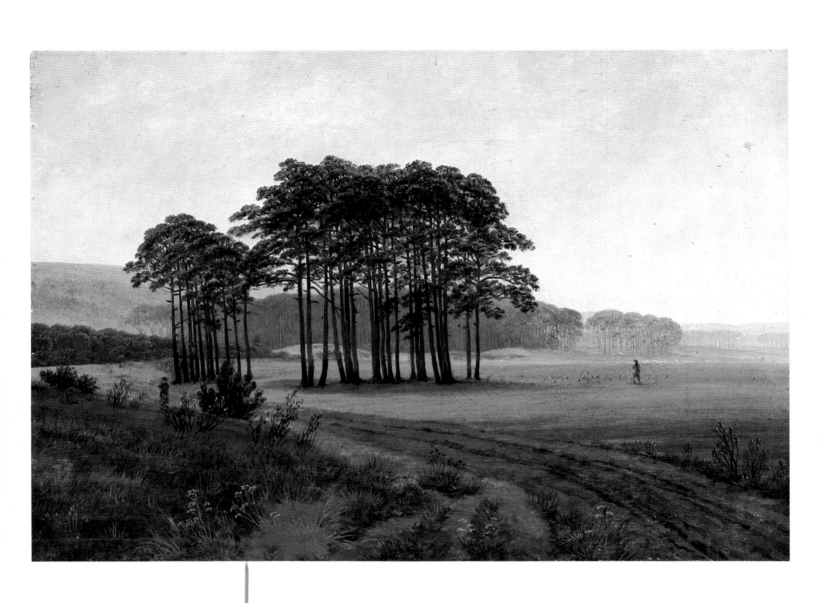

Pl. 26

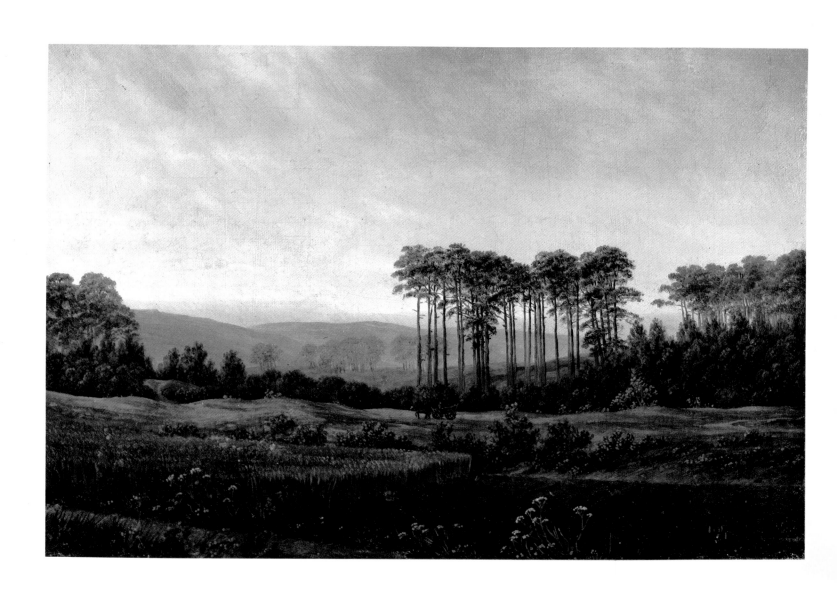

Pl. 27

28 *Ship on the River Elbe in the early Morning Mist (c. 1821)*

Oil on canvas, 22.5 x 30.8 cm
Cologne, Wallraf-Richartz-Museum

In the early 1820s Friedrich painted a number of misty landscapes. Not all of them met with the approval of his critics. When one of these paintings, depicting morning mist on the River Elbe with a couple of fishing boats and the vineyards on the opposite shore just visible in the distance, was exhibited at the Dresden Academy in 1822, one critic wrote: 'A thick white haze hangs so heavily over the whole scene that the signature of the famous artist provides the sole ray of sunlight illuminating it. Undeniably, nature does sometimes look like this, but then it is never picturesque. Only a quarter of an hour later, when the mist had dispersed, would the scene have made a good picture.'

The *Ship on the River Elbe in the early Morning Mist* belongs to this group of misty landscapes. The freshness of early morning is suggested by the bright, luminous colours used. Yet the seemingly optimistic mood intimated by the activity of the fishermen is once again associated with death. The unusually prominent bank of grass and flowers in the foreground, almost suggesting that the spectator is lying on the ground, is an allusion to the rapid passing of life. The edge of this strip of meadow slopes upward towards the chain of hills behind, still mysteriously enveloped in mist, like some metaphysical shore of the hereafter.

The ship is the ship of life moving downstream towards the mouth of the Elbe, the river representing death; it is moving from left to right across the picture, which also corresponds to the way the various lines of the bank and hills gradually converge. The mast is just to the left of centre, suggesting the continuation of this movement forward for quite a while to come. The motif of the lifting mist is also concerned with time, for it makes us think further than the actual moment depicted. In this sense the observations of the critic quoted above are to the point.

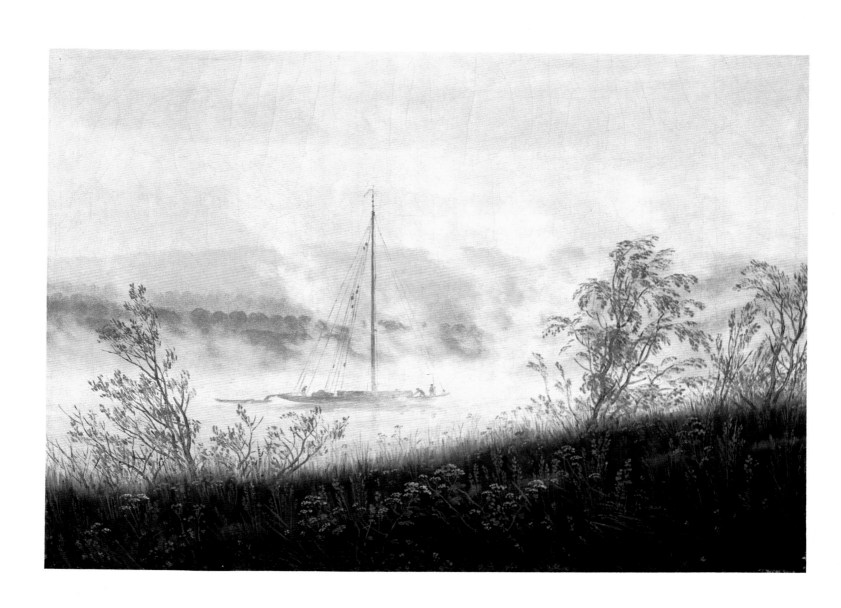

29 *Drifting Clouds* (1821)

Oil on canvas, 18.3 x 24.5 cm
Hamburg, Kunsthalle

This picture is one of the smallest Friedrich ever painted. With few exceptions his paintings can be classified according to the particular formats he tended to favour in the different periods of his life. The smallest format he ever used, *c.* 18 x 24 cm, occurs only in the years around 1821. Friedrich himself refers to the painting as being complete in a letter dated 21 July 1821. It is based on a study from nature showing a view from the Brocken, which he made on 29 June 1811.

Like the *Morning in the Riesengebirge* the picture consists of a narrow foreground strip showing the top of a mountain. Behind it the land slopes away steeply into the valley, which is out of sight. The eye travels straight from the mountain top in the foreground to the summit of the mountain ranges in the distance, which are a symbol of paradise. The traveller has to climb all the way down through the valley of death before he can reach this paradise which he can just glimpse vaguely through the clouds. The rocks in the foreground symbolize the Christian faith. The pond contains the reflection of the sky upon earth.

The experience of the traveller standing on the top of a mountain gazing at the panorama spread out before him is made into a metaphor of a religious experience. Whereas in *Morning in the Riesengebirge* (pl. 11) the metaphor is established explicitly through the symbolism of the cross and the gestures of the figures, in *Drifting Clouds* it is revealed as an ordinary manifestation of nature.

30 *Fields near Greifswald* (*c.* 1820–22)

Oil on canvas, 35×48.9 cm
Hamburg, Kunsthalle

The town is seen from the west, from the fields near the River Ryck. From right to left we can identify two churches – the Jacobikirche and the Nicolaikirche – the turret of the town-hall and, in front of it, the main gate of the town, the Vettentor, and St. Marien. In contrast to his idealized view of Neubrandenburg (pl. 16) in 1817, Friedrich has depicted his native town without any alterations: Baroque additions to Gothic buildings are faithfully recorded. The picture resembles a topographical view that has captured the magic of a sunny day: the leaping horses, the flocks of geese, and the little pond in which the sky is reflected all contribute to the idyllic atmosphere. Everything seems extremely realistic except for the dark area in the immediate foreground which is cut off from the remainder of the scene by a low bank and a row of bushes. The presence of this shadowy area seems to contradict the naturalism of the background, so we must assume that it is to be interpreted symbolically as representing this world in sharp contrast to the background which signifies paradise. The striking motif of the carefree leaping horse emphasizes this paradisical atmosphere still more. If we were to imagine ourselves approaching the town on foot, we would find ourselves emerging from the dark, rough area over the last bank and into the sunny meadow beyond.

In *Fields near Greifswald* Friedrich has taken and altered – in a way that is significant for the 1820s – a view of *Greifswald by Moonlight* of 1817 (now in Oslo). In the earlier work the same silhouette of the town rising beyond a stretch of water is depicted with the same atmosphere and in the same spatial setting as the *Picture in Remembrance of Johann Emanuel Bremer* (pl. 17). Whereas in the latter work the distant town can easily be seen as a symbol of the life to come, in this picture the symbolism of death is concealed, as in the *Chalk Cliffs on Rügen* (pl. 22). It is essential to know that Greifswald is Friedrich's birthplace if we are to understand how he transforms his links with the town into a metaphor of the longing for paradise.

Oil on canvas, 44 x 32 cm
Berlin (West), Nationalgalerie

The figure seen from behind is Friedrich's wife, Caroline. The room is Friedrich's studio in the house beside the River Elbe where he had lived since 1820. It has been established from old views of the town that there really was a row of poplars along the bank of the Elbe opposite Friedrich's house, though in his painting they appear closer than they would have been in reality. If desired, the picture can be interpreted as a genre scene, as the poet La Motte Fouqué did in the sonnet he wrote about it in 1822, full of gallant compliments to Caroline Friedrich; however, it can also be linked with elements in Friedrich's earlier works which would suggest a different interpretation. The dark interior stands for the narrowness of the terrestrial world into which light only enters through the window, representing the opening to the supernatural world. The woman is gazing out over the river to the opposite bank which is a symbol of the life to come. The river, though not actually visible, signifies death. It is indicated by the mast of a ship moored on the near-side bank of the river which is visible through the open window. A similar mast can be seen over the woman's shoulder, clearly belonging to another ship moored on the other side of the river. The relation between these two masts creates a suggestion of movement across the river. The concept from antiquity of the River Styx across which Charon ferried the dead, is here reinterpreted in Christian terms. Because of the way they grow straight upwards poplars are an allusion to the Christian longing for death. Similarly, the thin cross shape formed by the glazing bars of the window is to be understood symbolically; the vertical would, if extended downwards, meet the mast of the ship in the background.

The composition is symmetrical, though Friedrich manages to avoid any feeling of rigidity. In this way it differs from the earlier *Woman in front of the Setting Sun* (pl. 20). The slight movement and divergences from the symmetrical contribute decisively to the impression that the underlying theological thought of the picture is conveyed by the warmth of emotion. Friedrich suggests that the problem of death can be overcome by seeing it simply as the difference between two ways of life. The gentle sway of the ships' masts caused by the movement of the water is shared by the figure and even the architecture. The room appears to sink slightly to the right, whereas the woman leans a little to the left. These details are not merely an aesthetic game; they imply that nothing in this world is totally constant. The fact that Friedrich uses his own studio to express this thought is an indication of his familiarity and continual preoccupation with death.

32　*Village Landscape in the Morning Light* (1822)

Oil on canvas, 55 x 71 cm
Berlin (West), Nationalgalerie

33　*Moonrise over the Sea* (1822)

Oil on canvas, 55 x 71 cm
Berlin (West), Nationalgalerie

These two pictures were painted as a pair for the Consul Joachim Heinrich Wilhelm Wagener, whose collection forms the basis of the Berlin Nationalgalerie. Both works were completed towards the end of 1822. The *Village Landscape* is often erroneously referred to as the *Lonely Tree*, a description which totally overlooks the underlying idea of the picture. The title *Harz Landscape* is equally wrong since the chain of mountains in the background is based on a sketch Friedrich made in the Riesengebirge on 6 July 1810.

The title *Village Landscape in the Morning Light*, which first appears in a catalogue of 1865, seems appropriate in view of the fact that these two pictures deal with the theme of the times of day – as in *Morning* and *Evening* – only in abbreviated form. The morning landscape depicts an inhabited and cultivated plain enclosed by a range of mountains. The blue mountains are linked tonally with the sky and contrast with the many varied shades of green on the plain. In other landscapes the foreground, signifying the here-and-now, is usually limited to a narrow strip of land against which the other-worldly background is juxtaposed. In this picture, however, space develops consistently and is only halted by the distant mountains. This conception of space calls to mind the *Landscape with a Rainbow* (pl. 9), formerly in Weimar, in which the motif of the shepherd resting under an oak-tree also occurs. The *Village Landscape* is a depiction of earthly life with a few scattered references to the hereafter. The sky is reflected in the ponds, and the distant churches which echo the blue tones of the mountains beyond also establish a link between the earthly and the supernatural.

The oak-tree in the foreground meets the contour of the mountains in the dip between two peaks at precisely the point on its trunk where it is beginning to wither. The trees in the middle distance likewise have some withered branches. The tree-stump and the ruined castle are further symbols of the transience of life, but they are embedded in a setting in which various signs of life are evident. Smoke can be seen coming out of a couple of chimneys near the ruin, and the motif is repeated at intervals as far back as the distant mountains.

The composition is clearly dominated by the large oak-tree in the foreground. Even though the mountain range complements the form of the tree, the focal point of the picture remains chiefly in the foreground.

The *Moonrise over the Sea* is in every respect the antithesis of the *Village Landscape*. The people depicted are town-dwellers. They are watching the natural spectacle of

the moon rising very much as strangers to the environment. Their silhouettes project against the sky. The two women are seated close to one another as an indication of their fear, though their erectly-held heads stand out clearly against the moonlight. The man, on the other hand, is dressed in Old German costume and sits slightly stooped, his hat only just touching the ray of light cast by the moon. The home-coming ships are heading straight towards the seated figures and symbolize the approaching end of life. On the foremost ship the sail has already been partly lowered. The most important motif in the picture, on which the gaze of the three figures is riveted, is the rising moon, a symbol of Christ. The huge rocks on the shore denote the Christian faith. The largest, on which the figures are seated, curves downwards to form a hemisphere exactly complementing that formed by the glow of the moonlight. This creates a striking symmetrical motif with the horizon of the sea acting as a kind of axis. In this way the foreground and background, and the light and dark areas are linked as in the *Woman in front of the Setting Sun* (pl. 20).

While in the *Village Landscape* the observer's eye is invited to wander round the picture surface and take in the abundance of details one after the other, the limited number of objects in this picture can all be taken in at one glance. They cluster together like a magical symbol which the spectator is invited to investigate. The picture is dominated by a curious shade of purplish-violet. We know from a remark by Ludwig Richter that Friedrich regarded violet as the colour of mourning. This feeling of mourning is, however, counteracted by the luminous silver light. Preliminary stages of this composition can be found in *The Cross on the Baltic* (pl. 14) and *Two Men by the Sea at Moonrise* (pl. 15).

Pl. 32

Pl. 33

34 *Flat Country Landscape* (*c.* 1823)

Oil on canvas, 27.4 x 41.1 cm
Berlin, Schloss Charlottenburg

35 *Landscape with Windmills* (*c.* 1823)

Oil on canvas, 27.7 x 41.1 cm
Berlin, Schloss Charlottenburg

Friedrich painted these companion pieces at about the same time as the pair of landscapes (pl. 32, 33) just discussed. In this second pair an allegory of the terrestrial world is contrasted with an impression of the supernatural world, though Friedrich uses almost identical moods of nature to express the two concepts. In 1823 he entered the works in the Dresden Academy exhibition where they appeared in the catalogue under the titles by which we now know them. The critics were all struck by the naturalism of these two paintings – an unusual feature in Friedrich's *oeuvre* – and were divided in their opinion about the paintings' prosaic quality. Indeed, there are no other known works by Friedrich in which he seems so far removed from his predilection for allegory.

The *Flat Country Landscape* depicts a terrestrial idyll. It is summer and, to judge from the cloud formations and the way the light is falling, already late afternoon. The countryside is fertile. The village, with its thatched cottages like those Friedrich had so often sketched on Rügen, signifies security. The two women working in the fields and the half-built house with the bare rafters denote human activity. The golden field of corn visible behind the windmill on the right alludes to maturity, the approaching harvest and death. The windmill which grinds the harvested grain also suggests a process leading beyond the harvest, or death, and it is this motif above all which links this picture with its companion.

The *Landscape with Windmills* is based on a study from nature made on Rügen in 1801 or 1802. The painting differs from the sketch in a number of significant respects which indicate that Friedrich added the figures not only to enrich the composition, but in order to give it a specific symbolic meaning. The boat with the fisherman, a motif we find in a study dating from 1815, is placed directly below the church on the horizon, thus linking the foreground and the background in a symbolic sense.

At first sight the motif of the women busy with their washing and bleaching would seem to be a genre-like feature, but bearing in mind that in the other works the river separating the observer from the opposite shore is always a symbol of death, the washing and bleaching of linen in the sunlight can be taken here as a symbol of the purification of the soul in the life to come. On the right there is a small landing place where a boat is moored. It has a wooden gate which is half open and leads the eye back to the small ruined building on the small hill behind, beside which there is a

well with a pyramid-shaped roof reminiscent of a funeral monument. Next to it grows a birch tree which according to Friedrich is the tree of springtime and always signifies resurrection. Significantly, this is the only one of the trees in the original drawing that he altered in the painting.

All sense of time has been suppressed. It is impossible to establish the precise time of year, let alone day. The mood is gay and conceals the allegorical content, but the artist's message is clear, namely that death is a release; that it is a simple thing – merely the transition from one life to another.

The *Flat Country Landscape* can be described as a scene from nature with concealed allusions to death and paradise. Its companion piece, the *Landscape with Windmills* is paradise rendered in the language of nature. Friedrich uses his native countryside to describe how for him this world and the world to come are fused within nature.

It is remarkable that he should have painted this pair of naturalistic landscapes almost simultaneously with the *Village Landscape in the Morning Light* and *Moonrise over the Sea*, for in this other pair the contrast between the earthly and the supernatural is stated so emphatically that it was not realized for a long time that the two pictures belonged together at all. From this we can see that Friedrich adopted a great variety of approaches to the basic theme of his painting at this time and how supremely he employed the means at his disposal.

Pl. 34

Pl. 35

36 *Ravine* (*c.* 1823)

Oil on canvas, 91 x 72 cm
Vienna, Kunsthistorisches Museum

The *Ravine* was shown along with the *Flat Country Landscape* (pl. 34) and the *Landscape with Windmills* (pl. 35) at the 1823 exhibition at the Dresden Academy. The rock formation in the background derives from the Elbsandsteingebirge. Friedrich has made these crags seem higher than they really are and has increased the illusion of towering height still more by placing a deep ravine directly below the highest pinnacle. The choice of an upright format further emphasizes the verticality. The idea of nature's architecture, suggested by nearly all the rock formations in the Elbsandsteingebirge, is interpreted with a Gothic feeling for form. The rocks are envisaged as a cathedral built by God. The motif of human aspiration is indicated by the tree-stump in the middle foreground which is an allusion to death. Behind it can be seen two uprooted pine-trees that lie like bridges across the ravine of death, signifying how this life sinks to the depths before rising again to the heights of eternal life. This thought is illustrated by the steep rock-face which rises sharply on the right and clearly extends way beyond the edge of the picture. The Christian, symbolized by the pine-tree, enters the other world via death. The diagonal in the foreground that points downwards is balanced by the many diagonals and verticals that point upwards, including the tree-trunks and the ribbons of mist. This upward movement from left to right across the picture surface corresponds to a similar movement into depth, from the dark brown of the ravine in the foreground back to the bright blue sky just visible through the clouds.

37 *Arctic Shipwreck* (*c*. 1823–24)

Oil on canvas, 96.7 x 126.9 cm
Hamburg, Kunsthalle

In 1822 Friedrich had painted a polar landscape – now lost – described in a contemporary account as a 'Wrecked ship off the coast of Greenland under a May moon'. On the side of the ship was the inscription 'Hope', a name frequently given to ships in the eighteenth and nineteenth centuries. From very early on this lost landscape and the *Arctic Shipwreck* in Hamburg were confused with each other in the literature on Friedrich, the *Arctic Shipwreck* being given the title *Wreck of the Hope*. The theme was presumably suggested by contemporary newspaper accounts and depictions of polar expeditions. For instance, in 1822 a panorama by Johann Carl Enslen entitled *Winter Camp of the North Pole Expedition* was exhibited in Dresden, and in 1823 a painting entitled *North Pole Expedition* was exhibited in Prague by the stage painter Sacchetti. So in adopting this theme, Friedrich was following suit in depicting a current event, and he succeeded in exploiting its metaphysical aspect, which was frankly beyond the grasp of most of his contemporaries. On seeing the painting in Berlin in 1826, Friedrich Wilhelm III of Prussia is reported by Johann Gottfried Schadow to have remarked that 'the ice in the north must look very different to that'. Friedrich did not paint his view of the polar world merely for sensational purposes, however. He chose the unusual motif largely as a symbol of the inaccessible majesty of God. The eternal ice signifies God's eternal being while the wrecked ship denotes man's impotence and mortal existence, and the futility of trying to approach God by rational means.

The picture has frequently been interpreted, and without any justification, as representing the horror of the polar regions. What the composition and colour scheme in fact seem to express is the solemnity and sublime quality of the scene. The way the ice-floes are piled up against one another in the foreground reminds one of the steps leading up to a temple, which the imagination must climb in order to reach the flat expanse from which the icebergs soar up towards the clear blue sky.

Friedrich could not sell the picture during his lifetime. After his death his friend Johan Christian Clausen Dahl bought it from his estate and it remained in the Dahl family until acquired by the Hamburg Kunsthalle in 1905.

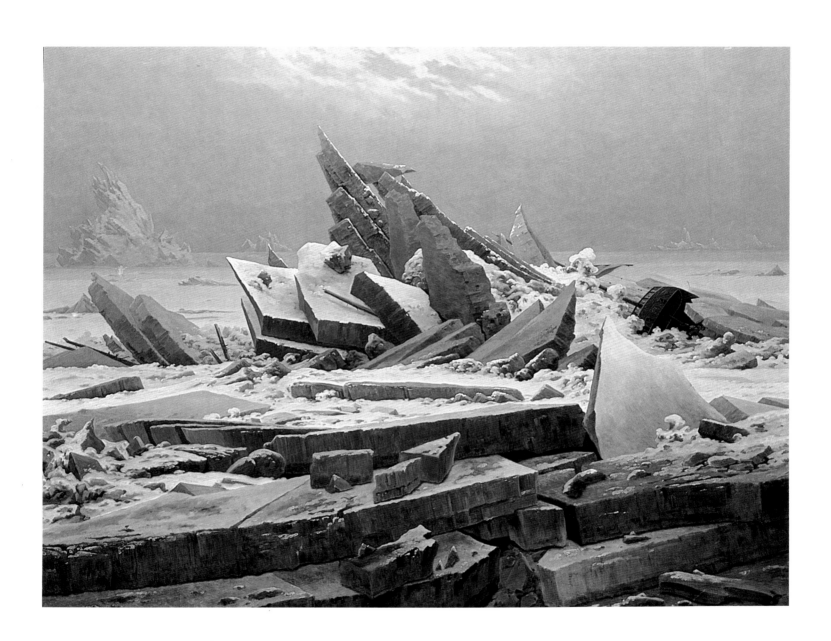

38 *Evening* (1824)

Oil on cardboard, 20 x 27.5 cm
Mannheim, Kunsthalle

In September and October 1824 Friedrich is known to have executed three oil studies of the evening sky. They were not intended as highly finished pictures as can be seen from the inscription 'Evening October 1824' scratched roughly along the lower edge of the painting with the top of the brush. Apart from three other studies of ice-floes painted on remnants of canvas, this is the artist's only known study in oils. They all show the influence of the Norwegian artist Johan Christian Clausen Dahl with whom he had been friends since 1818, and more especially since Dahl moved in to live in the same house as the Friedrich family in 1823. Dahl painted many cloud studies characterized by their daring brush-strokes which made the air seem tangible. In Friedrich's works, on the other hand, the sky is like a mysterious vacuum in which the clouds are suspended like the characters of a strange script. Their ethereal substance is highlighted by the glow of the setting sun. The feathery cloud configurations in the upper right-hand corner must have struck Friedrich as extremely suggestive, for he repeated them in a second study. In these rapidly painted sketches the sky assumes a divine quality when compared with Dahl's cloud studies and those of his contemporaries who portrayed meteorological phenomena in a more scientific manner. For Friedrich the sky possessed a religious significance and it was for this reason that he declined Goethe's commission to paint scientifically accurate studies from nature of specific cloud formations. In her memoirs the writer Helmina von Chézy records a remark by Friedrich's wife, Caroline: 'On the day he is painting air he may not be spoken to!'

39 *The Watzmann* (1824–25)

Oil on canvas, 133 x 170 cm
Berlin (West), Nationalgalerie

In *The Watzmann*, as in the *Arctic Shipwreck* (pl. 37), Friedrich depicted a region that he himself had never seen. For the mountain peak he used a watercolour by his highly-esteemed pupil August Heinrich, who died in 1822. This watercolour eventually passed from Friedrich's estate into the possession of Christian Dahl, from where it entered the collection of the National Gallery in Oslo. Like the *Arctic Shipwreck*, the eternal snow and ice of the Watzmann's glaciers is an allusion to God's majesty and inaccessibility. The large format, which Friedrich used on only a few occasions, is a further indication of the sublime intentions of the painting.

In this picture the observer's eye is drawn to and along the narrow path in the centre, while on either side the terrain descends steeply into a ravine. The rocky terrain slopes away to the right, the downward movement being emphasized by two uprooted pine-trees pointing down into the ravine. They illustrate the power of death, and are counterbalanced by the towering rocks rising on the left. The largest of these was sketched by Friedrich in the Harz Mountains in 1811, and the cavernous opening in it is presumably meant to signify a sepulchre. The pines and fir-trees clinging to the rock are symbols of Christians who have placed their hope in resurrection. The foreground as a whole is dominated by the contrast of dark and light areas and the conflict between the various lines of movement; it symbolizes earthly existence in which life and death are locked in permanent conflict. In contrast, the vast mountain rising behind seems to represent an area of peace and quiet. The downward movement in the centre is offset by the overall upward movement of the composition. The rock formation from the Harz Mountains functions as a kind of mediator between the spectator and the summit of the Watzmann.

The visionary quality of the picture stems not only from the obvious combination of totally different geological formations, but from the unreal spatial relationship created between the various individual motifs.

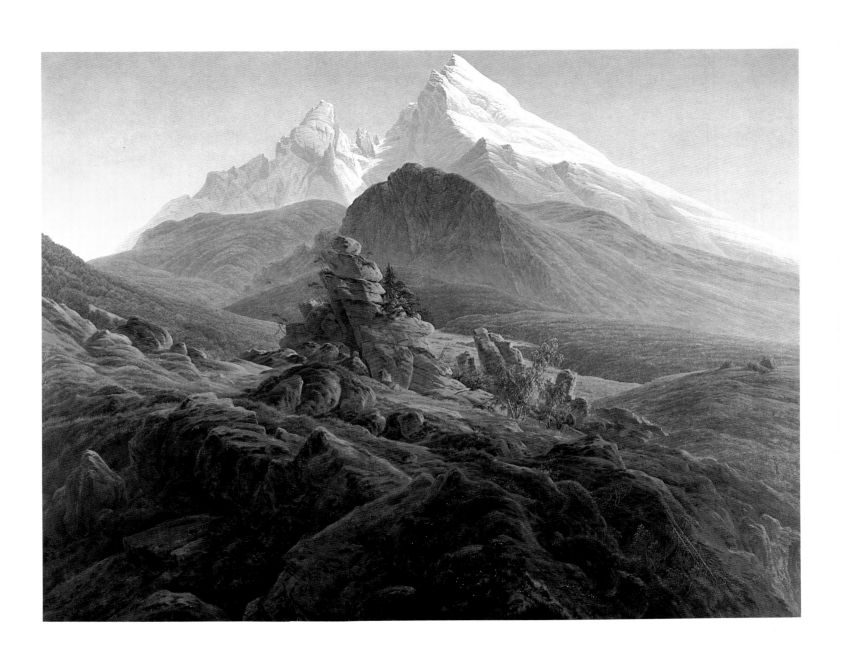

40 *The Snow-bound Hut* (*c.* 1826–27)

Oil on canvas, 31 x 25 cm
Berlin (West), Nationalgalerie

This picture belongs to the group of small-format paintings that introduce a new
period of creativity following Friedrich's illness between 1824 and 1826. In this
period he painted a great many winter landscapes. *The Snowed-up Hut* was shown in
the Dresden Academy exhibition of 1827 when it was bought by Prince Johann
Georg of Saxony.

The hay-barn, seen in close up with its thick blanket of snow, is treated rather like a
still-life. Through the open door nothing can be seen – just pitch darkness. The hay is an
allusion to the biblical parallel between human life perishing and the drying of the
grass. The hut symbolizes man's miserable earthly dwelling, being at the same time
a symbol of a sepulchre or tomb, as indicated by the dark interior. Similarly, the
broken branches and dried up flowers signify a life that has faded away and died, but
Friedrich never depicts winter as a symbol of death without connecting it with the
memory of spring, which is an image of the Resurrection. This thought is contained
in the shrivelled up flowers and the bleak willow trees behind the shed. For Friedrich
willows, which constantly shoot up new growth from an old trunk, are also symbols of
the Resurrection.

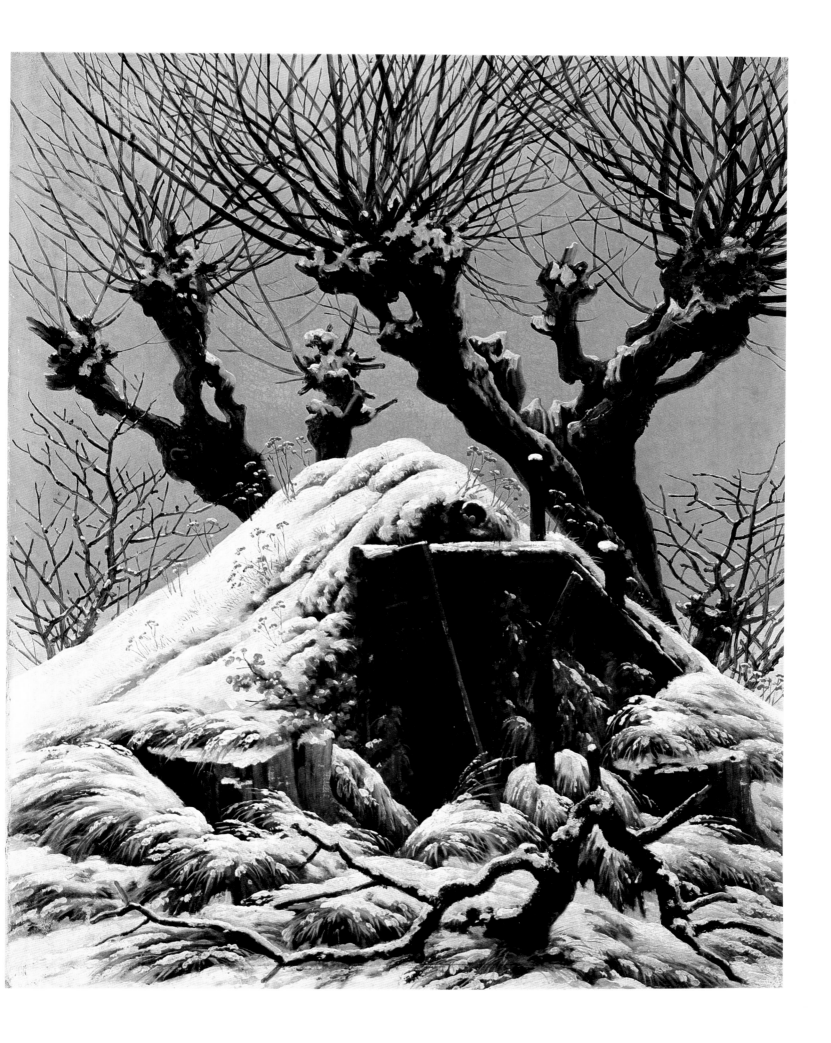

41 *Ships in Harbour at Evening* (*c.*1828)

Oil on canvas, 75.5 x 88 cm
Dresden, Gemäldegalerie

Friedrich painted this picture in 1828 for Baron Maximilian Speck von Sternburg, who had an important collection of old and modern masters at Lützschena near Leipzig. After the Second World War the collection was expropriated and presented to the Leipzig Museum, but *Ships in Harbour at Evening* had been auctioned many years before, in 1857, following the original owner's death.

The words 'Maxn v. Speck' are inscribed in large letters along the side of one of the skiffs in the foreground, suggesting that the skiff is to be equated with the Baron who commissioned the work. The boat lying in harbour signifies death. Friedrich intentionally made it a simple skiff in order to emphasize that death comes to all alike and that it removes all distinctions of social standing. To commission a memorial painting in advance of his death was a characteristic act on the part of a man who we know liked to show visitors round his future tomb and who always kept his wife's heart near him after her death in 1836. Perhaps the skiff moored next to his is meant to symbolize his wife. Maximilian von Speck and Friedrich must have been drawn very close by their mutual preoccupation with death.

It is one of the most complicated compositions that Friedrich created. The rhythmic diagonal row of home-coming fishing boats moves in from the horizon towards the harbour of death. The foremost of these boats is framed by the suggestion of a portal created by the poles propped up against the hut and the mast of the boat in the centre which is leaning over to the right. The five sails of the boats lying on the other side of the jetty form a symmetrical group, all turned towards the centre where the crescent moon is just visible below the clouds.

The richness of forms corresponds to the unusually intense colour scheme employed, dominated by bluish-violet, the colour of mourning, but interspersed with dashes of bright colours of striking brilliance.

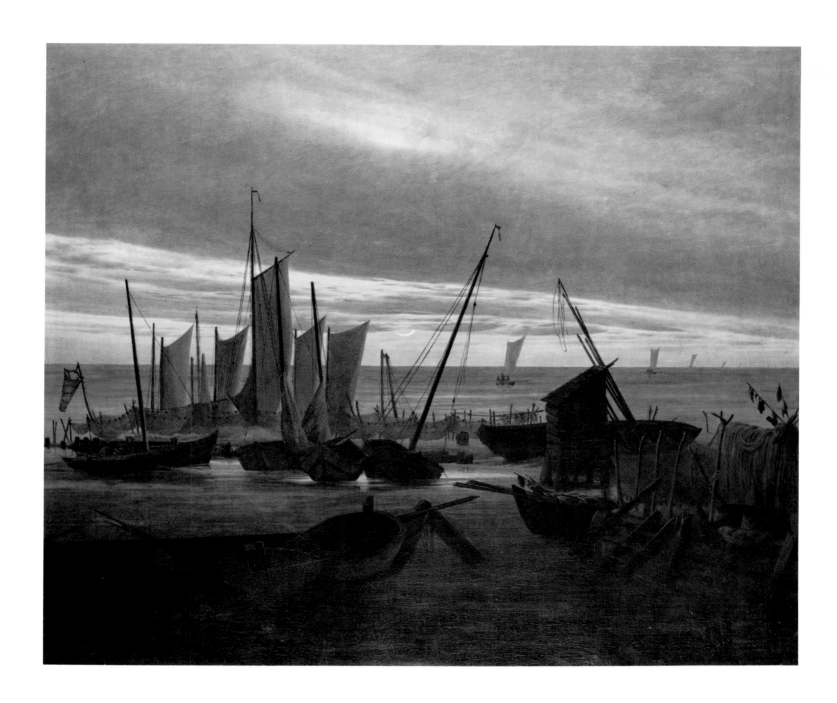

42 *The Churchyard (c. 1825–30)*

Oil on canvas, 31 x 25.2 cm
Bremen, Kunsthalle

Friedrich often turned to the motif of the churchyard in the course of the 1820s, not so much in large complex compositions like the *Abbey in the Oakwood* (pl. 8) of 1809 as in small, more intimate pictures. The Bremen painting shows the graveyard at Priesnitz, a village near Dresden. We know from Carl Gustav Carus' memoirs that he and Friedrich sketched tombstones together in this churchyard in 1824, so possibly the study on which this painting was later based also dates from that occasion.

In another version of the same theme in Leipzig the churchyard symbolizes the threat of death, but both here and in *Abbey in the Oakwood* it represents the life after death. The ground this side of the wall is a symbol of the dark life on this earth. The arched gateway set into the wall is closed by a broken-down gate hanging crookedly on its hinges. Its bars form a pattern which echoes the spire of the church tower and the sloping roof of the main body of the church. The tower immediately behind the wall is cut off by the upper edge of the picture and thus leads the spectator's imagination beyond the limits of the picture into heaven above. The churchyard with its tombstones and crosses is only partially visible through the bars of the gate. Significantly, it lies in the sunlight, and the bright green of the fresh young grass with its associations of springtime seems to hold the promise of a new life. Finally, the eye is led along the side of the church and away into the open countryside beyond, implying the freedom that lies beyond death.

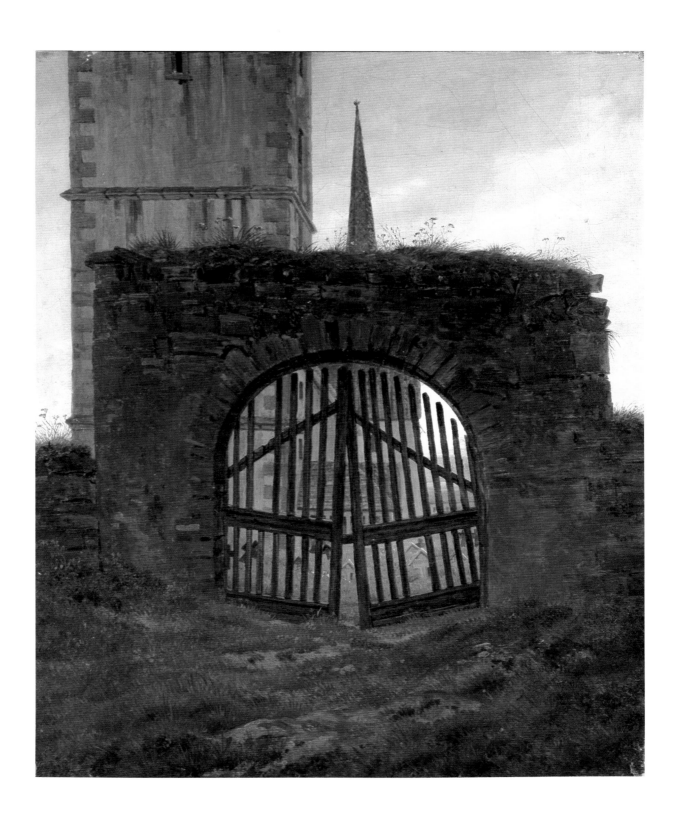

43 *Early Snow* (*c.* 1828)

Oil on canvas, 43.8 x 34.5 cm
Hamburg, Kunsthalle

Friedrich painted a very similar composition, entitled *The Chasseur in the Woods*, in 1813 or 1814, but with an overtly political message. It shows a French soldier standing on the path framed by the black opening of the forest. The forest trees symbolize the Germans united by their hopes of liberation and preparing for the death of the French soldier. According to a contemporary account the raven perched on a tree stump in the foreground is singing a death-song for the Frenchman.

In this second version of the theme which Friedrich exhibited at the Dresden Academy in 1828, the political overtones have been completely removed. The track leading up to the wood symbolizes the path of life which inevitably leads to death. The mysterious darkness of the wood hardly seems to be the goal of life, but the hint of blue sky just visible above it seems to suggest the existence of a more serene area beyond the wood.

The fir-trees, ranging from the saplings in the foreground to the towering mature trees in the background, represent the various stages in the life of the Christian. Whether the customary title *Early Snow* is appropriate, or whether Friedrich was in fact depicting the snow melting in early spring we cannot be sure. The essential thing is that the ground is just visible through the snow as an indication that winter and death are merely prerequisites for the new life.

In this way Friedrich indirectly links the present and the future in his painting and refers the spectator to the transcendental realm that lies beyond the limits of art.

44 *The Heldstein near Rathen on the Elbe (c. 1828)*

Watercolour, 26.2 x 23.1 cm
Nuremberg, Germanisches Nationalmuseum

In 1828 various German artists were called upon to contribute drawings for an album in honour of the third centenary of Albrecht Dürer's death. Friedrich sent in this watercolour of the Heldstein, near Rathen, a craggy rock in the Elbsandsteingebirge. It is not known whether he executed the watercolour specifically for this purpose or whether he simply sent in a work he happened to have in the studio. At any rate, the work contains no allusions to Dürer along the lines of the symbolism of works such as *Ulrich von Hutten's Grave*, a canvas probably dating from 1823, the third centenary of Hutten's death. The watercolour version of the Heldstein is based on a study from nature done in pencil and dating from *c.* 1808 (fig. 30), which Friedrich painstakingly converted. The pencil under-drawing records every contour with the greatest precision. A sparing amount of colour, light and shadow were then added with equal care in watercolour.

This faithfulness to the object and the deliberate omission of any stylistic exaggeration imply a deep reverence for nature. The distinction between light and shadow is of great concern to the painter. The dark tones all consist of grey wash in varying degrees of dilution, whereas all areas of colour simultaneously denote light. The palest area of light, the sky, is created out of the white of the paper, which can still be seen and felt throughout the whole sketch.

Around 1828 Friedrich took up watercolours again intensively for a while. He even considered some of these watercolour sketches to be so good that he entered them in the exhibition at the Dresden Academy. This sheet displays such a light touch that it can definitely be placed alongside others which can be dated with full certainty in the later 1820s.

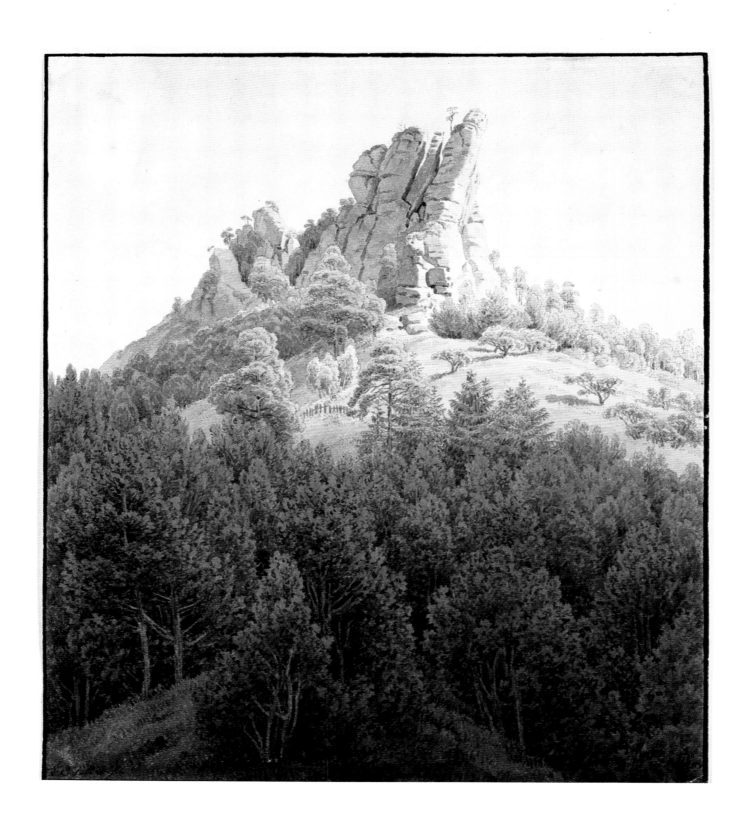

45 *Oak-tree in the Snow (c. 1829)*

Oil on canvas, 71 x 48 cm
Berlin (West), Nationalgalerie

This picture must have been painted *c.* 1829 since Friedrich sent it in to the Dresden Academy exhibition that year. The motif of an oak-tree beside a pond recalls the *Village Landscape in the Morning Light* (pl. 32). Here, however, the oak is conceived of in terms of a portrait expressing the character and fate of the tree, just as if it were a human being. In fact the tree is treated as a substitute for a human being. Its trunk and branches traverse almost the entire breadth and height of the picture. Despite its mutilated condition the trunk still stands erect and isolated as an image of defiance against the destructive forces of time. Nevertheless, the torso of a tree lying on the ground, creating a mysterious shape not unlike a crouching animal, implies that even the mightiest oak does not stand for ever; thus, Friedrich is using it to indicate the future condition of the tree that is still erect. As in previous instances, the oak once again symbolizes the pagan-heroic attitude to life, which in the last analysis is also subject to death.

The bizarre silhouette of the oak-tree stands out against the cold blue sky, which is a symbol of the superior force to which the tree is ultimately subject. However, it seems as if the cold spell has broken because behind the oak a pond has formed out of the melting snow. The blue of the sky is reflected on its surface and adds a spirit of reconciliation to the picture. While in front of the oak we see the heathen perspective of death, behind it the sphere of Christian hope is just beginning to open up.

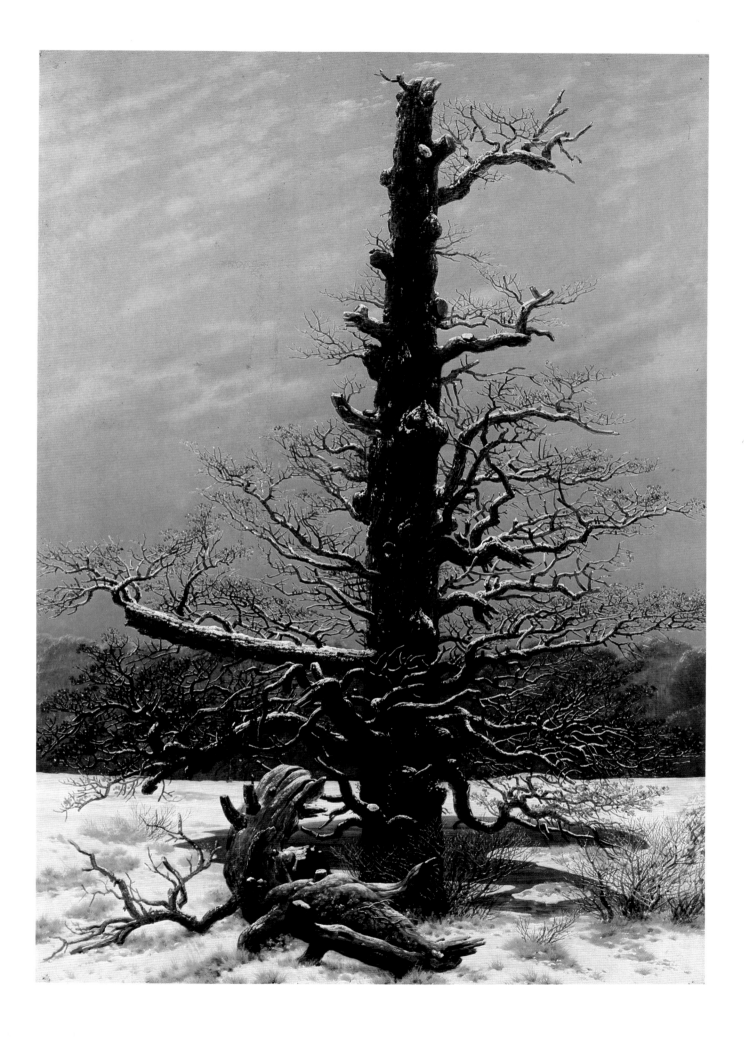

Oil canvas, 54×72 cm
Dortmund, Museum für Kunst und Kulturgeschichte, Schloss Cappenberg

Since 1944 this picture, previously held to be by Friedrich, has wrongly been considered to be a work by Carl Gustav Carus. In a sense the attribution to Carus is perfectly understandable, since it is the only known picture by Friedrich with an Italian landscape motif. However, he did once (*c.* 1800) depict the ruin of an antique temple in an etching of a mountain landscape. Friedrich never visited Italy, and in his aphorisms written *c.* 1830, entitled 'Observations on a Collection of Paintings Principally by Living or Recently Deceased Artists', he expressed sharp criticism of those painters who had moved to Italy in order to satisfy the public demand for brightly coloured southern views. For him personally, the north remained the sole aim of his religiously motivated artistic longing. Pictures such as the *Arctic Shipwreck* (pl. 37) or the two versions of the northern lights (fig. 53) – one lost and the other destroyed in 1945 – all bear witness to this attitude.

The Temple of Juno at Agrigentum must be seen in the context of this evaluation of the north and as an indication of his critical attitude towards the contemporary enthusiasm for Italy and the south. The ruins of the ancient temple, just like the ruins of churches dating from the middle ages which he depicts elsewhere, are symbols indicating that these cultural epochs have outlived themselves. Friedrich opposed the classicists who stressed the educational value of Greek and Roman culture in modern times. He refers to the symbol of the full moon over the sea as a symbol of Christ. The endless sea symbolizes the Christian concept of eternity in contrast to which the ruins illustrate the transience of pagan ideas.

Friedrich probably based his painting on an aquatint by the Swiss engraver Franz Hegi after a drawing by Carl Ludwig Frommel which appeared in a magnificent volume entitled *Voyage pittoresque en Sicile* published in 1826. The engraving showed the temple surrounded by olive-trees and aloes and included groups of tourists. By excluding these details Friedrich sought to emphasize the desolation of the pagan world.

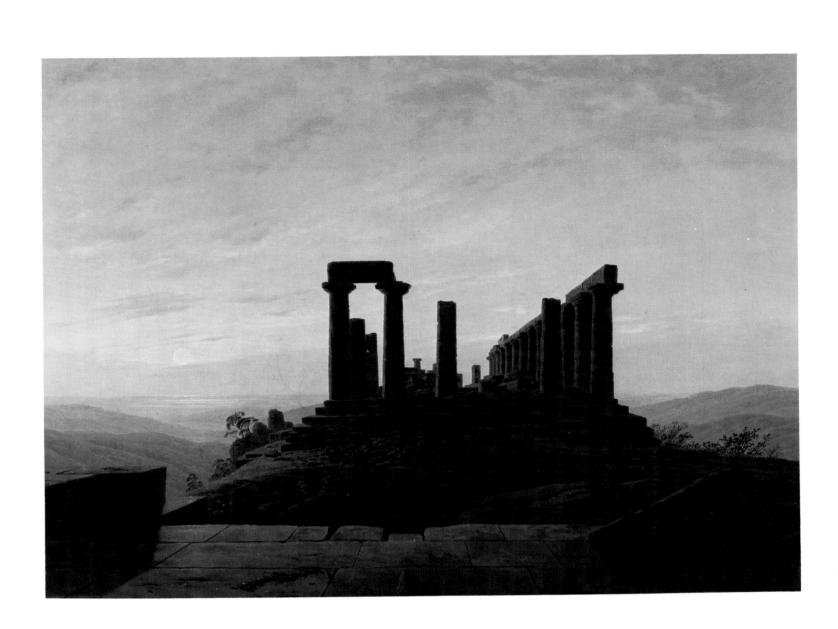

47 *Flat Landscape on the Greifswalder Bodden* (*c.* 1830–34)

Oil on canvas, 25.7 x 31.5 cm
Obbach bei Schweinfurt, Dr Georg Schäfer Collection

In the 1830s Friedrich painted a number of simple seashore scenes with fishing boats, using the same small format that he had favoured especially in the years 1815–20. Characteristic of these late seascapes is the mastery with which he renders the sky, usually a night sky with the reflection of the moonlight on both the clouds and the surface of the sea.

 This picture of the bay near Greifswald is an example of this group of seascapes. In contrast to the strong use of colour in night scenes such as *Moonrise over the Sea* (pl. 33) or *Ships in Harbour at Evening* (pl. 41), Friedrich has here forgone any strong colour effects of a symbolic character. Here the contrast between light and dark is enriched by only the most delicate nuances and shades of colour, so that a far more natural effect is achieved. The marshy shore in the foreground has been identified in the neighbourhood of Greifswald. The fishing boat that is about to come ashore is a symbol of the close of life. The dry land symbolizes the fisherman's home and sphere of existence, namely the world after death. Though the land near the water's edge is marshy, the moonlight – symbolizing Christ's mercy – shines evenly over this uncertain border area of existence just before and after death. By making the foreground into a symbol of the hereafter and the background into a symbol of life, Friedrich demonstrates that he is viewing death from a transcendental point of view. As in *Fields near Greifswald* (pl. 30) and other 'view'-like pictures, the realistic effects are used to express man's trust in the supernatural truth.

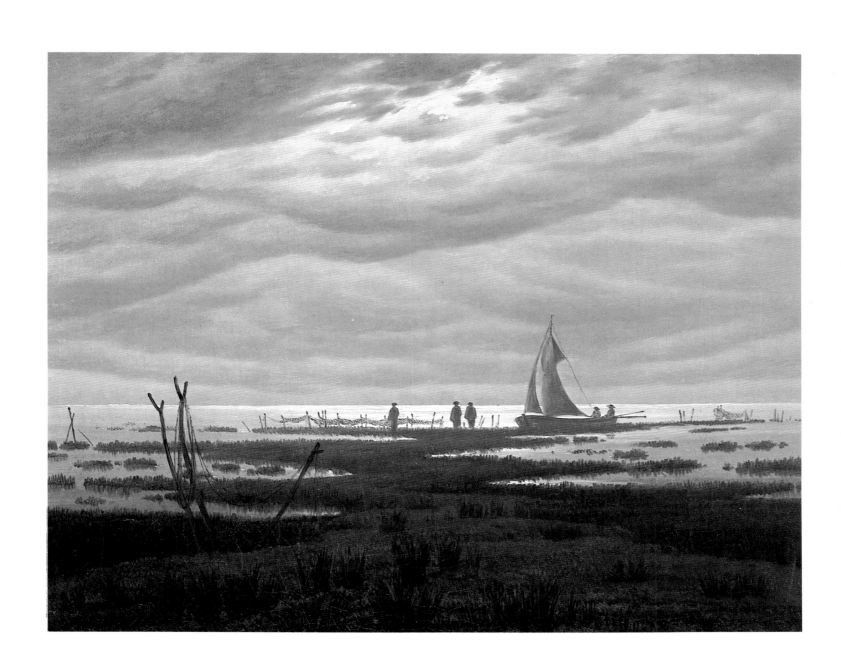

48 *The Evening Star* (*c.* 1830–35)

Oil on canvas, 32.3×45 cm
Frankfurt-on-Main, Freies Deutsches Hochstift

This painting depicts the same motif as the *Neubrandenburg* (pl. 16) of *c.* 1817, only in a simpler form. Here the return home from a walk is used to illustrate the approaching end of life. A family – mother, son and daughter – are walking along the gently rounded hill-top from which they can see Dresden, their home town, spread out below them. The figures might well be Friedrich's wife, one of their two daughters, and their son Gustav Adolf. While the daughter stays quietly beside her mother, the little boy has rushed forward a few steps in childish exuberance and is greeting the city joyfully with arms outstretched. The cap he holds in his right hand just touches the lower edge of the orange-coloured strip in the sky. The mood is that of an autumn evening. In the middle of the sky one can see the evening star, the dual symbol of death and resurrection. The horizon divides the picture into earthly and heavenly zones, the only objects which belong to both spheres being the human figures and the churches. The poplars which in Friedrich's works always signify death, are linked with the figures and the churches to form a rhythmic zig-zag of images uniting the background and foreground. In this way Friedrich indicates that mankind is part of some supernatural order and that his existence in this world is dominated by his longing to return to the transcendental. The bank of grey clouds lying across the sky sinks slightly towards the right-hand edge of the picture and corresponds to the upward flow of lines articulating the field in the foreground. The figures seem to be hemmed in by these imperceptibly converging lines. Melancholy and joy, oppression and consolation are all fused to create a bizarre dissonance. Nowhere is Friedrich's fundamental mood expressed with such shattering truth as in this picture where childish joy in living is used to symbolize the longing for death.

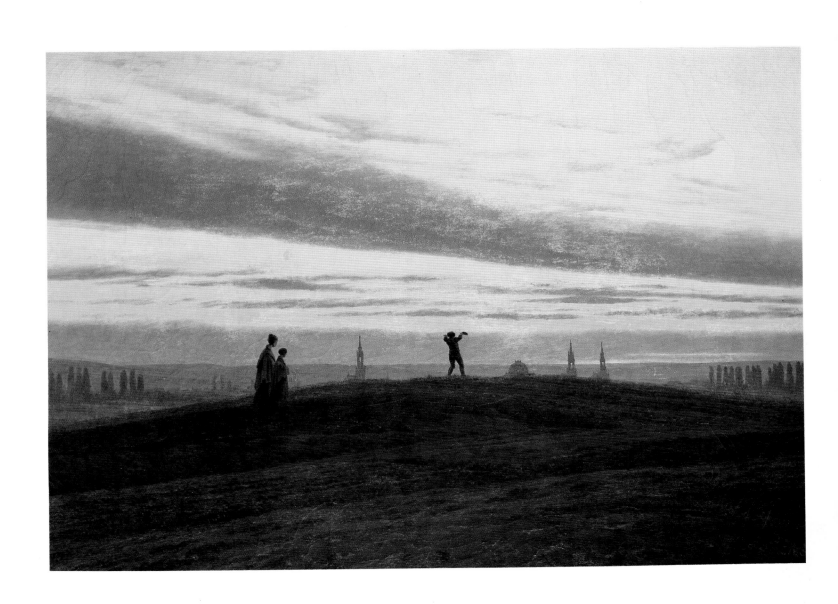

Oil on canvas, 34×44 cm
Berlin (West), Nationalgalerie

This picture is a variation of the work on the same theme, but showing two men, painted in 1819, now in the Dresden Gallery. The only major difference is that in the Berlin version a woman has been substituted for the younger man. According to Friedrich's friend Wilhelm Wegener, the figures in the Dresden picture represent the artist himself and one of his pupils, August Heinrich, who died in 1822. According to a less convincing account by Dahl they are two of his pupils, August Heinrich and Christian Wilhelm Bommer. August Heinrich's death could have been the reason why Friedrich replaced him in the second version with a woman, presumably his wife Caroline, who rests her arm on the man's shoulder as if seeking support. The couple are standing beneath a mighty pine-tree, an allegory of a Christian. The stony up-hill path is the path of life. It leads past the abyss of death, but the couple have eyes for nothing but the full moon, the symbol of Christ. The stump of a pine-tree in the foreground behind the travellers' backs is an allusion to their deaths. On the right-hand side of the composition the uncanny silhouette of the dead oak-tree that threatens to topple over into the abyss presents a curious contrast to the quiet contours created by the figures and the hanging branches of the pine-tree behind them. Two of the roots of the dead oak have already been torn out of the ground and stand out bizarrely against the sky. In this painting the meaning of the oak as the symbol of paganism which cannot avoid despair in the face of death is stated most explicitly. The large rock underneath the oak is part of the dolmen that Friedrich had sketched on 27 May 1806. The unprepared observer will scarcely be aware of the pagan connotations of the stone. The use of such indirect symbolism shows to what extent Friedrich's pictures are really personal statements. The row of pine-trees just visible behind the rock indicate the historical progression from paganism to Christianity.

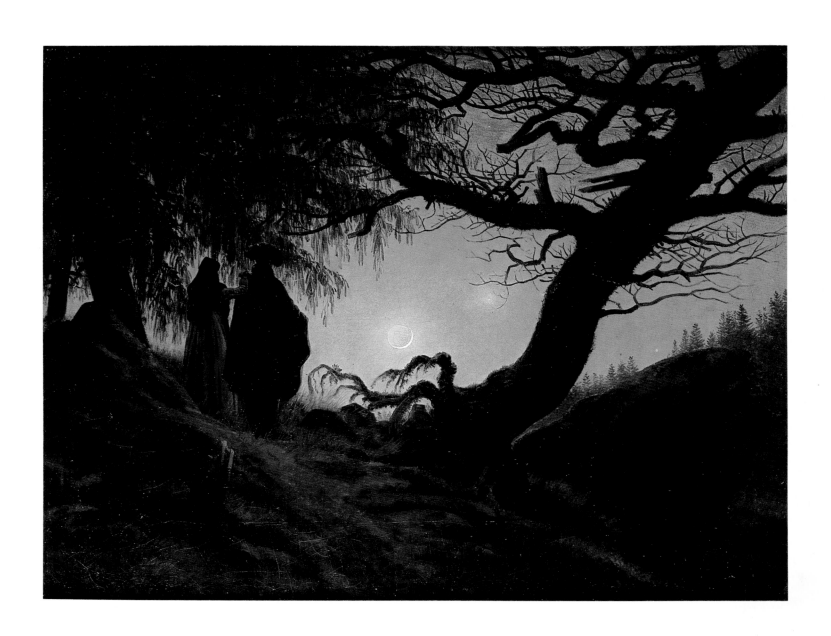

Oil on canvas, 73.5 x 102.5 cm
Dresden, Gemäldegalerie

The scene depicted lies to the north-west of Dresden on the south bank of the River Elbe. The avenue of trees on the left that ends so abruptly was laid out by Friedrich August III in 1744. The significant thing here is that Friedrich was employing a visible reality known to all Dresdeners as the symbol of a religious truth based on faith. The avenue is the path of life which emerges from the limitations and darkness of the trees into the open freedom of the plain, which symbolizes the life to come. The river is a continuation of this thought, for Friedrich has transformed the wide river in the foreground into a maze of shallow rivulets so that the boat approaching from the right must inevitably run aground. This imagery of death is made even more explicit by the interplay of colours. The purplish-brown of the muddy areas tones in with the pale blue reflection of the sky in the water, denoting the promise of eternal life as a solace at the moment of death. The observer involuntarily sees the ship as a symbol of his own fate. The way the ship is moving from right to left towards the foreground forces the observer to identify with it completely. Everything that is separated is united and comes to rest.

The scene is presumably viewed from a bridge over the river. In Friedrich's symbolic vocabulary bridges, across which the traveller passes from the shores of this world to the shores of the hereafter, always signify the comforting help of religion at the moment of death. The time of day and year depicted here also remind one of death. The olive-brown and golden-orange tones of the vegetation seem to indicate that it is autumn. It is also the moment just after sundown when the sun's rays no longer strike the earth directly. But everything is illuminated by the reflection of the magnificent glow that still suffuses the sky. The crescent of the moon signifies the consolation guaranteed by Christ in the night of death that is about to fall.

The painting is unique, not only within Friedrich's *oeuvre*, but in the entire history of landscape painting, because of the incredibly accurate and faithful rendering of the intensely rich colours of the autumn landscape immediately after sunset. This sublime beauty is not the result of personal or artistic virtuosity, but reflects a mental picture of death for the Christian believer; reaching such a peak of perfection is the only matter of doubt. Limitation of the subject matter and clarity of thought, combined with the utmost artistic effort in rendering colour, are also in the final analysis evidence of a moralizing intention on Friedrich's part; in this is rooted the ability of his extreme statement to convince us.

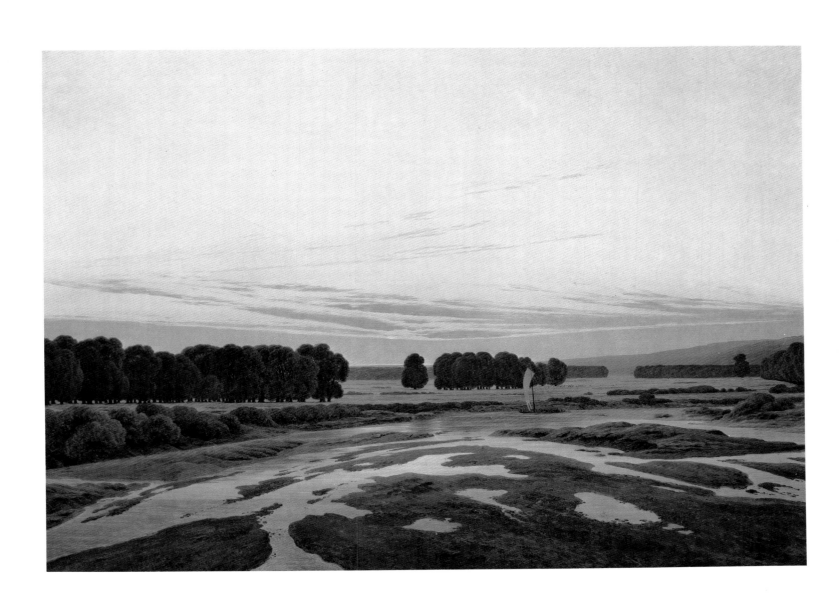

Oil on canvas, 72.5 × 94 cm
Leipzig, Museum der bildenden Künste

In this picture Friedrich took the basic seashore scene he had painted so many times before and intensified the effect by enlarging the format and introducing a more complex pattern of forms – figures, ships and a variety of miscellaneous objects lying on the foreshore. In addition he shifted the theme into a wholly personal sphere by portraying himself with the other members of his family. As with the *Monk by the Sea* (pl. 7) the introduction of a self-portrait, implying a more intensive examination of the self, is linked with greater artistic demands. This picture presents a far broader spectrum of life than the previous sea scenes.

The picture originally belonged to Friedrich's nephew and god-child Heinrich Friedrich, who happened to be staying with his uncle in June 1835 when the latter suffered a stroke. The old man leaning on a stick and seen from behind has been identified as Friedrich himself. He is the only figure in the scene to face out to sea. The young boy seated directly in front of the large ship in the centre is holding a Swedish flag and presumably represents Friedrich's son, christened Gustav Adolf in memory of the great Swedish king. The smaller of the two girls is probably Agnes, one of the artist's two daughters. The identity of the other female figure is problematical. It might possibly be his elder daughter Emma, but we do not know for sure. The man beckoning to Friedrich is presumably his nephew Heinrich to whom the picture belonged and to whom it was perhaps dedicated. His gesture could be interpreted as a promise to care for the artist's children after his death. The five ships correspond to the five figures on the shore. The large ship in the centre returning from a long voyage and already in the process of lowering its sails, is Friedrich's ship of life. It appears to be aiming for the mouth of the river. Between the artist and his ship of life the crescent moon is faintly visible in the sky. Only in the coming night of death will it be fully visible. The other ships correspond to the other four figures, the two dinghies near the shore, which are not sturdy enough to go to sea, apparently symbolizing the two children. The rowing boat lying with its keel upturned on the foreshore is reminiscent of a coffin and symbolizes death. The cross shape formed by the pole beside it decorated with little red flags is also intended in a symbolic sense. The rich harmonies of the evening light are at their most vivid near the shore and symbolize the intensity of religious experience in the evening of life.

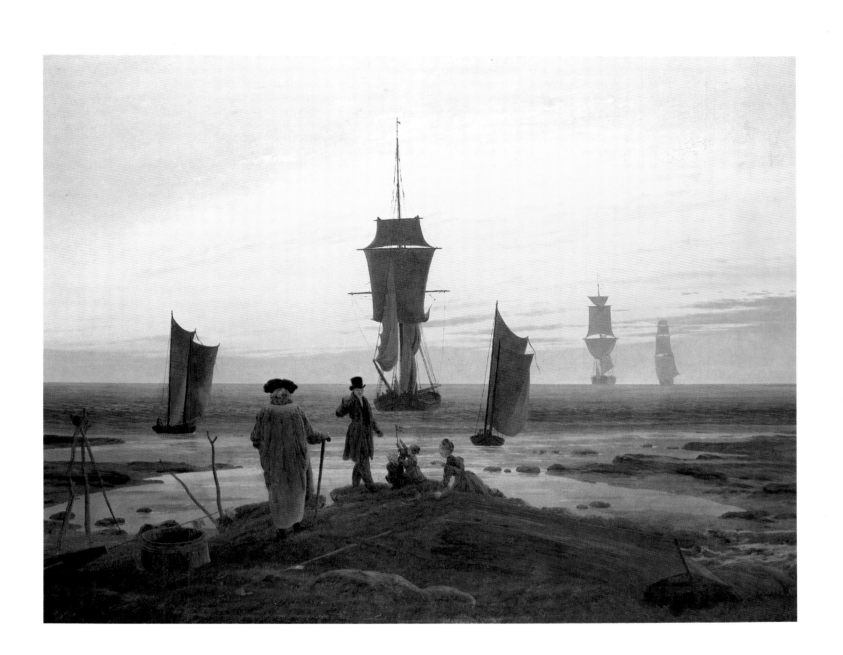

52 *Riesengebirge (c. 1835)*

Oil on canvas, 72 x 102 cm
Berlin (West), Nationalgalerie

This picture is popularly but incorrectly known as *Before Sunrise*. In fact Friedrich clearly had an evening scene in mind, for the traveller has reached the end of the ridge in the foreground and is resting on a stone, implying the end rather than the beginning of the day. The view derives from the Riesengebirge. The panoramic view across several mountain ranges recalls the spatial setting of the *Morning in the Riesengebirge* of 1810–11 (pl. 11). The figure is reminiscent both of this work and of *Mountain Landscape with Rainbow* (pl. 10), though a comparison reveals just how far Friedrich has distanced himself from that stage of his development twenty-five years earlier. A late sepia drawing seems to indicate that the picture is a more or less faithful rendering of a lost study from nature.

The painting contains no elaborate contrasts; no significant actions are being performed; no distinctive symbols have been added to make the intellectual content explicit. Its meaning is self-evident. Foreground and background, this life and the hereafter, are not so much separate as interwoven spheres. The motif of the man who has reached the end of life and stands before the abyss of death is depicted without any drama – indeed the scene can almost be described as idyllic. The contours of the mountain chains create a restless movement which becomes gradually calmer until it finally comes to rest at the highest mountain peak on the horizon. This mountain, towards which the traveller is gazing, is a symbol of God. Its form is echoed by the feathery, brownish-violet clouds above. They define the centre background of the picture just as the birch-tree, the symbol of spring and resurrection, defines the extreme foreground. The birch-tree and the clouds are linked not only by their relative positions in the composition but also by what they symbolize. They thus span the entire spatial depth of the picture.

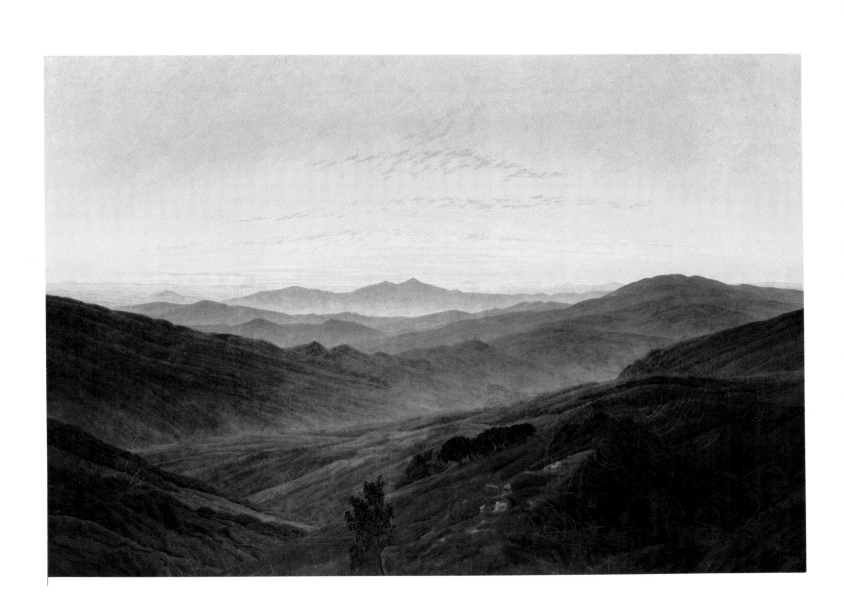

Oil on canvas, 72.5 x 103 cm
Oslo, National Gallery

After Friedrich's death several unfinished works were found among his effects; most of these had presumably been started before his stroke in June 1835. One of these paintings was this *Landscape in the Riesengebirge*. The background is based on a study from nature dated 13 July 1810, and in places the ink under-drawing is still visible through the thinly applied paint. The overall effect confirms what Carus wrote about Friedrich's method of working. 'He never began a painting until it stood lifelike before his mind, then he drew on the neatly stretched canvas, first lightly with chalk and pencil, then the whole of the outline properly and definitely with a quill pen and Indian ink, and soon proceeded to lay on the underpainting. Therefore his pictures in every phase of their development gave a definite, well ordered impression of his personality and of the mood which had originally inspired them.'

Friedrich returned to the theme of landscapes in the Riesengebirge several times in the course of the 1830s, seizing on a different aspect on each occasion. A specific feature of this painting is the unstable composition and the way the ground slopes away to the left, symbolizing death and acceptance of the inevitable. The drift of the clouds, in other words the motion of the heavens, re-establishes the balance. In the foreground a rough path winds its way between the rocks towards a distant field. In the middle distance a narrow strip of woodland serves as a frontier, the frontier of death, and behind it can be seen a sunlit meadow. The magnificent mountain landscape beyond, still only partly visible through the mist, is a symbol of the majesty of God. The spectator must let his imagination wander through the various areas of the picture if he is to understand that the path is an allegory of the transition from life to death.

Sunrise near Neubrandenburg (*c.* 1835)

Oil on canvas, 72.2 x 101.3 cm
Hamburg, Kunsthalle

This work also belonged to the group of paintings that Friedrich left unfinished at his death (cf. pl. 53). The foreground is based on a study of the countryside near Dresden dating from October 1824. The track runs past the fields towards the distant town. The haycocks dotted over the field on the left symbolize the rapid passing of human life. By contrast with earlier pictures, the town is not conceived here as the vision of some heavenly abode, but is depicted as a work of human hands and therefore transitory, like all human life. For this reason the Marienkirche, the largest Gothic church in the town, is shown in flames. This motif recalls another unfinished work of this late period depicting the cathedral at Meissen in ruins. Unfortunately that work is now lost and is known to us only through descriptions. Friedrich also made a sketch of the Jacobikirche at Greifswald as a ruin. Whether these sketches depicting still-standing buildings in ruins were intended as allusions to the future, or whether he wanted to demonstrate that the piety of the middle ages to which these buildings belong was an outlived form of divine worship, is hard to say.

The smoke from the fire has mingled with the grey clouds above, whose form echoes that of the clumps of trees growing round the town walls. Behind the town the glow of the sun is broken up into a symmetrical arc of five rays which completely dominate the sky, a symbol of divine power and infinity. All other elements in the picture are subordinate to it; even the fire seems insignificant in front of this powerful sunlight. By combining a representation of the power of light – which contradicts the idea that the time of day depicted is sunset – with the fire in the town Friedrich presumably intended to depict an allegory of the Last Judgment.

55 *Pine Forest with Lake* (*c.* 1836)

Oil on canvas, 36×44 cm
Obbach bei Schweinfurt, Dr Georg Schäfer Collection

Friedrich painted several pictures in oils after he suffered a stroke in 1835. In 1836 he even showed a new painting in the exhibition at the Dresden Academy. From Dahl we know that he continued to work on some unfinished canvases, though his command of the brush was somewhat shaky. The *Pine Forest with Lake* is apparently one of these last paintings. The motif recalls the *Evening* (pl. 25) in the times of day cycle in Hanover, though the looser technique now used indicates that the works were not executed at the same period. The tree-stumps signify death while the young pine-trees represent the generations to come. The boats moored along the edge of the lake suggest a mood of peace and quiet. As in other paintings they can be interpreted as symbols of death, but they also invite the spectator to cross to the other side of the water where the row of trees thins out to make room for the crescent moon, the symbol of Christ. The basic theme recalls the *Woman at the Window* in Berlin (pl. 31). The moon's glow is taken up by the small fire in the foreground which signifies the enlightening and warming power of religion in the terrestrial world.

In his last creative period Friedrich frequently contrasted two sources of light, one terrestrial and the other heavenly, in order to link the foreground and background of his pictures.

Despite the evening atmosphere, the vivid green of the vegetation – the colour of life and hope – contrasts with the intense bluish-violet of the sky, symbolizing melancholy and religious contemplation. This colour symbolism is reminiscent of Friedrich's style during the 1820s, including such works as *Moonrise over the Sea* (pl. 33) and *Ships in Harbour at Evening* (pl. 41). It thus differs from the faithful rendering of light effects at night which characterized such works of the early 1830s as the *Flat Landscape on the Greifswalder Bodden* (pl. 47).

Watercolour, 12.3 × 18.5 cm
Hamburg, Kunsthalle

During the years when he painted in oils Friedrich also used watercolour as his medium for straightforward, faithful renderings of landscapes without any allegorical meaning. When he could no longer paint in oils, he turned to watercolour and sepia techniques in order to express his ideas as well.

This watercolour of a *Landscape with Crumbling Wall* must be one of his last works. The brush strokes are extremely light, the format small, and the subject undemanding. Once again he expresses the idea of progression from this world into the life hereafter. The narrow area enclosed by the crumbling wall symbolizes this life. The shadows cast by the wall are tinted grey with diluted Indian ink. There is not much colour in this area. The rotten, tumbledown gate symbolizes death. It permits a little of the sunlight that suffuses the countryside beyond the wall to fall on the shady foreground. A flower near the gateway seems to be straining towards this stream of light. Friedrich envisages paradise as a broad river valley in summertime with the outline of Dresden just visible in the distance. In other words, he has once again adopted the motif of his earthly home as a symbol of man's ultimate home in paradise. Behind the town he even sketches in lightly the Elbsandsteingebirge as a symbol of God.

In 1826 he had depicted the same river landscape, though without the view of Dresden and the Elbsandsteingebirge, as *Summer* in a cycle of times of the year done in sepia. Like the Munich *Summer* of 1807 (pl. 4), this scene depicts earthly happiness. Perhaps Friedrich took up the theme again intentionally in this later watercolour in order to express his conviction that everything on this earth is ultimately a symbol of paradise.

Select Bibliography

Börsch-Supan, H. and Jähnig, K. W. *Caspar David Friedrich, Gemälde, Druckgraphik und bildmäßige Zeichnungen*, Munich 1973

Carus, C. G. *Friedrich der Landschaftsmaler*, Dresden 1841; *Lebenserinnerungen und Denkwürdigkeiten*, Leipzig 1865–66

Eberlein, K. K. *Caspar David Friedrich, der Landschaftsmaler*, Leipzig 1940

Einem, H. von *Caspar David Friedrich*, Berlin 1938; 3rd ed. 1950

Ettlinger, L. D. *Caspar David Friedrich*, Bristol 1967

Finke, U. *German Painting from Romanticism to Expressionism*, London 1974

German Library of Information *Caspar David Friedrich. His Life and Work*, New York 1940

Hinz, S. *Caspar David Friedrich in Briefen und Bekenntnissen*, Berlin 1968

Rosenblum, R. 'Caspar David Friedrich and Modern Painting', in *Art and Literature*, 1966, p. 134 ff.

Sumowski, W. *Caspar David Friedrich-Studien*, Wiesbaden 1970

Vaughan, W., Börsch-Supan, H. and Neidhardt, H. J. *Caspar David Friedrich 1774–1840: Romantic Landscape Painting in Dresden*, catalogue of the exhibition held at the Tate Gallery, London, 1972

Wolfradt, W. *Caspar David Friedrich und die Landschaft der Romantik*, Berlin 1924

Sources of Illustrations

The black-and-white illustrations in the text were supplied by the following:

Basle, Archiv K. W. Jähnig – fig. 4, 5, 8, 12, 14, 15, 17, 18, 28, 30, 40, 43, 46, 51, 54, 55, 58, 61, 62; *Berlin*: H. Börsch-Supan – fig. 37, 41; Staatliche Museen (East Berlin) – fig. 29; Staatliche Schlösser und Gärten, Schloss Charlottenburg – fig. 38; *Bremen*, Kunsthalle – fig. 33, 57; *Coburg*, Kunstsammlungen der Veste Coburg – fig. 48; *Copenhagen*, Royal Museum of Fine Arts, Collection of Prints and Drawings – fig. 7; *Dresden*, Staatliche Kunstsammlungen (Kupferstichkabinett) – fig. 63; *Düsseldorf*, Landesbildstelle Rheinland – fig. 3, 32; *Essen*, Museum Folkwang – fig. 11; *Frankfurt-on-Main*, Städelsches Kunstinstitut – fig. 10; *Hamburg*, Ralph Kleinhempel – fig. 1, 2, 34, 47, 52; *Karlsruhe*, Staatliche Kunsthalle – fig. 19; *Leipzig*, Kunsthistorisches Institut der Universität – fig. 59; *Leningrad*, Hermitage – fig. 42; *Mannheim*, Städtische Kunsthalle – fig. 6, 16, 24, 35, 36; *Marburg*, Foto Marburg – fig. 53; *Moscow*, Museum of Fine Arts – fig. 60; *Munich*, Bayerische Staatsgemäldesammlungen – fig. 27; Staatliche Graphische Sammlung – fig. 13, 49; *Nuremberg*, Germanisches Nationalmuseum – fig. 31, 39, 56; *Obbach bei Schweinfurt*, Dr. Georg Schäfer – fig. 23; *Stuttgart*, Staatsgalerie Stuttgart – fig. 9; *Vienna*: Graphische Sammlung Albertina – fig. 25; Kunsthistorisches Museum – fig. 21, 22; *Weimar*, Kunstsammlungen – fig. 20, 26; *Winterthur*, Stiftung Oskar Reinhart – fig. 50.

Index